make it yours

patterns and inspiration to stamp,
stencil, and customize your stuff

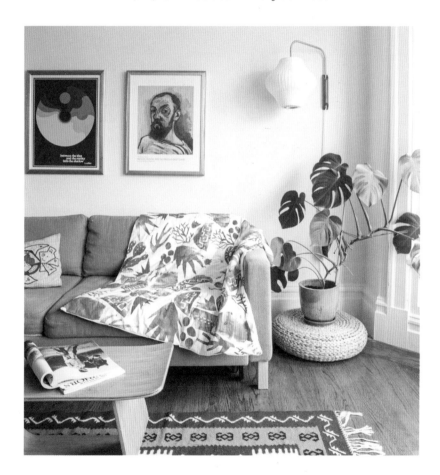

CHRISTINE SCHMIDT

CLARKSON POTTER/ PUBLISHERS
NEW YORK

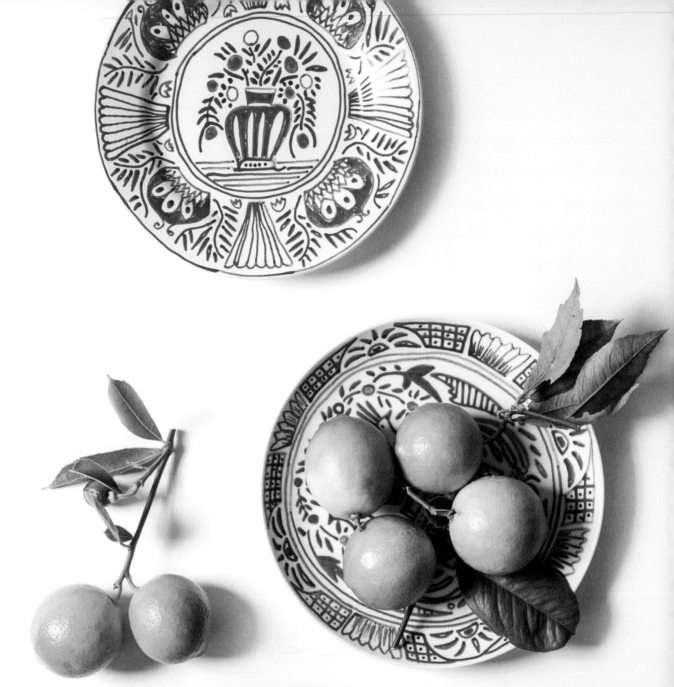

Copyright © 2017 by Christine Schmidt
Photographs copyright © 2017 by Aubrie Pick

All rights reserved.
Published in the United States by Clarkson Potter/
Publishers, an imprint of the Crown Publishing
Group, a division of Penguin Random House LLC,
New York.
clarksonpotter.com
crownpublishing.com

Library of Congress Cataloging-in-Publication Data
Schmidt, Christine
 Yellow Owl Workshop's make it yours : patterns
and inspiration to stamp, stencil, and customize
your stuff / by Christine Schmidt.
 pages cm
 Includes bibliographical references and index.
 1. Stencil work. 2. Relief printing. 3. Decoration
and ornament. I. Yellow Owl Workshop. II. Title.
III. Title: Make it yours.
 TT270.S28 2015
 745.7'3—dc23 2015012267

ISBN 978-0-7704-3365-9
Ebook ISBN 978-0-7704-3366-6

Printed in China

Book design by La Tricia Watford
Front and back cover photographs by
Hannah Garvin
Front and back flap photographs by Aubrie Pick
Illustrations by Christine Schmidt
Styling by Miranda Jones and Christiana Coop

10 9 8 7 6 5 4 3 2 1

First Edition

contents

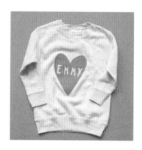

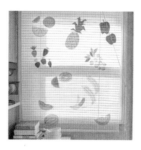
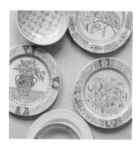

introduction: studio essentials

When I sat down to write this, my third craft and printmaking book, I thought hard about how I could earn your time, trust, and money with these pages. Almost two years later, I'm staring at a Post-it I penned when I began writing these pages that reads: "Original. Informed. Practical. Inspiring." And I am proud that, in my estimation, this book is soundly all of these things.

ORIGINAL I dug deep in my brain to create original motifs and patterns that suit contemporary tastes and appeal to a wide variety of sensibilities and passions.

INFORMED I worked hard to provide a solid foundation on color, design, materials, and pattern compositions to inform readers in an approachable and useful way. I want you to feel you've learned skills—not just for the projects contained in this book, but also for thinking critically about future creative endeavors. I was lucky to have a formal art education but you don't need it. Loads of great artists and designers didn't go to art school.

PRACTICAL I designed, produced, and tested (and designed, produced, and tested again) projects that would be functional for everyday life while being accessible to different skill levels, budgets, and uses. I have a stocked space in my Yellow Owl Workshop studio, but I made all of these projects in my house. I looked at traditional techniques and asked how I could use them differently with modern time-saving materials and do them in a home setting. I also considered specialized and expensive equipment and asked how I could pare it down with the same results for the at-home printmaker.

INSPIRING This is the biggest one for me because I wanted to share what thrills me while putting a fire in your belly to join up. This book is jammed with more than fifty projects, but I ditched dozens that didn't suit my chicken scratch manifesto, so all that remain are projects that will inspire you in all future printmaking endeavors.

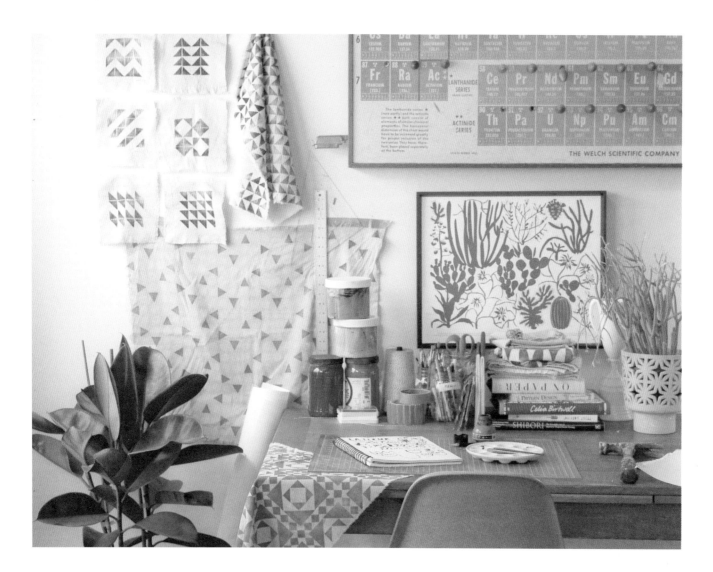

finding inspiration

I am excited for the day my daughter, now three years old, asks me where babies come from because I can answer that question. As the mom of a young kid, I am used to fielding questions about things that I think are just so obvious they almost can't be explained— they just are. I can explain how much infinity is, the meaning of the word *the,* or why I just don't like yellow mustard. I feel a bit the same way about explaining my inspiration for my line of goods, Yellow Owl Workshop, and my own personal work. Sometimes ideas quickly manifest from my fingers as if they were already formed, like birthing a full-grown George

Burns. But other times I am aware of a slow build. I sketch a stranger's vintage bag, the decorative borders of a restaurant plate, or a painting I saw at a museum. You never know when inspiration will strike.

I hope you find some of your own inspiration in this book, but when I share my ideas, it's to show you how to trust yourself. Keep your eyes open to find what piques your creativity. No need to dissect or ask why you like something. Just like falling in love, it is important to jump right in. Don't overthink it, just trust.

your personal process

Each person's process will differ, and it's important to learn what works for you. After I find my inspiration or land on a new pattern or idea, I draw a quick sketch, take a photo with my phone, or bookmark it on my computer. Then I go back, maybe immediately or maybe not for a while, and draw it again. (And again and again.) Each time I add and lose elements that don't serve my intended vision. Perhaps I rework it with a different material, scale, technique, or color palette. I keep refining and reimagining until something just clicks.

Oddly I find it easier to explain and think critically about my work when it isn't quite right and my brain is trying to fix it. Maybe the negative space is wrong, there's not enough contrast, and so on. I then take what didn't work from that version and try it again. I enjoy executing this slow process manually with paint or pencils because it gives me time to think and I get distracted in the making. It allows me to toss deliberate thoughts (or worse—overthinking) out the window. Give yourself the space and time to draw and redraw, brainstorm, and take a step back, until you land on your refined vision.

new challenges

If you're feeling particularly stuck or if you want to get into more of a routine, try challenging yourself in a new way. I am not much for fitness, but I do perform a daily exercise. Each morning, or whenever I am feeling blocked, I like to set a timer for 5, 10, or 20 minutes and just make something quickly with whatever I have on hand. I learned this trick from a drawing class where we would warm up the noggin with quick, timed sketches, called "gestures," without considering what the end product would look like.

OK COMPUTER!

Back in art school in the 1990s, we all held a general disdain of the oncoming digital age. We would lament the end of "real photography" and the enslavement of computers between Pixies songs. Even the graphic design elective I took involved manually cutting up Color-aid paper and StudioTac adhesive. (Anyone?) Years later, I've discovered that, duh, technology opens up more possibilities than it hinders and can actually help me with my lo-fi methods. While I always return to the tactile analog process, I have taught myself Adobe Photoshop and Illustrator out of business necessity. I find them particularly useful for changing the color palette and scaling prints I have scanned in. I have a tablet that facilitates drawing, bringing the process closer to the way I normally work. All the templates in this book can be transferred with tracing paper, but you can scan, photograph, and scale the templates as needed as well.

Try carving a stamp without drawing or planning first. Mix up paint and just watch the colors swirl together and see what happens on paper. These simple acts are outrageously satisfying and often are the best things I make all day. They are honest. Even if I throw away what I make, having done it psychs me up and reminds me that the process is as important as the product. Try it! Experiment with your prints. Keep the messed-up bits and play around until you've explored all the creative possibilities.

using this book

This book is organized by type of motif: abstract, everyday, custom, celebration, flora and fauna, and travel. Motifs are images that you can use once or repeat to create a pattern. For instance, repeating one circle motif makes a polka dot pattern. Repeat a tree motif and you get a forest. (I recommend looking at Appendix B on page 183 before you dive in so you understand the language I use in the chapters.)

For each project, I've estimated the time it will take and the skill level required—so everybody from greenhorns to professional printers can find something that suits them. Each project uses a different method of customizing your stuff—like block printing, stenciling, or fabric dyeing. These techniques are meant as springboards because you can take a motif from one chapter and use it with a printing method from another chapter. I've also included suggestions for "remixing" each project, and sometimes I've added bonus projects that use the same technique to make something entirely different. My intention was to get you to think critically like a designer and teach you the skills you need so you can adapt the techniques to make awesomely personal goods that suit you.

party time

Because printing, by nature, produces multiples, many of these projects are great for craft parties. I don't belong to a book club or a fitness group, but I do like making things with my friends. I have called out several projects in this book that I think are good for groups—though just about any craft is better with a pal. Here are some tips for throwing an awesome craft party.

SELECT THE RIGHT LOCATION The most important component is a solid table with good light. If you have a house with a good-sized table and chairs, lucky you! For all you folks living in small places (or for those who want to host larger groups), consider a public park with tables or a community center that allows you to rent the space for a few hours. You could also ring up a local restaurant or bar and ask if you can use the space (provided you clean up and spend a certain amount of money on food or drink).

PICK A SEASONAL PROJECT Choose seasonal motifs and projects to keep it current and useful. Unless you live in the Southern Hemisphere you probably don't want to be printing tank tops in January. This book is loaded with templates, so find one that suits the season. Winter holidays can be especially hectic schedule-wise and some people (not me) like to get a jump on those holiday gifts. Consider throwing a party several weeks before the holiday so everyone is more prepared for the holiday gifting season.

KEEP IT SIMPLE If you have never thrown a craft party before, start with a manageable number of people, say four to eight. The party should still be fun and relaxing for you, and inviting a small group will allow you to spend time with your guests, explain and answer questions about the craft, and still drink and snack. Plus, no amount of enthusiasm and coaxing can make that lame-o from the office worth it.

NOTE THE DRESS CODE All of these projects might get you a little dirty, so it's good to tell your guests to dress casually. Leave the black-tie finery and stilettos at home. We primarily work with water-based inks that wash easily, but a host going for extra credit might consider supplying some stain remover.

GET YOUR SUPPLIES You can either cover all the costs for the supplies or have your friends chip in. Good to let them know ahead of time if there is a specific fee! You could also divvy up the materials list and have everybody bring one thing. If people are bringing their own supplies, have them mark their tools with a certain color *washi* tape or write their initials in permanent marker before the event.

ARRANGE YOUR SUPPLIES Arrange supplies in the order in which they will be used. Keep the paint or other messy bits away from finished goods. Laundry drying racks or clotheslines are great for drying larger volumes of prints with a crowd. It's good to plan this before guests arrive.

KNOW YOUR STUFF It is a lot easier to show others how to do something you understand. Bring this book for reference. Read through the project and do a dry run with the materials you will use. This will make it easier to answer questions and troubleshoot during the event. This also gives you a sample of what the finished pieces will look like—and that alone can help others.

PROVIDE DRINKS AND SNACKS A necessity. I have a rule that drinks and snacks stay off the crafting table, and it's best to choose snacks that don't leave residue on hands that will be crafting.

other ideas

Make crafting social—no matter the distance and circumstance. Below are a few ideas to get you started.

CRAFT PEN PAL Want to have a long-distance craft party? You can ship each other boxes of supplies and instructions so you can learn together and share.

LOANER BOX Have a friend who is down, sick, or laid up? A box of craft supplies—even those you have already used—will be more fun and useful than chocolates or wilting flowers. Sometimes focusing on a project can really pass the time and lift the spirits while providing a fun and useful end result. Be sure to include a return address label if you expect any items to come back to you.

GROUP GIFT Work with your team, group, troop, or coven to create a great group project. Good for fund-raising or for making a commemorative gift to celebrate a special time or a personal parting.

getting your supplies

Although I have a studio full of supplies and equipment, I also run a business and have a kid. Often my only time to create is at night at my own kitchen table with things I have handy. I think everybody with a busy schedule and a non-Martha craft budget can relate, so I have handpicked projects that will generate stellar results at home with easy-to-find materials and without costly special equipment. Appendix A on page 168 will give you a complete overview of tools and supplies by type of printing, but here are the necessities you need to get started.

PENCIL Pencils are great for sketching patterns, marking measurements, making notes, and transferring designs to stamp blocks. I use a mechanical pencil when I want the accuracy of thin lines for templates and marked measurements. I use a hand-sharpened pencil when drawing because I can make a variety of line widths and tones.

ERASERS While synthetic rubber or vinyl erasers (like on top of a pencil or a Pink Pearl) are the most common type, they can be abrasive and tear paper—especially delicate tracing paper, which is used to trace templates for many projects in this book. A gum eraser is a better option because it won't damage paper or smear the graphite; plus, it lets you clear out large areas quickly.

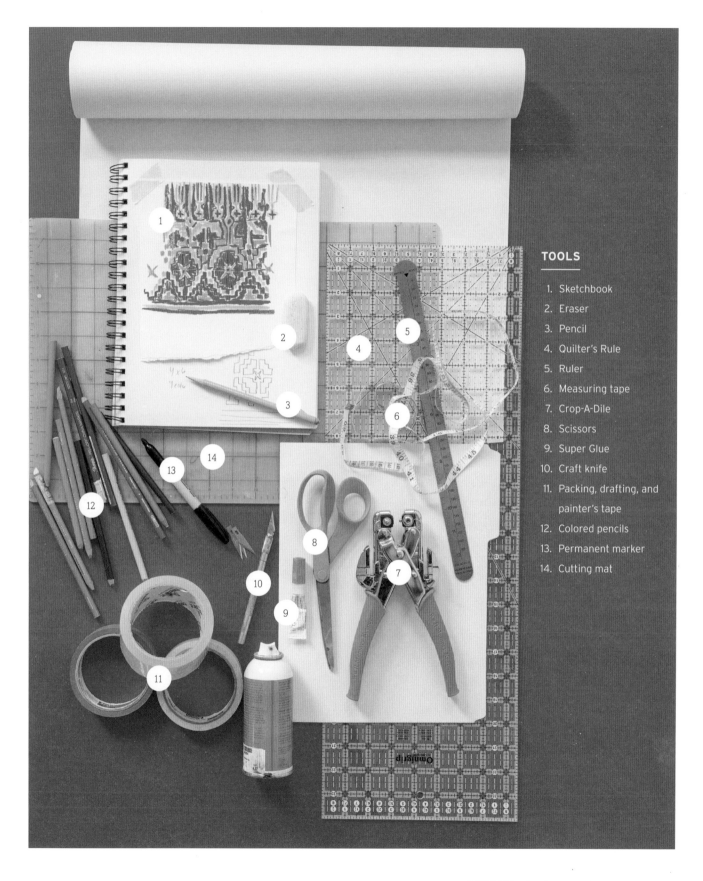

TOOLS

1. Sketchbook
2. Eraser
3. Pencil
4. Quilter's Rule
5. Ruler
6. Measuring tape
7. Crop-A-Dile
8. Scissors
9. Super Glue
10. Craft knife
11. Packing, drafting, and painter's tape
12. Colored pencils
13. Permanent marker
14. Cutting mat

PERMANENT MARKERS Use these to make indelible marks on many surfaces. I always have fine point and ultra fine point markers around in a few colors.

SELF-HEALING CUTTING MAT A cutting mat for your studio. Made from a sandwich of several layers of special vinyl, this surface "self-heals" because the polymer is not rigid, so cuts close themselves up. The soft ground also means less wear on your craft knife blade, which means fewer blade changes. These usually come with marked measurements and angles to aid in sizing and cutting. I flip it and use the back side when I am painting or gluing small items because I can easily clean the surface with a rag. This mat is a real workhorse in the studio and can last a long time if you store it flat and out of direct sunlight. I use my small cutting mat, 18" × 12" (45.5cm × 30.5cm), most often. I also carve my stamps on it and carry it to the trash to dump the excess rubber shavings.

CRAFT KNIFE Often known by the brand name X-Acto, these knives are shaped and used like a pen to cut a variety of materials like paper, cardboard, foam core, and even leather. These knives handle delicate details and straight lines better than scissors. While the blade will gnarl or rip delicate tissue or fabric, it works well to precisely cut thicker materials. Hold the knife in a fixed position in your hand and move your arm down the paper to make a cut. Use a straightedge (like a metal ruler, a triangle, or a T square) as a guide to cut straight edges. Rotate the material to make curved cuts. When cutting thicker material, first score it by running the blade halfway through the stock. This gives a little alley for the blade to travel on as you make successive cuts until you go through the stock. Keep extra blades handy and change them often for safety and for smooth, precise cuts.

SCISSORS Look for stainless steel blades and a model that feels good in your hand. A cutlery store can sharpen the blades for you, if needed. Because paper is more rigid than fabric, it can dull blades more quickly, so some folks have dedicated scissors for each. Those people are more organized than I am; my Fiskars get me through.

HOLE PUNCH Until a few years ago I only had a rusty old hole punch. Then I upgraded to a Crop-A-Dile by We R Memory Keepers. It is a sturdy tool that can punch through paper, leather, plastic, metal, cardboard, chipboard, acrylic, fabric, and wood with both ⅛" and ³⁄₁₆" (3mm and 4.8mm) holes, and it sets metal eyelets and flat snaps. It also has a sliding measuring guide for placing holes. Get one—you won't regret it! Their Big Bite punch is even larger and has an arm that extends 6" (15cm), so you can make holes in the middle of large sheets.

MEASURING TOOLS You'll definitely need a ruler for small dimensions and a metal measuring tape for larger dimensions. A 48" (122cm) level with measuring marks is one of my best and most functional purchases. A T square is essentially a ruler with a perpendicular head and is handy for making right angles. Just rest the head against the edge of a table or cutting mat. Quilter's Rule original rulers are clear acrylic grids with marked measurements. I use my Omnigrip no-slip 8½" × 24" (21.5cm × 61cm) Quilter's Rule to align stamps for printing, measure the space and drops between stamps, and use the straightedge as I would a ruler. Treat yourself!

IRON An iron is good for making items flat before printing and for heat-setting fabric inks. Keep some scrap fabric around to place over objects that need to be ironed and to protect the iron's surface from dried ink or paint. An ironing board is handy, too, but sometimes I just throw a towel over my table and get on with it.

SKETCHBOOK A great place to jot down your tips, process notes, color formulas, measurements, and sketch patterns. And don't forget about your inspiration, too! Get whatever kind tickles your fancy. I always carry a small sketchbook in my bag and fill up larger ones at home.

PROTECTIVE GLOVES These are useful when using paint, inks, and dyes that can stain your hands or when you just want to be able to slip them off and answer the phone or eat a taco. Projects requiring gloves will be noted.

TRACING PAPER All the templates in this book can be traced with tracing paper. The translucency allows you to see the image to be traced. Vellum is slightly thicker than tracing paper and also slightly more expensive, but is super durable. Parchment paper from your kitchen can also work in a pinch, but it is less translucent.

SCRAP PAPER Always handy to have paper to provide text printing surfaces and as a protective layer when you are spraying or painting. Give your recycle bin a look!

SEALANTS These coatings are used to prepare a surface or seal a finished piece for durability. Mod Podge sets the standard here as a sealant and glue in one. Available in matte, glossy, and other effects, it is a studio necessity because it dries crystal clear and is flexible. My mom, an art teacher who often needs to seal many items at once, turned me on to Krylon's Triple-Thick Crystal Clear Glaze, which gives a high-gloss, glass-like coating. The drawback of this one is that you need to spray it in a well-ventilated area with ample scrap paper under the project to catch the excess.

PAINTER'S TAPE Good for securing paper and stencils in position, and even as a stencil itself. It won't leave adhesive goo behind because it is specially formulated to remove cleanly. It's also waterproof.

CLEANING SUPPLIES Keep plenty of clean towels and hand-washing supplies around. Baby wipes are my best friend for a surprisingly handy cleanup. These work especially well with rubber stamps.

FIRST-AID KIT You just never know.

abstract & geometric patterns

Geometric and abstract shapes are called "nonrepresentational" because they don't look like a certain thing, but with a conscious hand, they can conjure up certain places and things. A circle over wavy lines may suggest a seascape. Tumbling triangles hint at a mountain range. Two circles on either side of an oblong oval could be a face. Don't feel restricted by your school geometry here—you don't need to make perfect shapes or impeccably straight lines. Shapes and lines that look soft and irregular, rather than sharp and straight, add a dynamic energy that looks even better when printed on a surface by hand.

Play with your shapes and resist the urge to make *this* look like *that*. You'll find the motifs you make will be all the more exciting for it. In this chapter we plunge into basic pattern structures, the relationships between motifs, and the play between positive and negative space, so you can be on your way to creating masterful patterns with other motifs and projects in this book.

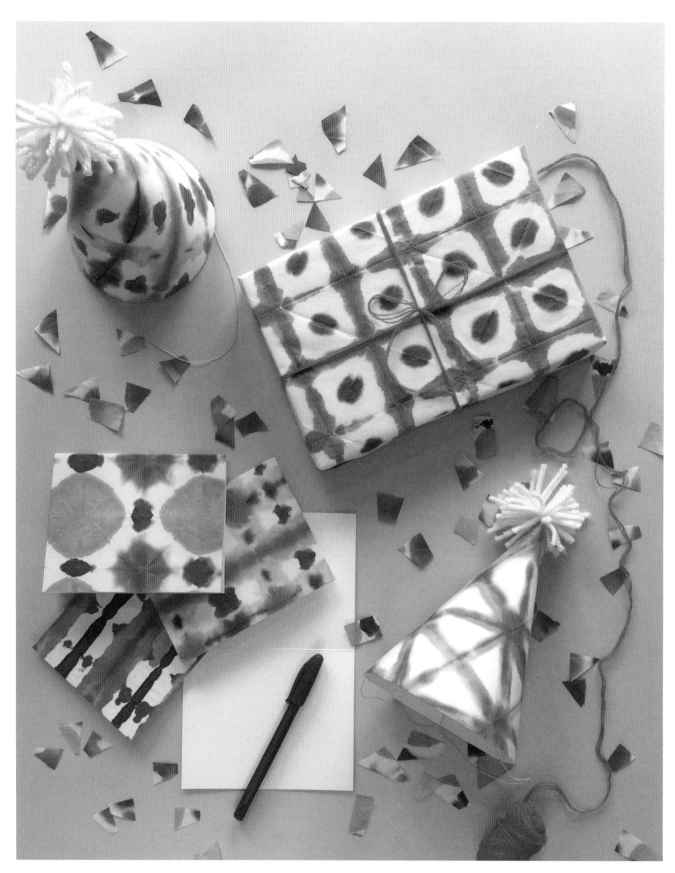

dyed *washi* paper

TIME: 10 minutes

DIFFICULTY: ● ○ ○ ○

LEARN: How to mix colors, and essential *shibori* folding techniques

REMIX: Use this technique to dye fabric; use the finished paper for stationery and other projects

MATERIALS

Washi paper, 12¹⁄₈" × 18¹⁄₈" (30.8cm × 45.8cm)

Bone folder (optional)

Small bowl(s) at least 4" (10cm) wide, one bowl per color

Liquid food dye or liquid watercolor paint

Water

Iron (optional)

Simple, quick, and colorful is the name of the game when making this versatile dyed paper. The process only takes about 10 minutes, but I'll bet you'll have so much fun you won't stop for hours. It's important to use *washi* paper because it is thin enough to be folded several times, easily accepts ink (thanks to its uncoated surface), and has good "wet strength," meaning it doesn't tear easily when saturated. Use any size, but I like a large pad because I can fold it many times and achieve more complex patterns.

In terms of "dye," studio staples such as watercolors and acrylics thinned to a watery consistency work, but surprisingly, I have the best luck with liquid food dyes from the kitchen pantry. (This also means I can safely use my kitchen bowls without worry of contamination.) Apply dye directly with an applicator or by placing the food dye tip directly to the edges for more contrast on the folded edges.

instructions

1. Align the long side of the paper with the edge of the table. Take the right edge of the paper and fold it over to the left about 2" (5cm). Crease with bone folder or side of thumbnail. **(a)**

2. Flip the sheet of paper over and fold the creased edge in to the right until the edge of the paper is flush with the second fold. Crease with bone folder or side of thumbnail. **(b)**

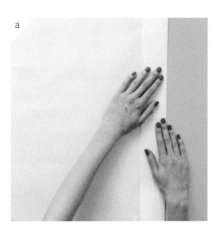
a

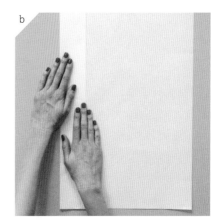
b

3. Repeat step 2 until the sheet is completely folded, accordion-style, and you have one long strip. **(c)**

4. Fold the bottom-left corner of the folded strip up to meet the right edge. (This creates a triangle.) Crease with bone folder or side of thumbnail. **(d)**

5. While holding triangle fold in hand, flip the paper over. Fold the bottom corner of the triangle up to meet the left edge of the folded strip and crease. **(e)**

6. Continue flipping the paper over and folding up the triangles until you have a tight triangular stack. **(f)**

7. Pour a small amount of food dye into a bowl and add water to dilute. The proportion of water to dye will vary the saturation of color. Use a more concentrated solution for brighter colors. **(g)**

8. Dip corners or edges of the paper in the dye bowls and allow the dye to penetrate the paper. Leaving it in the dye bath longer will allow more dye to creep up the paper fibers, resulting in more color coverage. **(h)**

9. Unfold the paper gently and lay it out to dry. Once dry it can be pressed using a no-steam iron on low to remove folds or wrinkles. **(i)**

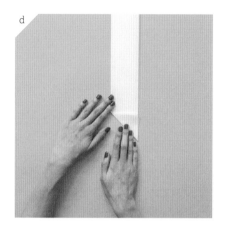

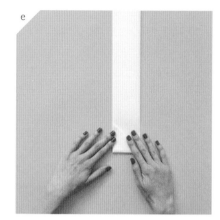

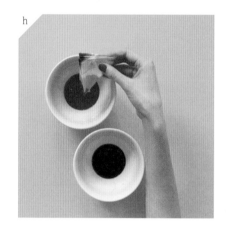

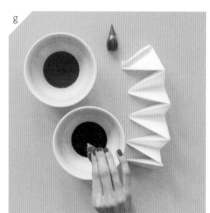

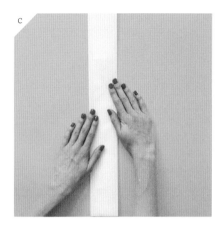

place mat party

Washi paper is so versatile that you can use it for a slew of projects. Invite friends or family over to make this fun and simple project with you. These durable place mats can be wiped clean and are suitable for even the very young to make. Plus, it's exciting when you're able to trade results and dye combinations with others. It helps if you have a large flat surface or even a clean floor to fold paper on. If it's the right time of year, try the project with the dye left over from coloring Easter eggs.

Materials: Dyed *washi* paper (page 15); 2 sheets of clear adhesive shelf liner, 15" × 20" (38cm × 51cm); large spoon; scrap fabric, larger than 15" × 20" (38cm × 51cm); iron; ruler; craft knife

1. Place one finished sheet of dyed *washi* paper on your working surface.

2. Peel the adhesive backing off one sheet of the shelf liner and place it with the sticky side down over the *washi* sheet. Burnish the surface of the shelf liner with the back of a large spoon.

3. Place a piece of protective scrap fabric over the shelf liner and quickly iron it on the lowest possible setting with no steam.

4. Flip the paper over to the other side and repeat steps 2–3.

5. Use a ruler and a craft knife to trim ½" (13mm) from all four sides of the place mat to achieve a crisp edge.

custom stationery

Make personalized stationery with a handmade touch and even file folders and boxes to match.

Materials: Dyed *washi* paper (page 15); scored cardstock; spray adhesive; scissors or craft knife

1. Cut the dyed *washi* paper slightly larger than the cardstock.

2. Apply spray adhesive to the front of flat cardstock and place the *washi* paper on top. Smooth the *washi* paper with your hands, working from the center out, to affix it to the cardstock.

3. Use scissors or a craft knife to cut the *washi* paper to the size of the cardstock.

wrapping paper

While you can use the *washi* paper as is, the wrapping paper is slightly transparent and can tear easily. This fast technique gives the paper strength so it can be used as wrapping paper or for other decorative paper uses.

Materials: Dyed *washi* paper (page 15); newsprint or scrap paper, 18" × 24" (45.5cm × 61cm) sheet; spray adhesive; scissors

1. Place the dyed *washi* paper on a large piece of newsprint or scrap paper and spray evenly with a spray adhesive.

2. Turn *washi* paper over and position onto the scrap paper. Affix by smoothing it with your hands, working from the center out.

3. Trim away excess scrap paper.

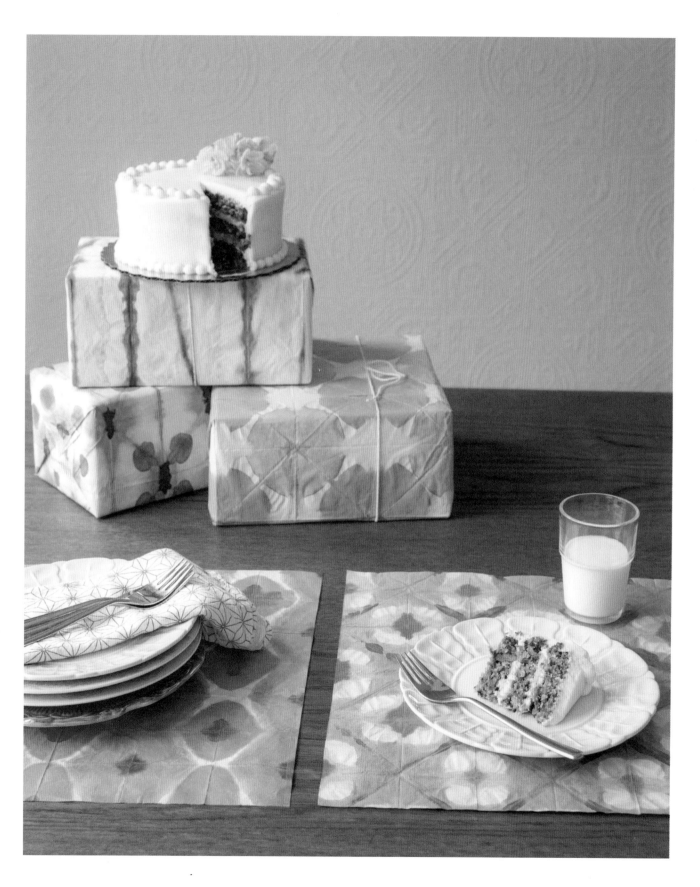

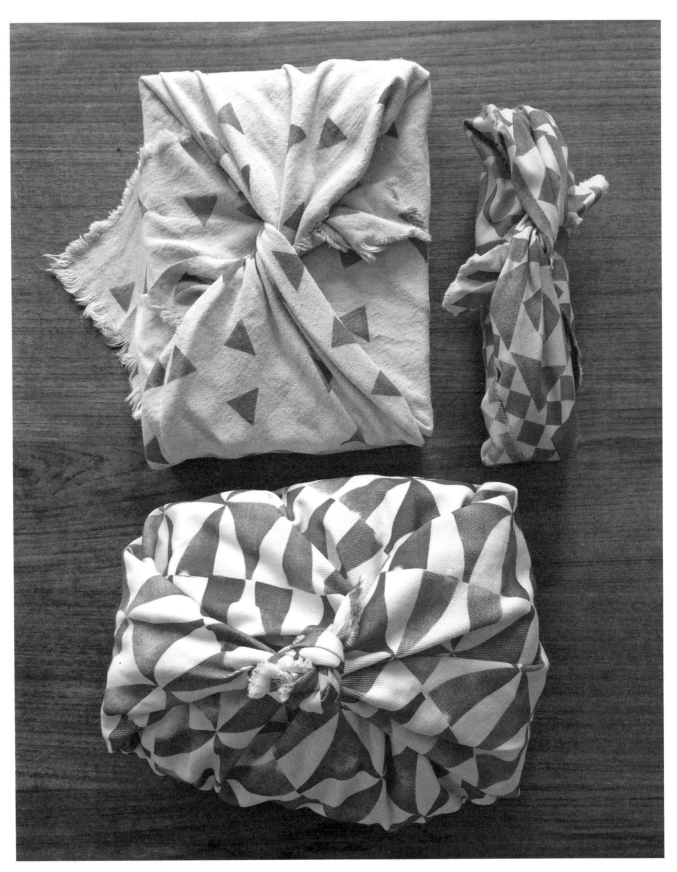

cut-a-stamp

TIME: 30 minutes

DIFFICULTY: ● ○ ○ ○

LEARN: How to make an inexpensive, fast, and giant stamp, and the basic pattern structures for printing with it on paper and fabric

REMIX: Use this technique to make large, low-detail stamps with any motif

MATERIALS

Templates (page 146)

Pencil

Scrap paper, 5" × 5" (12.5cm × 12.5cm) (optional)

Tracing paper, 5" × 5" (12.5cm × 12.5cm)

Adhesive craft foam, 5" × 5" (12.5cm × 12.5cm)

Cutting mat

Craft knife or scissors

Clear acrylic mount, 5" × 5" (12.5cm × 12.5cm) or clear acrylic CD cover (optional)

Plastic spoon

Textile ink

Inking plate

Foam or rubber brayer

Rayon or twill cotton fabric, 22" × 22" (56cm × 56cm)

Ruler or straightedge

Iron or dryer

Stamping is the best way to dip your toe into printmaking because it is fast, versatile, and can yield complex patterns with simple repetition. You could mount this stamp to any rigid object, such as wood or chipboard, but I like clear acrylic mounts because they let me see exactly where I am printing. I sized these stamps so you can use a clear plastic CD cover—because what else can you do with CDs these days? This project lets you create numerous patterns by placing triangles in different rotations on a 4" × 4" grid. You can get a lot of different looks and complex patterns with this humble shape so move the triangles around and have some fun!

I like lightweight twill cotton for this project because it has a tight weave and frays nicely when washed. The face of twill has a diagonal texture so I print on the flat back. You could also use old bed linens or any scraps of natural fiber fabric. For more inspiration, look through the prints on the following pages to see other templates and pattern structures.

instructions

1. Sketch your 4" × 4" grid on a sheet of scrap paper if you like, or pick out the template of your choice. I used template A on page 146. Press hard on the pencil to make heavy marks as you trace the template. **(a)**

2. Turn tracing paper over and place it onto adhesive craft foam. Use the side of your thumbnail to transfer graphite pencil lines onto the foam. **(b)**

a
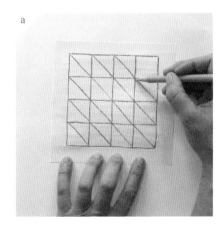

b

c

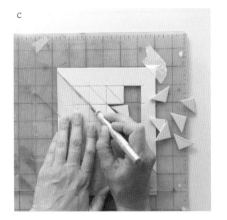

d

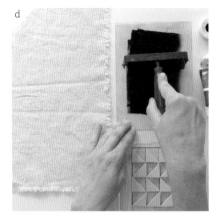

e

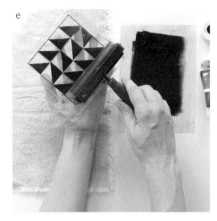

f

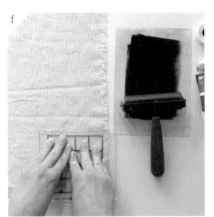

g

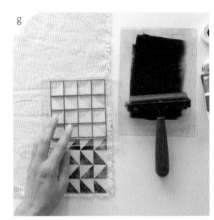

h

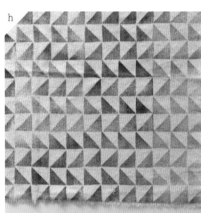

3. Place craft foam motif side up on a cutting mat and cut out the motif with a craft knife. **(c)** Turn tracing paper over (so tracing is visible) and place the mount faceup over the template. Peel adhesive backing off foam and place it in position on the case, lining it up with traced motif.

4. Add two heaping spoonfuls of ink to inking plate and run brayer through ink until it is evenly coated. **(d)**

5. Roll brayer over foam stamp until it is evenly coated with ink. **(e)**

6. Lay fabric on a flat working surface and (using a ruler or straightedge as a guide) position stamp on fabric. Press firmly all over the mount before lifting the stamp. **(f)**

7. Repeat steps 4–6, printing in a grid pattern. **(g)** Heat-set print with hot dry iron on cotton setting or one hot cycle in dryer. You're done! **(h)**

color reverse spot pattern

This pattern is created with the 4" × 4" grid with one motif that is reversed so the positive printed space becomes the negative unprinted space. **(a)**

rotating pattern

This pattern was created with a 4" × 4" grid with one motif that rotates the motif 90 degrees for each grid square. **(b)**

multidirectional four-spot pattern

This pattern is created in a 4" × 4" grid and is a way to make a pattern flow in every direction. Each row has one staggered triangle motif that points in a different direction. Although optional, I chose to make another stamp in a 4" × 4" grid to fill in empty grid squares with circles to add more interest. **(c)**

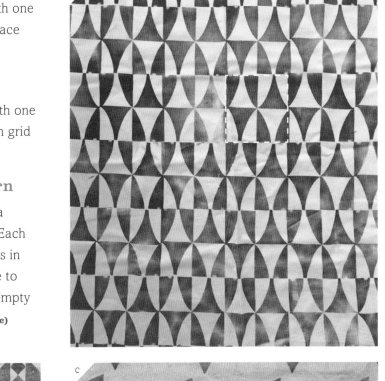

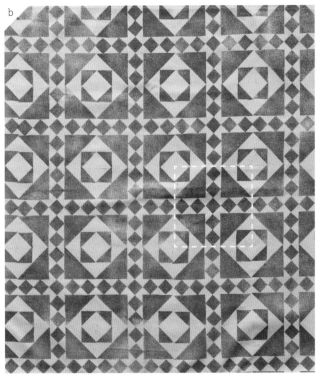

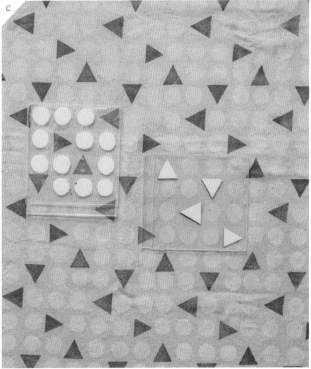

FUROSHIKI WRAP PROJECTS

Use your newly stamped fabric to create reusable gift wrap in the Japanese tradition of *furoshiki*. Begin each of these four wraps by placing the cloth in a diamond orientation on the table. The top is corner A and clockwise are B, C, and D. Position the fabric so that the printed side will face out in the end, and use square knots throughout.

small box wrap

1. Place the gift box in the center of the fabric so one edge of the box is perpendicular to the table edge.

2. Wrap corner C up and over the object and tuck it under the box.

3. Wrap corner A over the box. Some fabric will hang over one side.

4. Bring corners D and B together and knot.

small bag wrap

1. Place the loose items in the center of the fabric.

2. Knot corners A and B.

3. Knot corners C and D.

4. Hold both knots in your hand to carry your new bag.

bottle wrap

1. Place the bottle down at corner D with the neck pointing away from you.

2. Roll bottle until it meets side B.

3. Twist sides A and C together and knot.

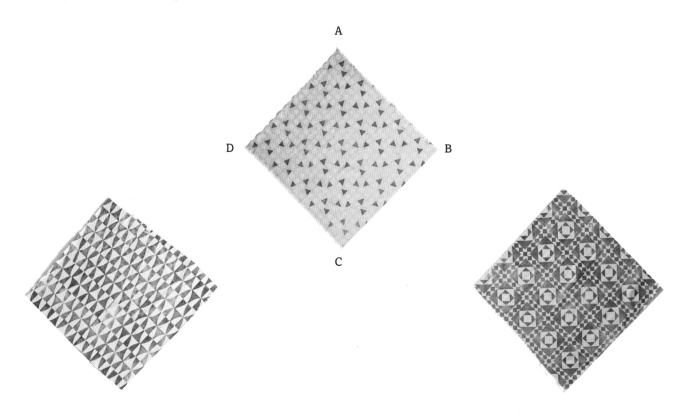

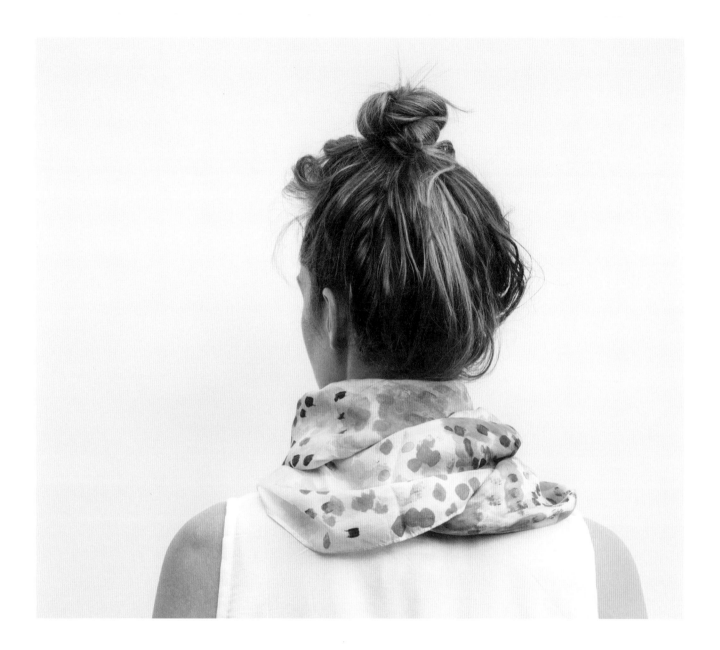

abstract painted scarf

This paint-mixing exercise might just create one of your favorite functional accessories. I live in San Francisco where a scarf is needed year-round, and silk, despite its sensual thinness, traps heat well when you need it and lets it pass when you don't. Here we play with colors and use different paint applications to build up dimension and texture into a fresh, wearable garment. We start with primary colors (red, yellow, and blue) and blend them to make secondary and tertiary colors all the while applying paint in varying viscosity to create layers of strokes and colors.

TIME: 1 hour + drying time

DIFFICULTY: ● ● ○ ○

LEARN: How to mix colors, paint on silk, and employ various painting techniques

REMIX: Use these materials for your own motifs on clothing or on a decorative pillow cover

MATERIALS

Silk scarf, 15" × 60" (38cm × 152.5cm)

Beach towel or absorbent cloth cut larger than the scarf

Paint palette

Bamboo brush, 1" (2.5cm)

Large flat brush, 1" (2.5cm)

Flat brush, ¼" (6mm)

Round brush, ¼" (6mm)

Red, blue, and yellow Dye-Na-Flow or similar silk paint, 2½ oz (74mL) each

Small bowl of water

Spray bottle with nozzle (optional)

Iron

For my fabric, I chose a lightweight semitransparent white silk so the color can be seen on both sides of the scarf. Thicker-weight fabrics won't soak through thoroughly, and therefore aren't suited for scarfs, but will still work well for other garments. My favorite neck scarf size is 15" × 60" (38cm × 152.5cm). It loops around my neck twice with good room for knots and styling, but you can use any silk scarf you like.

Painting adds moisture to this scarf so you need an absorbent layer like a thick cotton canvas, to soak up the excess. These paints do not bleed when they are wet again but it is important to let the scarf dry between layers to fully control application and bleeding of paint. You could use straight pins to secure the scarf to the absorbent surface but I chose to just use my hands to straighten it out when needed. Remember to wash your scarf and iron it flat before beginning because the paint wants to pool in the wrinkles. Here I share the thought process and techniques I used to make this specific scarf, but feel free to go your own way!

instructions

APPLYING THE INITIAL WASH

Here we create soft fields of color in wet areas with diluted paint, which is called a "wash." We overlap these fields to create secondary colors from our primary color palette.

1. Lay an absorbent cloth and then the silk scarf on a work surface. Saturate bamboo brush in water and apply to scarf to wet an area that is about the size of your open-palmed hand.

2. Dip large flat brush in red paint and press onto wet area. Dip bamboo brush in water and apply to red-painted area to make it spread farther across the silk surface. Add more water with the bamboo brush as needed to keep the area moist. Clean brushes in water.

3. Repeat step 2 with yellow and blue paints, allowing colors to overlap. Overlapping red and yellow will result in orange. Overlapping yellow and blue will result in green. Overlapping red and blue will result in purple. **(a)**

4. Repeat steps 2–3 until the entire scarf is covered with a soft wash.

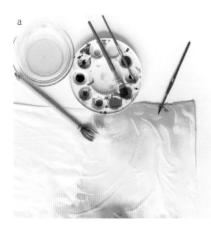

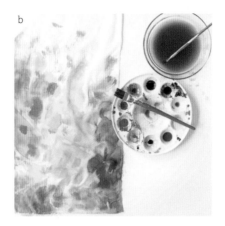

EMPLOYING THE WET-ON-WET TECHNIQUE

For this second layer we use less diluted paint and a firmer brush to create bolder strokes of color over the washes. We again layer color over color to create more vibrant effects. The firmer brush allows for greater control of strokes. Try to work quickly and with a moist scarf so the strokes bleed a little to create a softer edge.

1. Dip large flat brush in water and then into red paint. Quickly press brush onto scarf in areas that are red, orange, and purple. I made about 1" (2.5cm) strokes but vary yours as much as you like. If the scarf is drying too quickly, add more water with either the bamboo brush or a spray bottle. Keep the scarf damp so the paint bleeds a bit. Clean brush when finished.

2. Repeat step 1 with yellow paint and paint over areas that are yellow, orange, and green.

3. Repeat step 1 with blue paint and paint over areas that are blue, purple, and green. Set scarf aside to dry. **(b)**

CHOOSING COLORS

I chose red, yellow, and blue for this scarf because I can mix all the hues with them. To avoid mucky browns, I was careful not to let the secondary and tertiary colors bleed into one another. Because I want to wear this scarf looped around my neck, I wanted an allover composition with a flurry of color. I did use dry brushstrokes in varying density and angles to create a sense of movement.

c

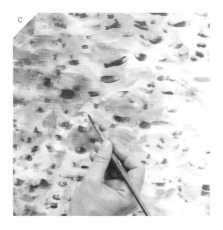

d

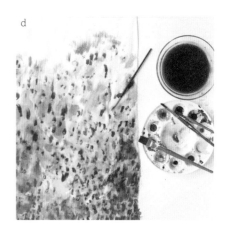

EMPLOYING THE DRY BRUSH TECHNIQUE

In this step we work on a dry scarf with a round brush to give small dashes of vivid colors right from the palette. Mix your secondary colors in the palette.

1. Dip small round brush in red paint and apply in short ½" (13mm) strokes to areas that are red, purple, and orange and over any other areas you like. The dry scarf means the paint should not bleed and should stay very bright. Vary the distance between the strokes and the length of the strokes so some areas are more densely painted than others. Clean brush. **(c)**

2. Repeat step 1 with yellow paint, applying paint to areas that are yellow, orange, and green and any other areas you like.

3. Repeat step 1 with blue paint, adding quick dashes of paint to areas that are blue, purple, and green as well as areas in between.

4. Mix orange, green, and purple in your color palette and add small strokes in between areas where those colors appear in different hues. Set to dry. **(d)**

ADDING THE FINISHING TOUCHES

Look critically at the scarf and decide if you want to add more color using the wash, wet-on-wet, or dry brush techniques.

1. Evaluate the dry scarf. Are there any gaps in color you don't like? Any parts of the composition that don't flow as you'd like? If so, fill them in with one of the techniques above. Allow scarf to dry.

2. Heat-set the colors with a dry iron and put that sucker on!

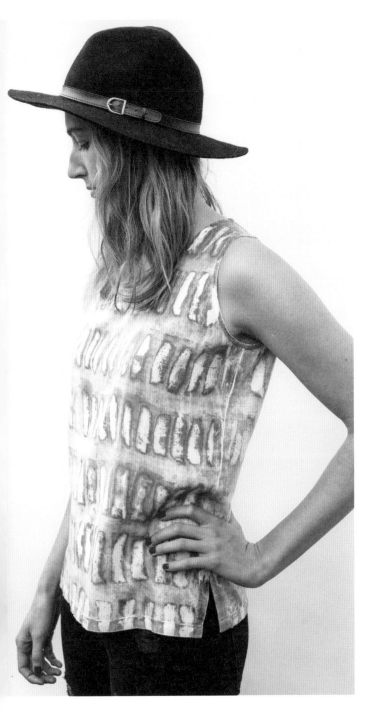

dye resist tank

We use chipboard to prevent the resist (see page 172) and the dye from spreading to the other side of the garment. The size of the chipboard should be just a hair smaller than the dimensions of the tank lying flat so you can slip it in between the two cloth layers. Rather than painting on the Dye-Na-Flow, I tried spraying it on and liked the variegated look the diluted ink made.

Materials: Tank top made with natural fibers; measuring tape; chipboard or cardboard; craft knife; water-based resist paste; 1" (2.5cm) flat brush; small spray bottle; Dye-Na-Flow; water; iron

1. Measure the tank laying flat. Use craft knife to cut the chipboard to size. Insert chipboard between layers of tank.

2. Apply resist with brush and set to dry.

3. Dilute Dye-Na-Flow in water bottle with water to desired opacity.

4. Spray both sides of the tank and set to dry.

5. Remove chipboard and heat-set tank with iron.

6. Put tank in washing machine for one cycle with warm water and detergent.

cork wall

TIME: 3 hours + drying time

DIFFICULTY: ● ● ○ ○

LEARN: How to stencil with multiple colors

REMIX: Use this technique to create cork trivets, coasters, or floor tiles

MATERIALS

Primer

Paint tray

Paint roller, 4" (10cm)

25 (or as many as you need +1) cork tiles with adhesive tabs, 12" × 12" (30.5cm × 30.5cm)

Templates (page 146)

Pencil

Tracing paper

Cardstock, chipboard, or manila folder, 8½" × 11" (21.5cm × 28cm)

Craft knife

Permanent marker

Ruler

Cutting mat

Plastic stencil sheet, 14" × 19" (35.5cm × 48.5cm)

Scissors

Sheet of chipboard or cardboard, 18" × 24" (45.5cm × 61cm)

Tape

Four bottles of acrylic paint (pink, blue, orange, and yellow), 8 oz (237mL) each

4 stencil brushes, 1" (2.5cm)

Rags

Level

Measuring tape

I was looking for a cool, flexible way to display artwork without ruining the walls with tacks. These patterned tiles create a colorful focal point for the room, and by rotating the tiles in a random pattern, the smaller shapes join to create larger motifs. Because I was printing many tiles, I devised this registration method to hold the tiles and stencil them in place. By spacing the motifs far apart, I was able to use several colors without running the risk of colors bleeding into each other.

Cork is sold in varying textures and colors. I chose the finest texture and lightest color so the image would be crisp and only require one coat of primer. The primer smooths the divots of the natural cork and allows the bright colors to pop. You can lose the primer and use the natural cork color in your composition, but it may require multiple stencil coats to get an opaque color on the absorbent natural ground.

instructions

1. Pour primer into the paint tray and coat each tile using paint roller. Let dry. Paint a second coat if necessary for full coverage. **(a)**

2. Trace templates with pencil onto tracing paper, making sure to create heavy pencil marks. **(b)**

3. Turn traced images over onto cardstock and rub outlines with the side of your thumbnail to transfer pencil marks to the cardstock. **(c)**

a
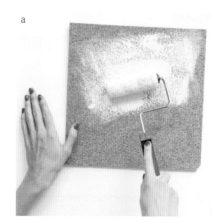

b

c

d
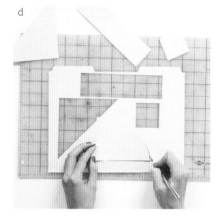

e
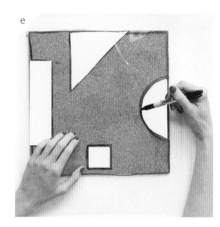

f
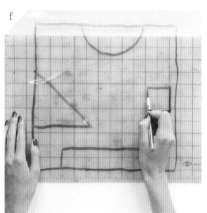

g
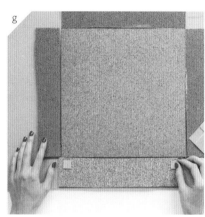

h
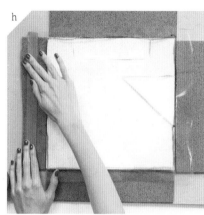

4. Cut out shapes from the cardstock with craft knife. **(d)**

5. Use permanent marker and ruler to draw a 12" × 12" (30.5cm × 30.5cm) square on the plastic stencil sheet. Place the shapes in position inside square as shown above (and on page 146). The rectangle, triangle, and half-circle should be centered and edges should be flush with their respective sides. Trace the shapes onto stencil sheet with permanent marker. **(e)**

6. Cut out the shapes from the stencil sheet using a cutting mat and a craft knife. This is your stencil. **(f)**

7. Use pencil, ruler, and scissors to cut four 3" × 12" (10cm × 30.5cm) strips from one cork tile. Center a tile on chipboard, primer side up. Place cut strips on left, top, right, and bottom sides of tile. Secure strips in place with an adhesive tab on each end. This is your registration board. **(g)**

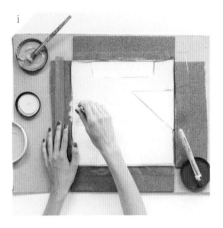

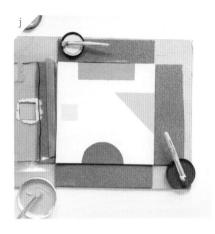

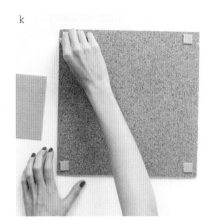

8. Secure the stencil in place with a 12" (30.5cm) piece of tape on the left or right side (whichever is opposite of your dominant hand). **(h)**

9. Pour a dollop of paint in the lid of each of the four colors. Load a stencil brush with each color. Use an up and down motion to stipple the paint onto the surface, using the designated color for each shape. Flip back the stencil and remove tile. Wipe off any paint that may have seeped through to the other side of the stencil with a wet rag. **(i)**

10. Place new tile primer side up on the registration board, repeat step 9, and continue until all tiles are stenciled. Set tiles aside until they are dry to the touch—about an hour. **(j)**

11. Turn dry tiles print side down. Peel off one side of the adhesive tabs and apply tabs to the four corners of each tile. **(k)**

12. Lay out your tiles in desired order and vertical or horizontal orientation on the floor. Rotate tiles to create different compositions. You may choose to have like shapes (the rectangle, half-circle, and triangle) meet to create larger shapes for variety. **(l)**

13. Use pencil, level, and measuring tape to mark the outside perimeter of the tile arrangement on your wall.

14. Peel the paper off the adhesive tabs from one tile and place it in the bottom-right corner of perimeter frame. Use a level to make sure it is straight.

15. Peel off adhesive tab paper and align next tile to the first. Continue until all tiles are in place.

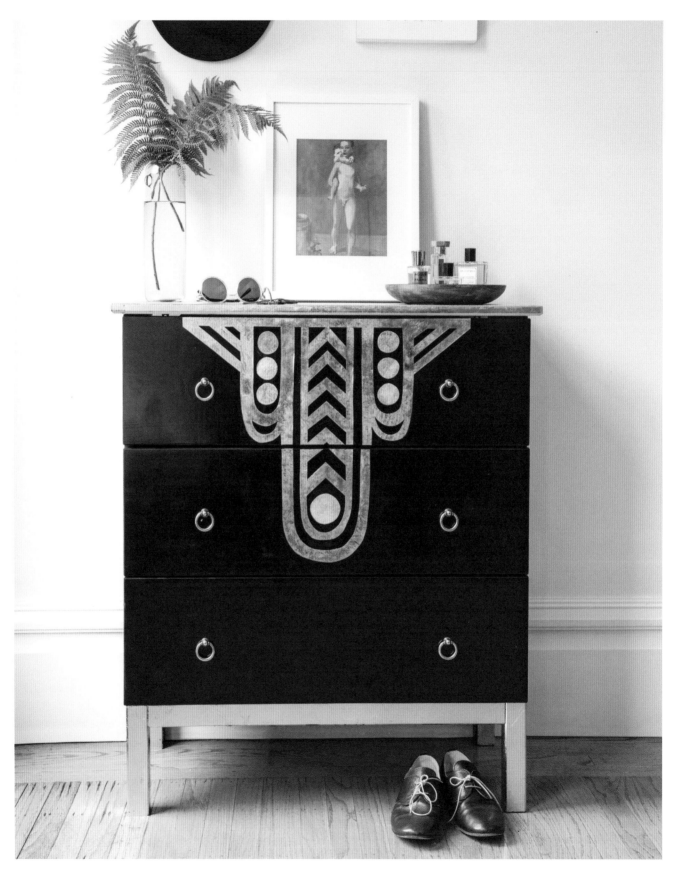

art deco dresser

TIME: 4 hours

DIFFICULTY:

LEARN: How to apply gold leafing to surfaces using two techniques

REMIX: Use these techniques to decorate any wood, glass, or paper item; create a large canvas stamp with this motif

MATERIALS

Damp cloth

Dresser

Rag

2 foam brushes, each 2" (5cm)

Gold leaf kit with 25 sheets of leaf, adhesive sizing, brush, and sealer

Additional gold leaf sheets

Templates A, B, and C (pages 148–149)

Clear contact paper

Craft knife

Cutting mat, cardboard, or chipboard, 20" × 18" (51cm × 45.5 cm) or larger

Masking tape

Tracing paper, 8½" × 11" (21.5cm × 28cm)

Fine point permanent marker

Scissors (optional)

Flat brush, ½" (13mm)

Mod Podge, Gloss Finish, 16 oz (473mL)

During art school I paid bills by working as a mural painter and faux finisher. It was the late 1990s and faux marbling and sponge painting could not be stopped. I especially loved metal leafing with gold, copper, and silver. Using a simple Ikea dresser, this project showcases both the traditional method of leafing and a new method I developed to get crisp leaf motifs every time.

Art Deco, an art and design movement that started in France after the Second World War, played with geometric shapes, symmetry, and gold, baby, gold. The motif can be scaled or multiplied to fit any dresser, wall, or even a jewelry box. Gold and metal leaf works on many surfaces, even glass and melamine. Always remember to seal your surface before you begin so the adhesive sizing takes—and to seal it after to protect your work. I like to use large foam brushes to apply sealer and adhesive because these products will ruin your expensive brushes, and the larger brush size facilitates the application process.

instructions, part 1 (traditional method)

We will use this method to cover the entire dresser top. It is best to do this project indoors, where nothing will fall or blow onto the surface as you work.

1. Wipe the dresser clean with a damp rag. Any dust will prevent the adhesive from working properly.

2. Use a foam brush to apply the adhesive sizing in a thin, even coat to the top surface of the dresser. Allow it to dry for at least 20 minutes, up to one hour, or until sizing is clear and tacky. This time will vary depending on your climate. If you start too soon, the gold leaf will tear and move with the wet sizing.

3. Wash and dry your hands immediately before applying leaf because oil, sweat, or residue will make the leaf stick to your hands rather than your work surface. Open to a fresh sheet of gold leaf in the booklet. Place gold leaf facedown on the adhesive surface. Press gently and remove booklet, leaving only the gold leaf. Smooth with a small bristle brush.

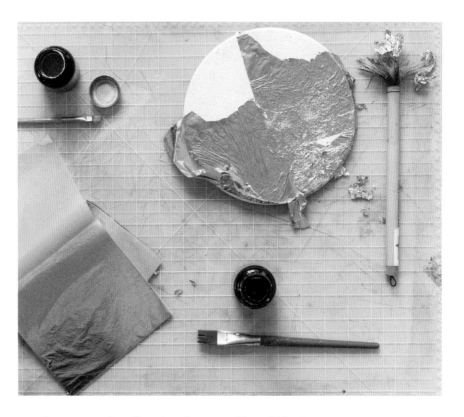

4. Repeat step 3 until surface is covered in gold leaf.

5. Place small bits of leaf over any gaps and smooth them with the bristle brush. Use a gentle stippling motion to get into any grooves and then a wiping motion to slough off the extra leaf.

6. Use the second foam brush to apply at least two coats of protective sealer, allowing time to dry between coats.

instructions, part 2 (cheater's method)

We will use this method to create the stenciled decoration on the face of the dresser.

1. Remove adhesive backing from a sheet of contact paper and lay it faceup on a table. Press gold leaf sheets onto contact paper. Once you have covered the surface with gold leaf, paint on at least two layers of sealer with a foam brush and set to dry overnight.

2. Place gold-leafed contact paper, plastic side up, on a cutting mat about 20" × 18" (51cm × 45.5cm).

3. Trace templates A, B, and C on tracing paper (template C is a mirror image of template B—see pages 148–49) and attach the three templates with tape onto the gold-leafed contact paper. Using a craft knife, cut out the three shapes. You may want to use scissors to cut out the circles.

4. Lay the dresser on the ground with the drawers facing up. Position the gold-leaf decoupage motif in the center of the top drawer with contact paper side down. Align the straight edge of the motif with the top edge of the top drawer. Apply small pieces of tape to secure the main large motif and the circles in position.

5. Lift up portions of the gold-leaf decoupage motif and coat the back with Mod Podge, removing tape as needed. Lay motif back down and smooth with your hands. Wipe up excess Mod Podge with a rag.

6. Using a craft knife, cut a centered line between the top and middle drawers. Fold over edges and adhere with Mod Podge.

7. Brush Mod Podge on decorated surfaces to seal the leafing.

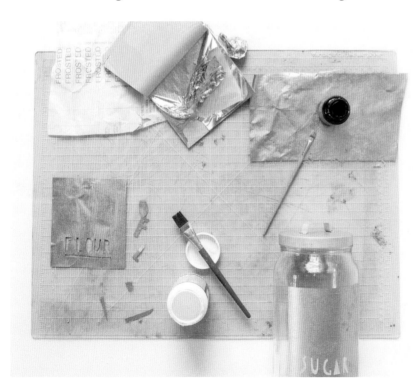

copper leaf plate

Metallic leaf can add luster to just about everything. Swap out gold for copper leaf to make this decorative plate using the Cheater's Method.

Materials: Glazed ceramic plate; Mod Podge; clear contact paper; copper leaf sheets

1. Apply clear Mod Podge with a brush on finished glazed plate and set to dry.

2. Affix copper leaf to clear contact paper and seal as specified on page 36.

3. Cut up pieces of leafed contact paper, brush with Mod Podge, and adhere to plate.

4. Brush Mod Podge on decorated surface to seal.

copper leaf planter

Class up those boring, plain planters with some metallic leaf. Do not place leaf in areas that will have persistent contact with water because it will erode the Mod Podge. Here I just cut out geometric shapes, but use any shapes you like.

Materials: Glazed planter; Mod Podge; clear contact paper; copper leaf sheets

1. Apply clear Mod Podge with a brush to outside of finished glazed planter and set to dry.

2. Affix copper leaf to clear contact paper and seal as specified on page 36.

3. Cut up pieces of leafed contact paper, brush with Mod Podge, and adhere to side of planter.

4. Brush Mod Podge on decorated surface to seal.

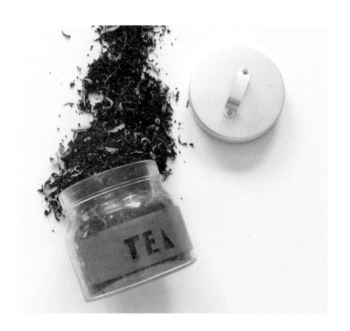

flour, sugar, and tea containers

After a year-long quest to find copper flour, sugar, and tea containers on eBay, I just decided to use the Cheater's Method to spiff up my current batch of sealed glass containers from Ikea. The size of the square of contact paper that you cut will be determined by the size of your container. Glass with straight sides will work best.

Materials: Glass containers; alphabet template (page 154); Mod Podge; clear contact paper; copper leaf sheets

1. Brush clear Mod Podge on the sides of glass jars and set to dry. This gives the leaf something to stick to.

2. Apply copper leaf to clear contact paper and seal as specified on page 36.

3. Cut words out of leafed contact paper with craft knife and adhere to side of container with Mod Podge.

4. Seal decorated surface with at least two thin coats of Mod Podge.

copper paper weights

Great for a paperweight or a decorative element for your plants or coffee table, this project uses the Traditional Method to make fool's gold (or silver or copper) out of any clean rocks you have lying around.

Materials: Rock; copper leaf kit with sheets of leaf, adhesive sizing, brush, and sealer

1. Coat rock with sealer, making sure to push it into every nook and cranny of the rock, and set to dry.

2. Apply metal leaf, again taking care with the crevices, and seal as specified on page 36.

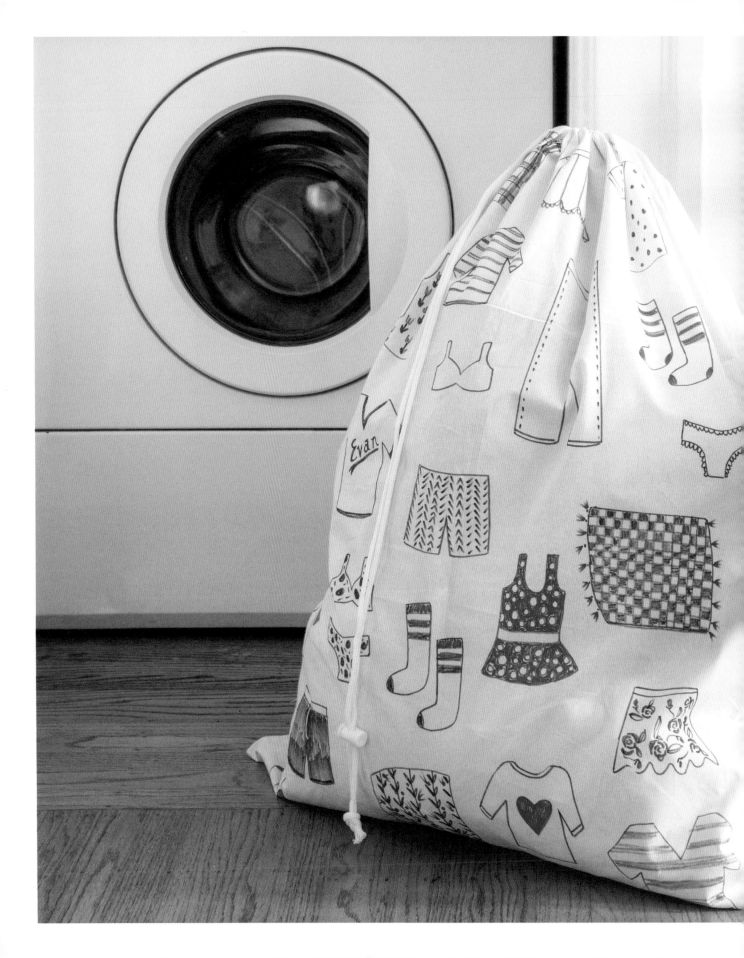

CHAPTER 2

everyday patterns

Motifs that you can identify as a person or particular object are called "figurative" or "representational." Unlike the abstract and geometric motifs from the first chapter, these look like things from the world around us. In the fabric store these are called "novelty prints" but I really prefer the term "conversational" because they are approachable and fun. I've packed this chapter with as many motifs as possible to give you options, but look back at basic pattern structures to see how you can repeat single motifs for a whole new look.

laundry bag

TIME: 1 hour

DIFFICULTY: ● ○ ○ ○

LEARN: How to style a random pattern and draw on cloth

REMIX: Use this technique to decorate totes or any natural fabric item; apply techniques from the Logo Stamp project (page 77) and draw your own logo motif for team gear. Or make it a party project and give guests blank goods, like canvas lunch sacks, and have them personalize their item during the gathering.

MATERIALS

Templates (page 147)

2 sheets of tracing paper, 8½" × 11" (21.5cm × 28cm)

Pencil

2 sheets of cardstock, 8½" × 11" (21.5cm × 28cm)

Scissors

Cotton laundry bag, 24" × 36" (61cm × 91cm)

Fabric markers in assorted colors

Iron

Each week my husband, Evan, rolls his work clothes into a ball and trudges two blocks to the dry cleaner. I made this bag for him after watching this messy ritual one too many times. I kept the color palette limited because it suits him, but feel free to use as many colors as you like. I made this a single-direction pattern with the motifs facing upright because it hangs from and is carried by the drawstring on top.

This would be a great project to do with kids. You could have them do the whole project or just trace the shapes and let them fill each one in. Remember to wash and iron the laundry bag before beginning. This inexpensive plain weave cotton bag shrank but that actually helped by bringing the threads closer together for a tighter weave that was easier to draw detail on.

instructions

1. Trace all templates onto tracing paper using heavy pencil lines.

2. Turn tracing paper with the drawing side down onto cardstock and rub the side of your thumbnail over pencil lines to transfer design.

3. Cut out the shapes with scissors.

4. Place shapes onto bag in desired position and outline with fabric marker. I chose to lay out motifs so they were all right side up and spaced about 1" (2.5cm) apart.

5. Fill in the shapes in whatever way inspires you. You could do a solid fill, write in words, or draw patterns.

6. Repeat steps 4–5 until the entire bag is covered.

7. Heat-set the fabric with an iron.

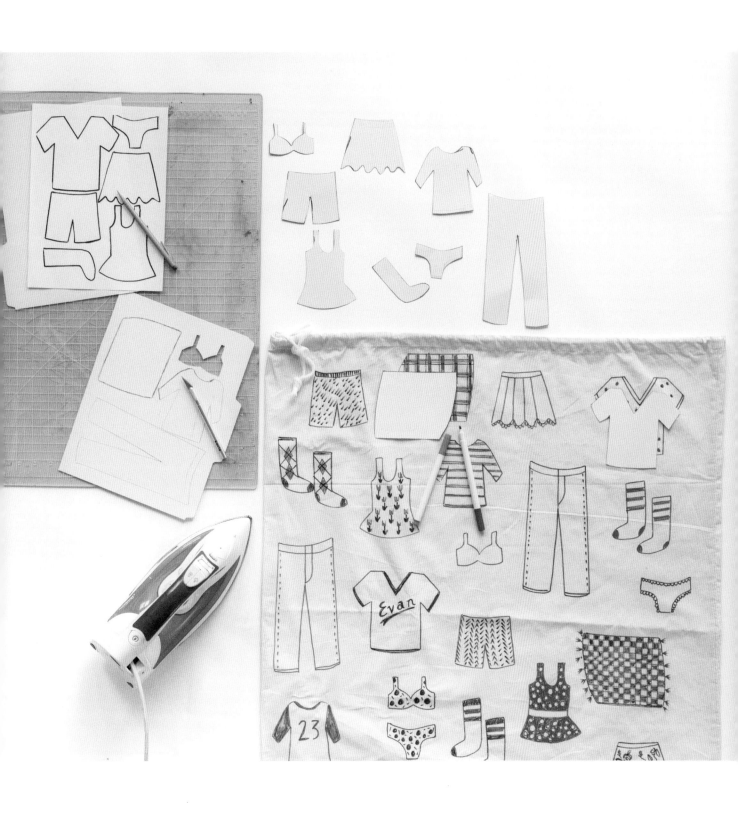

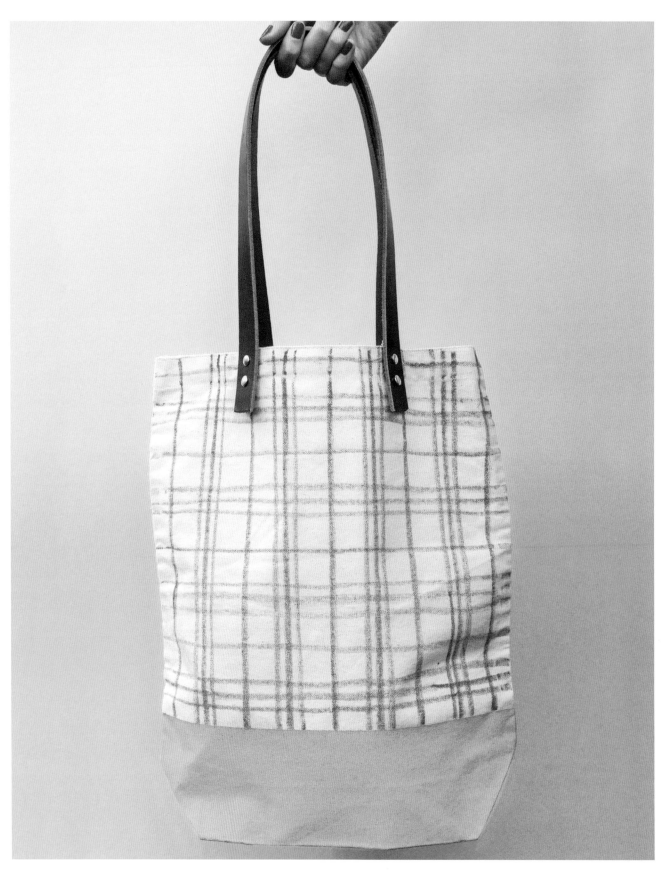

plaid tote

TIME: 1.5 hours

DIFFICULTY: ● ○ ○ ○

LEARN: How to stencil and draw on fabric, upgrade existing tote with leather handles, and feature fabric as your pattern

REMIX: Use this technique to draw or paint any natural fabric item

MATERIALS

Cotton canvas tote

Painter's tape, 2" (5cm) wide

Fabric screen printing ink, 4 oz (118.3mL)

Stencil brush, 1" (2.5cm)

Fabric Fun pastel dye sticks

Iron

2 sheets scrap paper, at least 17" × 15" (43cm × 38 cm)

Scissors (optional)

Leather strap, about 50" (127cm) long, 1" (2.5cm) wide, and 1.6mm to 2mm thick (optional)

High-quality hole punch, such as Crop-A-Dile (optional)

8 double cap brass rivets (with a length, base, and cap of $^5/_{16}$" [7.9mm]) (optional)

Hammer (optional)

Step up your tote game with this easy and super-flexible project. You could draw a logo or any design you like. To draw a specific design use dressmaker's carbon or Saral wax-free transfer paper. I wanted custom totes but didn't want to pull out the sewing machine so I worked up this technique to give some solid details to a plain canvas tote. You could stencil and draw your design and just stop at step 9, but if you are up for it, add some classy and sturdy leather handles. Because you are cutting the handles yourself, you can make them any length that suits you. Feel free to use a straightedge and ruler to draw the plaid pattern, but I liked the hand-drawn nature of the pattern to contrast with the more formal handles.

I chose fabric screen printing ink for the bottom panel to give the illusion of a bag made with contrasting fabrics. While you could also paint the plaid pattern with screen printing ink, I like the bright, rich colors, variety of line thickness, and tonal changes that the Fabric Fun pastel dye sticks give. We heat-set the screen printing ink and pastels at the same time, but you will need a different sheet of scrap paper for each side of the tote because the pastels stick to the paper as heat from the iron draws excess pigment from the cloth.

instructions

1. Place a strip of painter's tape across the bottom of the tote so the bottom edge of tape is 4" (10cm) above bottom seam. Repeat with the reverse side of tote.

2. Fill paint lid with paint, dip stencil brush into paint, and stipple paint onto bottom portion of tote, adding more paint until the coat is solid. Remove tape and set to dry. Repeat with reverse side of tote. (Note: If your tote has a gusset, open it up and paint the inside. Pay special attention to coating the seams.) **(a)**

3. Place a strip of painter's tape over the top of painted portion of tote.

a

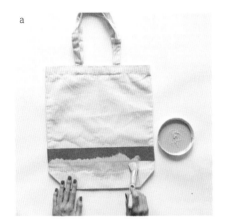

b

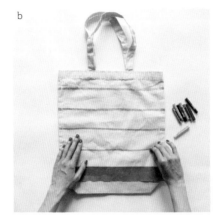

c

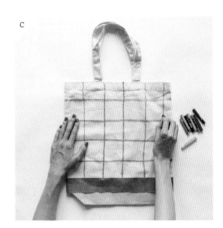

d

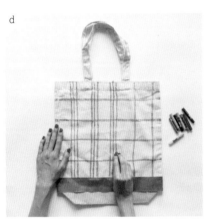

e

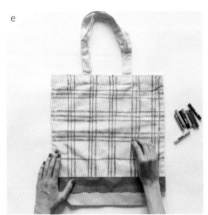

f

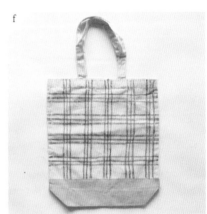

4. Use Fabric Fun pastel dye sticks to draw parallel horizontal lines across width of tote, starting about 2½" (6.5cm) from top. **(b)**

5. Draw parallel vertical lines down length of tote, starting 2½" (6.5cm) from left seam. **(c)**

6. Draw parallel vertical lines on either side of each existing vertical line. **(d)**

7. Draw parallel horizontal lines on either side of each existing horizontal line. **(e)** Remove tape.

8. Repeat steps 3–7 on reverse side of tote. **(f)**

9. Heat iron to cotton setting with no steam. Place scrap paper over tote and heat-set dye sticks and screen printing ink. Repeat with reverse side of tote, using clean scrap paper. **(g)**

g

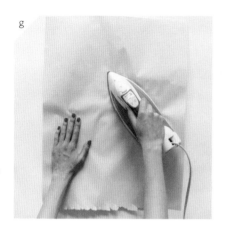

h

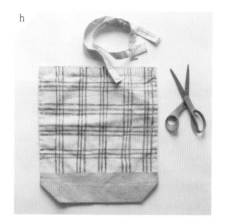

i

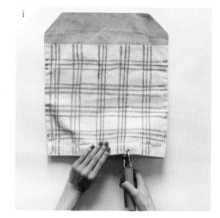

j

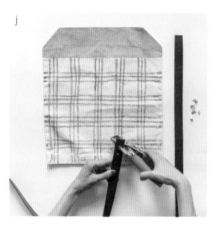

k

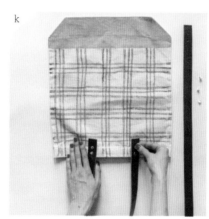

l

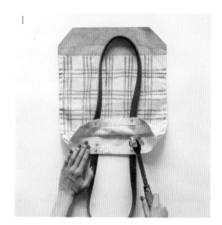

10. If desired, use scissors to cut off each handle. **(h)**

11. Punch two holes ½" (13mm) and 1½" (3.8cm) from top of tote on each of the handle areas. Repeat with reverse side of tote. **(i)**

12. Cut leather strap into two equal pieces, each about 25" (63.5cm) long. Punch two holes ½" (13mm) and 1½" (3.8cm) in from both ends of each strap. **(j)**

13. Align leather strap with punched holes on tote and place male rivet through each hole. Place female side of each rivet on the inside, over the male rivet. **(k)** Hit with hammer to close rivet. **(l)**

14. Turn tote over to reverse side and repeat step 13.

15. Awesome job! Now go hit the town.

different strokes for different totes

I used different painting techniques to make an
abstract floral tote with the screen printing ink and
fabric pastels. Don't draw in areas already painted on
because the fabric pastels need direct contact with
the fabric to adhere.

Additional Materials: Detail paint brushes

1. Use textile screen printing ink to paint or fabric
 pastels to draw on design.

2. If desired, heat-set and attach new leather handles as
 described in steps 10–14 of previous project.

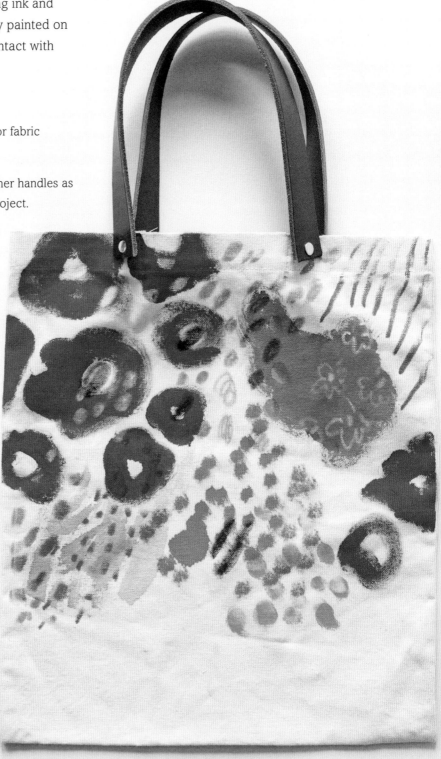

carve-a-stamp

TIME: 30 minutes

DIFFICULTY: ● ● ○ ○

LEARN: How to carve and print Carve-a-Stamps

REMIX: Use this technique to carve stamps of any scale; apply techniques from Recipe Cards project (page 55) to print this with multiple colors

MATERIALS

Template (page 149)

Tracing paper

Pencil

Carve-a-Stamp Block, 2" × 3" (5cm × 7.5cm)

Linoleum carving tool with assorted blades

Stamp ink pad (dye-based or all-purpose)

Scrap paper

With motifs I devised as modern-day hieroglyphics, this project is about carving your own stamps with a rubber block. Unlike cut-foam stamps, the rubber block allows you to get fine line quality. I created the Carve-a-Stamp Block, which is two pieces of rubber block glued to a wood mount, because it is easy and safe to carve and it produces a crisp print every time. If you don't buy this product, you can absolutely do this with two rubber blocks that are 2" × 3" (5cm × 7.5cm). My Carve-a-Stamp Kit includes everything you'll need—templates, a carving tool with multiple blades, a pencil, and two pieces of transfer paper (so you can design and carve both sides), and several templates, but I made the one on page 149 just for you guys.

Here's the most important thing to remember: When carving this, a relief block, it is *always* Opposite Day. You carve away the top layers of the top block (the part you *don't* want to print) and you carve the design backward (because you turn the block the other way to print). If you choose to bypass the drawing and transferring of the design provided, just remember the stamp will print in reverse of the design. This is especially important to remember when you are using text. I can't even tell you how many times I have made that annoying mistake—and I do this for a living! When you are carving, hold the tool at a slight raised angle from the block and slowly push the blade away from your body. You don't need to dig deep—just think about shaving your legs or peeling a carrot. Be deliberate with your carving because you can't un-carve anything!

Designs with less detail are the easiest, so that is a good place to start. Designs with more detail and fine lines are more challenging, but who says you can't start there? I have taught this technique to hundreds of people, some even as young as four, and it is incredibly forgiving and honestly just fun! After you have transferred your design, practice your knife skills on an area that is to be carved away.

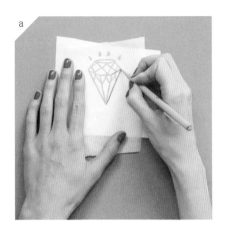

a

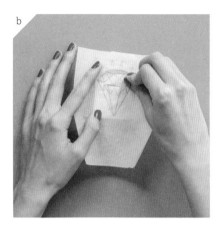

b

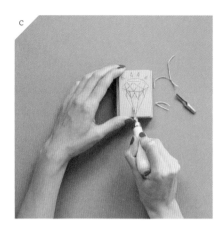

c

d

instructions

1. Trace template onto tracing paper with pencil. **(a)**

2. Turn tracing paper over so that the outlined design is facedown on one side of the rubber block. Use your thumbnail to transfer the graphite from paper to block. Holding paper in place with one hand, carefully lift a corner of the page to make sure the image is transferring. **(b)**

3. Load carving tool with smallest gouge. Holding lino cutter at a slight angle (about 30 degrees) from block, slowly push knife away from your body. Rotate block instead of tool to create curves. **(c)**

4. Load carving tool with widest gouge and clear away large areas around the motif. **(d)**

5. Place your fingers in the side grooves and press stamp into the ink pad several times until the face is covered with ink. Press the inked stamp firmly facedown onto the printing surface. This is your print. Examine the print impression. If details are showing up that you don't like, just carve those raised areas away with the carving tool.

6. Repeat step 5 until you get the print you like.

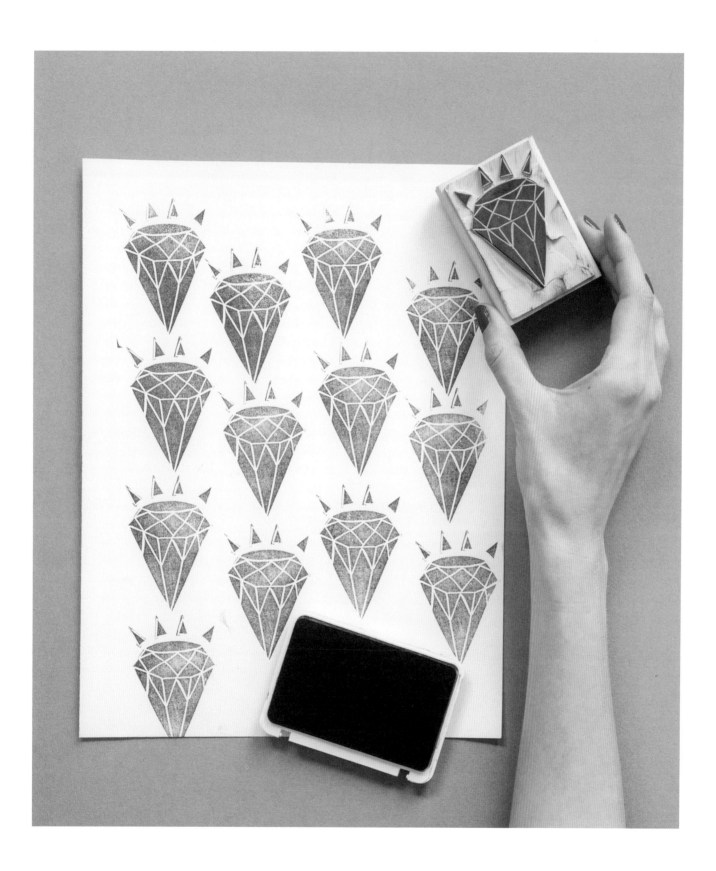

message board

TIME: 1 hour

DIFFICULTY: ● ○ ○ ○

LEARN: How to decoupage wood surfaces

REMIX: Use this decoupage technique for keepsake wooden boxes or recipe boxes

MATERIALS

Wood panel, 18" × 24" (45.5cm × 61cm) with 2" (5cm) cradle

400-grit sandpaper (optional)

Rag

Rubbing alcohol (optional)

Base coat paint (optional)

Foam brush, 4" (10cm)

Graphics (pages 150-51)

Laser printer

White paper (standard weight, not cardstock)

Scissors

Scrap paper

Mod Podge

Chalk marker

As an anti–list maker and avid forgetter-of-all-things, I've had to change my ways now that I've got a toddler in tow. I wanted a message board that looked good whether it's blank or packed with messages, so I worked up this project. These wood panels are available in many sizes in art stores and their depth allows you to rest a chalk marker on the top for writing. Remember that you must use photocopies from a laser printer. (An inkjet print will bleed when it hits the liquid Mod Podge.) You can just bring the book to the copy shop or lay the template directly on the copy glass. Because you don't glue the graphics down until later, you can move them around until you get the composition you want. Remember you can also repeat one or two motifs to get a pattern; take a look at pattern repeat structures on page 184.

instructions

1. Prep the wood panel if it is rough by sanding with 400-grit sandpaper. Cleaning off wood with a wet cloth will raise the grain. Best to use a soft rag that is either dry or moistened with rubbing alcohol that evaporates quickly. Prime and paint the panel a solid color if you like, using a large foam brush.

2. Apply a coat of Mod Podge to the surface and sides of the wood panel with a foam brush and allow it to dry.

3. Photocopy the graphics provided (pages 150–51) or design your own. Use a laser printer to print the images on white paper and then cut out the graphics with scissors. **(a)**

4. Position graphics in place to create a composition. I chose to space the graphics at least 2" (5cm) inside the perimeter of the panel and then spaced them evenly from one another but you could bunch them together as well. My composition means I will be writing my list over the graphics, but I chose this design so the board would still look interesting when there was no writing on it at all. **(b)**

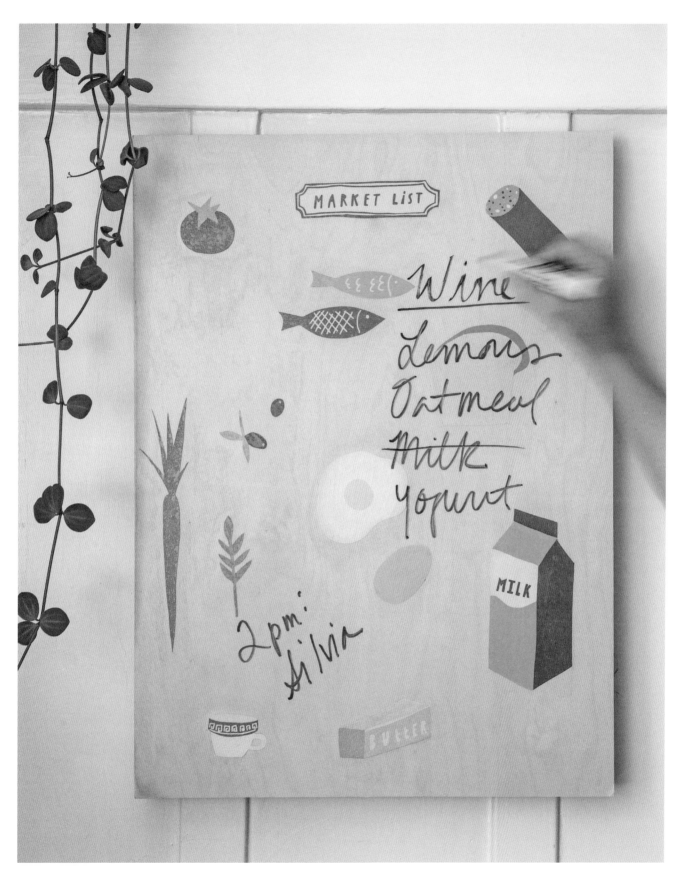

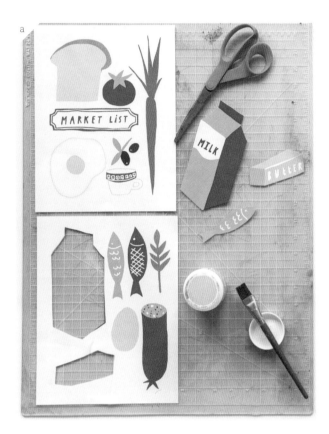

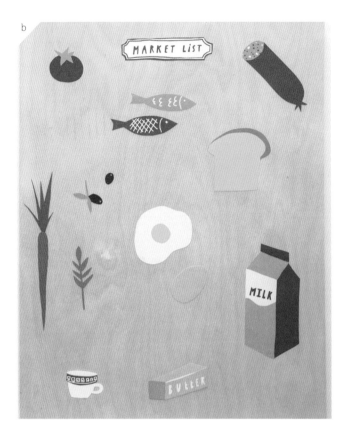

5. Place one of the graphics facedown on scrap paper and use foam brush to coat it with Mod Podge. Then quickly place graphic back in position. Use foam brush to coat the front of the graphic with Mod Podge, stroking from center to edges. This will adhere the graphic and ensure a smooth surface.

6. Repeat step 5 until all the graphics are adhered in position.

7. Paint several coats of Mod Podge over the entire surface and set it aside to dry for at least 24 hours.

8. Use a chalk marker to write your messages and wipe them off with a damp cloth when needed.

recipe cards

TIME: 2 hours

DIFFICULTY: ● ● ○ ○

LEARN: How to register and print a two-color design

REMIX: Use this technique to design and create your own party invitations, greeting cards, and art prints

MATERIALS

Templates A, B, and C
(pages 152–53)

Tracing paper

Pencil

1 or 2 rubber carving blocks,
4" × 6" (10cm × 15cm)

Stamp carving tool and multiple gouges

Soft cloth or toothbrush

2 stamp ink pads, colors as desired

Index cards, 4" × 6" (10cm × 15cm)

Nothing tells a story quite like a recipe box. Earmarked family favorites mingle with your own culinary adventures in a handy box. This pattern is created using a two-color reduction print with a special modification. In a normal reduction print, you carve a portion of the block and print it. Then you carve away more portions of the block and print it again in a different color. In my modification, each color is printed from one of the two sides of the same block. That way, you don't have to print the entire set of recipe cards at once, and can always print more later. After all, you never quite know how many recipe cards you'll need. These large stamp blocks are carved in the same manner as the previous Carve-a-Stamp project (page 49), except we use larger blocks that are not mounted. Clean stamp blocks with warm dishwater and a soft cloth or toothbrush before and after printing each side of the block.

I have my recipe box broken up into four parts (starters, mains, sweets, and drinks) and use a different background color for each card category, but feel free to play around with your ink colors. Here we use a card that is the same size as your block, which makes for easy registration, or alignment, of stamps. Because the rubber block is a little soft, I chose to align the top left corner with every print for accuracy. I included an optional lined stamp for the back of the card to use if you get cookin' and can't quit!

instructions

1. Place tracing paper over templates A and B and outline the designs with heavy pencil marks. Remember to outline the exterior rectangle like a frame so you can orient the template on the block.

2. Starting with template A, turn the paper over so that the outlined design is facedown on the carving block and the frame meets the sides of the block. Burnish the design with the side of your thumbnail to transfer it to the block.

3. Carve around lines on the design that you transferred with a narrow V-gouge and clear larger areas away with a wider U-gouge. This is side A.

4. Turn block over and repeat steps 2–3 with template B. This is side B.

5. Lay side A faceup on your work table. Press the stamp ink pad over the face of the block until the design is evenly coated.

6. Lay an index card over the block so the edges of the card align with the edges of the block and press down firmly. Use a rigid book to apply even pressure if needed.

7. Repeat steps 5–6 with the desired number of index cards, plus a few extra. Clean block by gently scrubbing with a soft cloth or toothbrush in warm water.

8. Turn the block over to side B and ink block with a different color. Repeat step 6 until stack of cards is printed on both sides. Clean block by gently scrubbing with warm water.

9. Allow cards to dry thoroughly. If printed reverse sides are desired, follow steps 1–3 and 5–7 with template C.

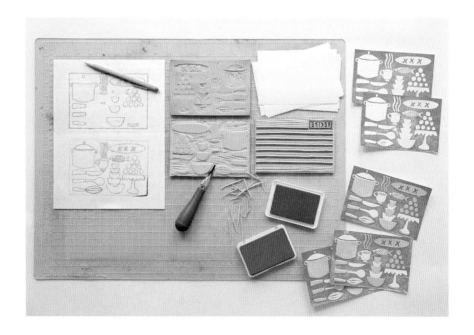

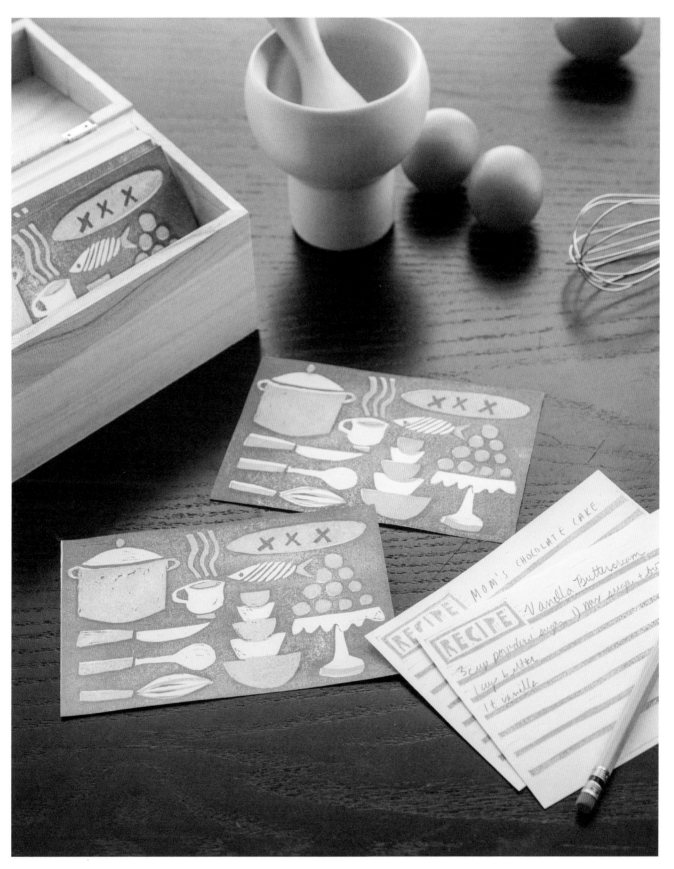

custom motifs

Nothing is more personal than adding initials, a monogram, or a logo to customize a project. It's a great way to personalize items for your home or business, or to add a special touch to a thoughtful gift. In this chapter I show you how to make sweet custom stationery, design and print a logo, and even stencil leathercraft! These tricks can be used to add individualized flair to many projects in the book so you can truly make your mark.

custom monogram

TIME: 1 hour

DIFFICULTY: ● ○ ○ ○

LEARN: How to create a simple letter stamp

REMIX: Use your stamp to monogram clothes, folders and files, or business cards; use this technique to make stamps for leather (page 71) or fabric

MATERIALS

Templates (pages 154-55)

Tracing paper

Pencil

Adhesive craft foam,
4" × 4" (10cm × 10cm)

Cutting mat

Craft knife or scissors

Mini ink pad, 1¼" × 1¼"
(3cm × 3cm)

Heavy cardstock or manila file folder, 8½" × 11" (21.5cm × 28cm), cut to size

Colored paper, 9" × 12"
(23cm × 30.5cm), as needed; one sheet yields 2 cards or 1 envelope

Scrap paper

Rubber cement

Custom-printed stationery will cost you a mint, so I am pleased to say one of these custom cards and envelopes will cost you almost nothing. For a quicker project, use premade notes and envelopes. These are great as a gift—or as a gift for yourself. I like to make a bunch at once so I always have one handy for a quick note. The monogram is used on both the cards and envelopes, and it's mounted directly to the top lid of a mini ink pad for a fast, all-in-one solution. You will get two cards per sheet and one envelope per sheet. The materials and instructions below are for a single personal stamp; adjust as desired. It is easier to use a larger piece of foam than is necessary so your fingers have room to hold the foam while you are cutting.

instructions

MAKING THE INITIAL STAMP

1. Place the tracing paper over the alphabet templates and use a pencil to trace a first initial or first and last initials onto tracing paper. Make sure that the pencil lines are heavy.

2. Turn the tracing paper over and use the side of your thumbnail to rub the graphite from the tracing paper to the craft foam.

3. Place the craft foam with the motif side up onto a cutting mat and use craft knife or scissors to cut out the stamp. To cut curves, hold the craft knife in position and rotate the foam around the blade to cut. Use scissors if that's easier for you. The scale of the templates is for a mini ink pad but use any scale ink pad you like; just make sure the lid is flat.

4. Peel the adhesive backing off the foam and place on lid of ink pad. Remove lid and press the stamp onto ink pad and then onto the paper.

STORE-BOUGHT STATIONERY

Rather use off-the-shelf stationery? Here are the most common American sizes and uses:

4 bar (reply card, flower gift): $3^1/_2"$ × $4^7/_8"$ (card), $3^5/_8"$ × $5^1/_8"$ (envelope)

A2 (thank-you note): $4^1/_4"$ × $5^1/_2"$ (card), $4^3/_8"$ × $5^3/_4"$ (envelope)

A6 (greeting card): $4^1/_2"$ × $6^1/_4"$ (card), $4^3/_4"$ × $6^1/_2"$ (envelope)

A7 (invite, announcement): 5" × 7" (card), $5^1/_4"$ × $7^1/_4"$ (envelope)

A9 (wedding announcement, art print): $5^1/_2"$ × $8^1/_2"$ (card), $5^3/_4"$ × $8^3/_4"$ (envelope)

To deliver a piece of mail, the U.S. Postal Service requires that it be a minimum of $3^1/_2"$ (9cm) high by 5" (12.5cm) long and 0.007" (0.2mm) thick.

MAKING THE ENVELOPES AND CARDS

1. Trace envelope and card templates with tracing paper using heavy pencil lines.

2. Place tracing paper on cardstock and rub with side of thumbnail to transfer the template outlines.

3. Use scissors to cut out templates.

4. Place colored paper facedown and place envelope template over colored paper. Use craft knife to cut around the outside of template. Place envelope on piece of scrap paper, stamp top half as desired, and let dry.

5. Repeat step 4 with card template. Stamp as desired and let dry.

6. Place card template in the center of envelope template. Fold in edges A, B, C, and D of envelope (as shown below) over the card.

7. Apply rubber cement to sides B and D. Fold side C over and press to adhere. Rub off excess rubber cement.

8. Repeat steps 4–7 as many times as desired. When you're ready to mail a card, place filled-in card inside envelope and seal with rubber cement applied to side A.

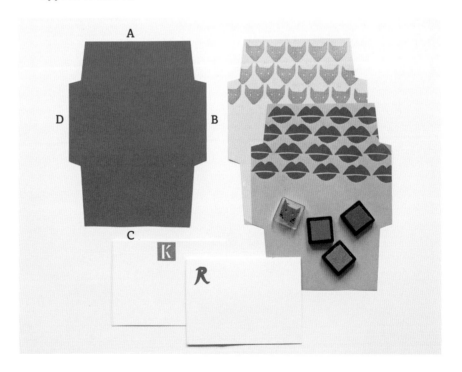

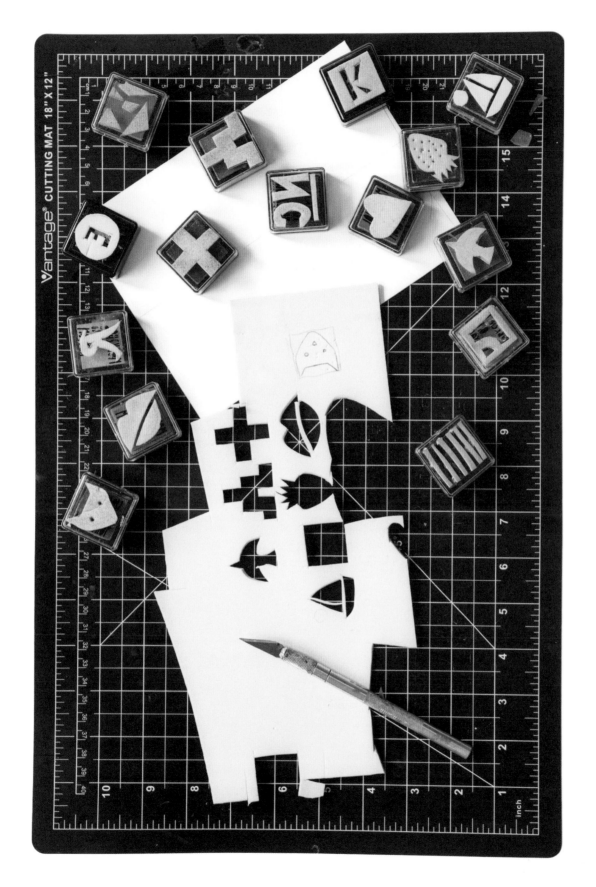

stamp embossing

Stamp embossing gives you the look of metal or color foil. Here we use a pigment ink pad (which dries more slowly and is more sticky than a dye-based or hybrid ink pad) and pour embossing powder over it. The powder sticks to the pigment ink. Then we use a heat gun to liquefy the powder. You can't use a hair dryer because it will just blow your powder away! I like using this for monograms or logos because that extra little step builds up the drama—especially with dimensional gold and silver powders that raise the surface and have a metallic sheen not achievable with metallic ink pads alone. Experiment with different colors of ink to achieve different looks. If you are doing a large run of printing, stamp a few impressions and apply powder before the ink can set. The heat gun will work even when the ink is dry.

TIME: 10 minutes

DIFFICULTY: ● ○ ○ ○

LEARN: How to emboss paper

REMIX: Stamp emboss any other flat, porous surface, such as wood or clay

MATERIALS

Scrap paper

Rubber stamp

Pigment or embossing ink pad

Paper, wood, clay, or other flat porous surface

Embossing powder

Heat gun

instructions

1. Place scrap paper underneath the item to be stamped. Ink the rubber stamp with pigment ink and quickly stamp the design onto the desired surface. **(a)**

2. Pour embossing powder over the inked image and tap the powder around the image until it is fully covered in powder. **(b)**

3. Tap the excess powder gently onto scrap paper so you can return it to the container. **(c)**

4. Turn on the heat gun and hold it about 8" (20.5cm) away from the surface of the image. Using a rotating motion, apply heat to the surface until the powder liquefies. **(d)**

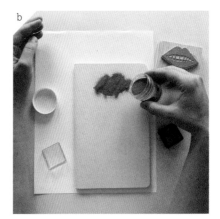

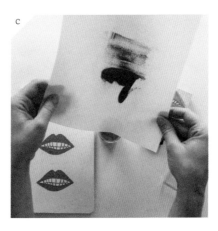

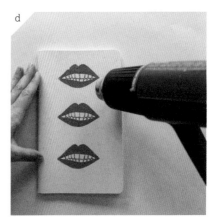

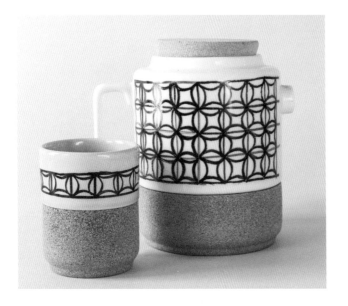

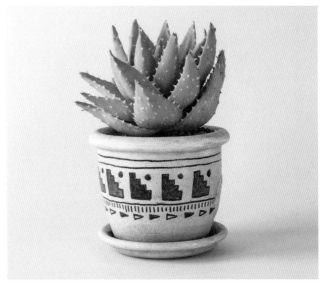

tea set

Caffeine never looked so good. Spiff up any old mug or other store-bought ceramic or glass item with this technique, which utilizes the basic materials employed for the Très Bien Bathroom Set on page 83. I used it to make the plates on the copyright page. I didn't want to heat-set this item in the oven because of the cork, but I recommend heat-setting any items if possible. Glass drinking cups and glass vases are also great to use with this technique.

Additional Materials: Template (page 153); tea pot or mug

1. Complete steps 1–7 from the Très Bien Bathroom Set project (page 83) using this template.

2. Set to dry for 72 hours.

plant pot

This is a fun way to add some personality to terra-cotta pots or glazed planters. Remember to thoroughly scrub the outside of the pot before beginning. I skipped the heat-setting for this project because I don't handle pots that often.

Additional Materials: Template (page 153); ceramic pot

1. Complete steps 1–7 from the Très Bien Bathroom Set project (page 83) using this template.

2. Set to dry for 72 hours.

team t-shirts

TIME: 1 hour

DIFFICULTY: ● ● ○ ○

LEARN: How to screen print multiple items of clothing with contact paper stencils

REMIX: Use this technique to screen print simple shapes and text to personalize all your wares

MATERIALS

Templates (pages 154 and 156)

Permanent marker

Tracing paper, 8½" × 11" (21.5cm × 28cm)

Contact paper, 8½" × 11" (21.5cm × 28cm)

Cutting mat

Painter's or drafting tape, 1" (2.5cm) wide

Craft knife

Pre-stretched screen printing frame, 11" × 14" (28cm × 35.5cm) screen, 12xx multifilament or 120 mesh monofilament

Clear packing tape, 2" (5cm) wide

T-shirts, as many as desired

Plastic spoon

Fabric screen printing ink, 4 oz (118.3mL)

Squeegee, 6" (15cm) wide

Dryer

If I had to pick one project to plead my case for screen printing in *Craft Court* (which is a made-up show I would totally watch), this would be it. Here we use a screen printing frame as it was first created: a physical stencil attached to mesh in a rigid frame. We use packing tape and contact paper to create a stencil so we don't have to worry about the islands and bridges as we do for regular stenciling, say with Mylar. While you can do this with a flooded screen and pieces of cut paper, I like to assemble my stencil and use contact paper. The adhesive lets me know exactly where I am placing the stencil on the screen. Letters and numbers can be easily peeled off and swapped out, making this a great project for custom clothing and prints. Trace the templates backward because you will apply them to the back of the screen mesh, which lies directly on the cloth. Because the stencil is attached to a screen printing frame with this method, you can print quickly with one squeegee pull instead of many stippled brush marks. Print your design many times without ink bleed and enjoy great accuracy until the entire team is covered.

instructions

CREATING THE SCREEN

1. Use permanent marker to trace templates onto tracing paper. Place sheet of contact paper on top of cutting mat and place tracing on top of contact paper, backing side up. Affix with painter's or drafting tape.

2. Use craft knife to cut out shape and letters from contact paper. **(a)**

3. Place screen, mesh side up, on table. Remove contact paper backing and place it in the center of the screen. Peel off letters or numbers and place them in position inside the shape. **(b)**

4. Apply strips of clear packing tape to cover area between contact paper stencil and edge of the screen.

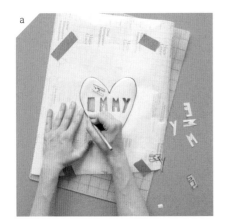
a

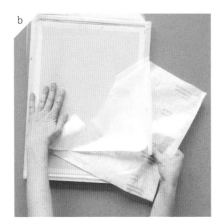
b

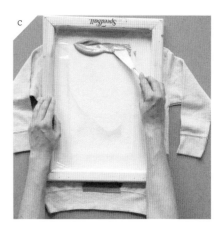
c

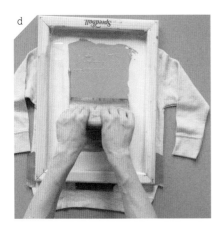
d

PRINTING THE IMAGE

1. Lay T-shirt onto print table. Lay screen frame in position, centered on the front of the shirt. Use small pieces of painter's or drafting tape on the shirt on the top, left, bottom, and right of the screen frame. Repeat this step with all shirts.

2. Place one shirt on table and smooth out wrinkles. Lay screen frame in position, mesh side down, and place three heaping spoonfuls of ink 1" (2.5cm) above the stencil on frame. **(c)**

3. Spread ink gently from top to bottom of screen, holding squeegee at a 45-degree angle. This makes the holes of the mesh fill with ink. Pick up squeegee and gently tamp ink off squeegee just above the stencil.

4. Secure screen in position at the top with one hand or have a friend hold the screen in position from the opposite side. Hold the handle of the squeegee at a 30-degree angle with your fingers on top and thumbs on the bottom. With even pressure coming from the top of your hands, slide squeegee from top of stencil to bottom, picking up extra ink with edge of squeegee. **(d)**

5. Remove T-shirt for drying and repeat steps 2–4 until all shirts are printed. When ink is dry, place T-shirts in the dryer for one high-heat cycle.

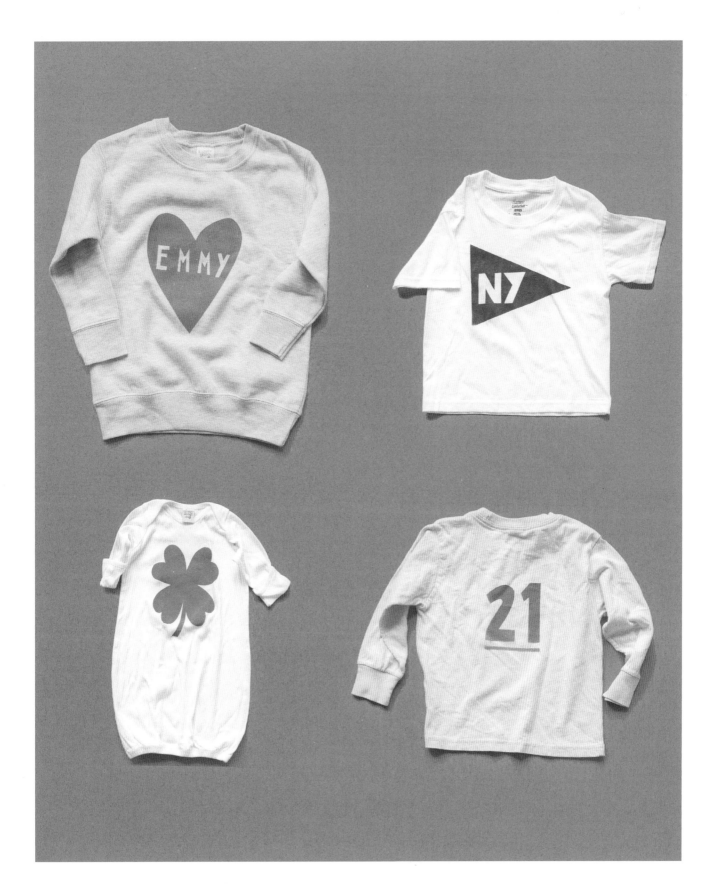

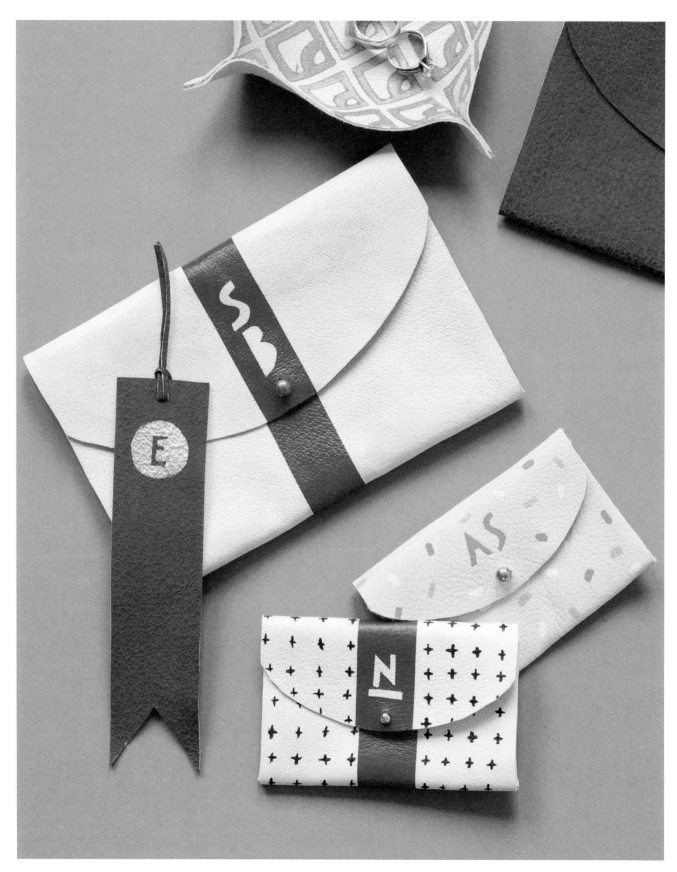

monogram leather clutch

TIME: 1 hour

DIFFICULTY: ● ● ○ ○

LEARN: How to stencil on leather and make a wallet

REMIX: Use this technique on existing leather goods like shoes, purses, and pet collars and leashes, or dive right into freehand painting, like the shoes on page 75.

MATERIALS

Templates A, B, C, and D
(page 157)

Pencil

Tracing paper, 8½" × 11"
(21.5cm × 28cm), 2 sheets

Manila file folder

Bone folder (optional)

Scissors

Drafting tape, 1" (2.5cm) wide

High-quality hole punch, such as
Crop-A-Dile, ³/₁₆" (4.8mm)

Craft knife

Leather, 12½" × 16½"

Fine tip permanent marker

Cutting mat

Painter's tape, 1" (2.5cm) wide

Stencil brush, ½" (13mm)

Leather paint

Button stud with screwback, 7mm

Flathead screwdriver

Leather sealer (optional)

Fashion is a fleeting product, but style is enduring and personal. This no-sew clutch has a simple design that can be can be customized in every way. Use different colors of leather and paint colors to suit your mood. Add initials or words to express yourself. Scale the template up or down to suit your need. Dress it up or dress it down but make it yours!

I choose leather paints but nail polish will do in a pinch. Painter's tape works like a dream because it won't mar the leather surface and provides a crisp line. You can also use this stencil technique on an existing leather bag. See pages 178–81 for more leather information.

instructions

1. Trace templates with heavy pencil marks on tracing paper. **(a)**

2. Turn tracing paper over onto open manila folder and rub with bone folder or thumbnail to transfer design. **(b)**

3. Cut out template with scissors. Tape templates A, B, C, and D together with drafting tape as shown. **(c)**

4. Cut out holes with hole punch on templates A, B, and C, as shown on page 157. Since the hole on D is in the center, it will need to be created with the craft knife. **(d)**

5. Place leather facedown and put template on top. Place as close to the edges as possible so as not to waste any leather. Trace with permanent marker and mark holes. **(e)**

6. Cut out leather with scissors and use hole punch and craft knife to make four holes in specified locations. **(f)**

a

b
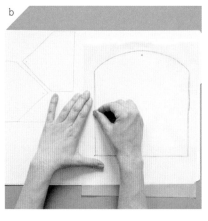

c
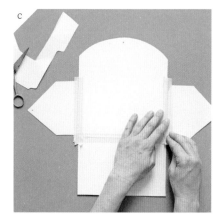

d
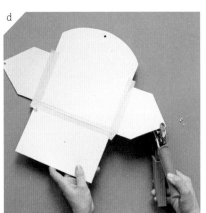

e
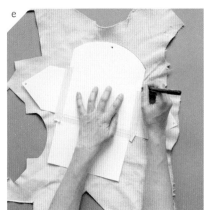

f
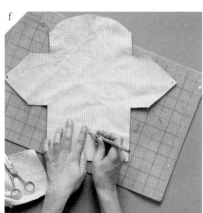

7. Lay leather flat, front faceup on cutting mat. Place a piece of painter's tape that runs down the center line from the middle of the rounded flap to the top, leaving ½" (13mm) on the top and bottom.

8. Place strips of tape to the left and to the right of the center tape. **(g)**

9. Remove center tape and place on cutting mat. Use permanent maker to draw initials on the tape, then cut with craft knife. Gently peel letters from mat and place in desired position on leather at least ½" (13mm) above center hole. Letters should be at least ⅛" (3mm) inside tape. **(h)**

10. Load small stencil brush with leather paint and stipple paint over tape edges and letters using an up-and-down motion to create a thin coating of paint. Set to dry. Remember that thinner coats are better than heavy coats. I went for three coats of paint on these puppies. Remove tape and letters and set to dry at least 4 hours. **(i)**

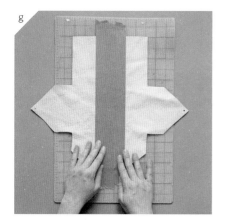

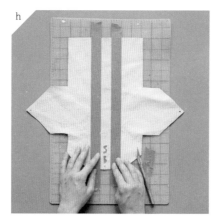

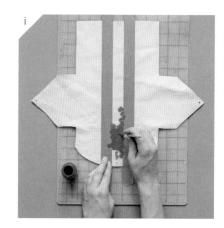

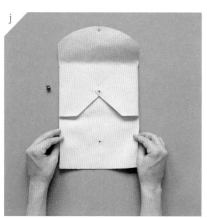

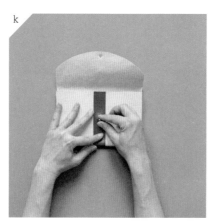

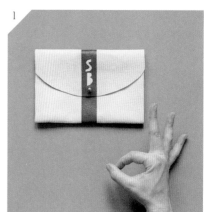

11. Unscrew the bottom button stud and thread it through the left and right flap holes. The back with the screwhead should be facing in. Tighten with screwdriver if needed. **(j)**

12. Fold bottom flap over and push the head of the button stud through front hole. If the bottom will not fit through, just make tiny slits on both sides until it barely slides through. **(k)**

13. Seal with leather sealer if desired. Throw your phone and lipstick in there and hit the town! **(l)**

After I finished my clutch I had a lot of leftover leather I didn't want to waste. I worked up these projects to use it up and ended up with a wallet and bookmark. I also played with techniques besides stenciling. I used my Custom Monogram stamps (from page 61) and painted them with leather paint to create a stamped pattern on the leather tray. I used the stamp embossing technique (from page 64) to create a personalized bookmark.

bookmark

I created this craft as a wedding favor for my bookish friends. I didn't have any twine so I just cut a thin piece of the leather to thread through.

Materials: Template (page 157); leather; pencil; tracing paper; manilla file folder; scissors; Custom Monogram stamp (page 61); gold pigment ink pad; gold embossing powder; heat gun; high-quality hole punch

1. Trace bookmark template with heavy pencil marks on tracing paper. Turn tracing paper over onto open manila folder and rub with bone folder or thumbnail to transfer design. Cut out template with scissors.

2. Position template on leather, trace with permanent marker, and then cut leather.

3. Follow steps 1–4 of the stamp embossing technique (from page 64) to transfer monogram to bookmark.

4. Punch hole ½" (13mm) from top.

5. Cut an 8" × ⅛" (20.5cm × 3mm) strip of leather.

6. Fold leather strip in half and thread through hole in bookmark about 1" (2.5cm), creating a loop. Thread the ends of the leather strip through the loop and pull to tighten.

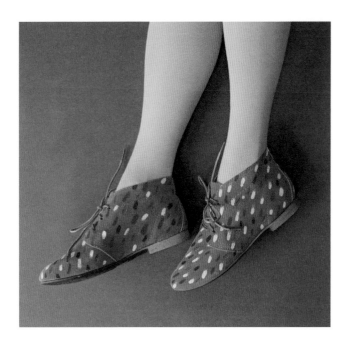

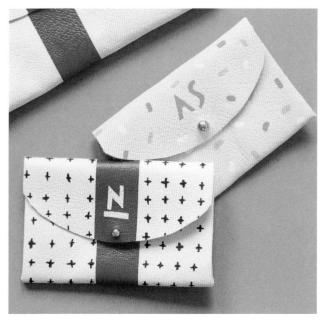

abstract painted shoes

Jazz up plain shoes with some freestyle painting that will make them truly one-of-a-kind.

Materials: Suede, faux suede, or leather shoes; deglazer or nail polish remover; leather paint; brush

1. Prepare clean leather shoes with deglazer or nail polish remover. Skip this for suede or faux suede.

2. Paint any design you like with your leather paint and set to dry.

wallet

This unisex mini version of the clutch makes a great wallet, business card holder, or jewelry satchel. While you can use the same 7mm button stud screwback required for the clutch project (page 71), I went with a smaller 5mm button to better fit the scale of this petite project.

Additional Materials: Template (page 157); button stud with screwback, 5mm

1. Trace smaller template on tracing paper.

2. Follow steps 2–13 from the Monogram Leather Clutch project (page 71), using your smaller button stud with screwbacks.

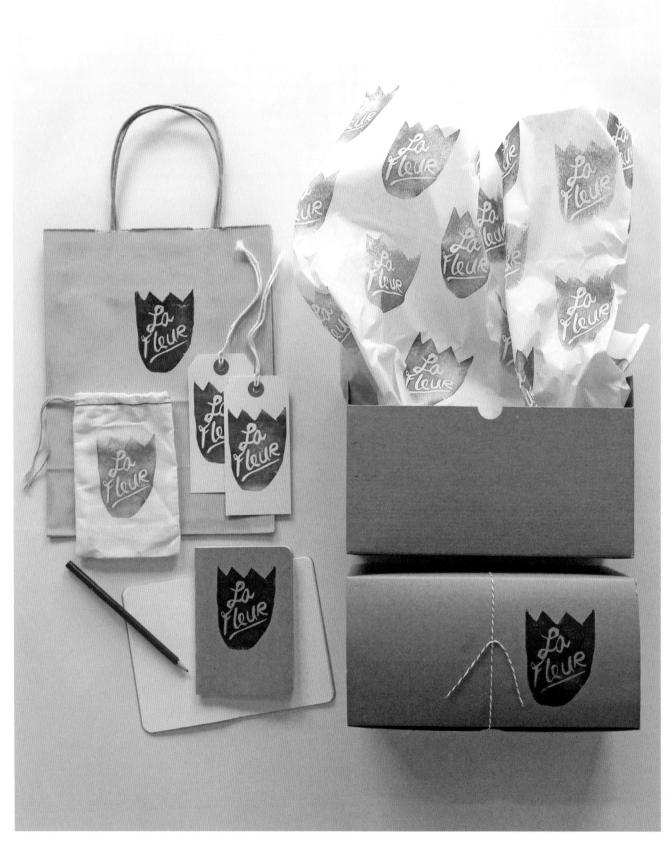

logo stamp

TIME: 1 hour +

DIFFICULTY: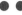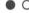

LEARN: How to design and print a logo

REMIX: Use your logo to personalize all your goods, such as textiles (using the screen printing technique on page 67), office supplies, glass (see page 83), and gift bags

MATERIALS

Pencil

Logo on paper (smaller than 2" × 3" [5cm × 7.5cm])

Template (page 156)

Tracing paper

Carve-a-Stamp block or rubber block, 2" × 3" (5cm × 7.5cm)

Stamp carving tool and multiple gouges

Craft knife

All-purpose ink pad

Paper to be stamped

Now that you are churning out handmade goods, you deserve a little branding. Here is a crash course in designing a logo for your business, yourself, or a special event. Logos are visual identities and they should reflect your personality. This is usually a combination of words and a graphic symbol. A successful logo is unique, memorable, and clearly conveys information. Logos aren't just all business: They are great fun for weddings and stationery.

instructions

BRAINSTORMING THE LOGO

A successful logo should contain the following elements:

HIGH-CONTRAST FEATURES One-color designs are easy to print by hand and less expensive to print mechanically (like offset or foil) on other items. Plus, they're clean and functional without too much detail to distract or get lost. Think of Coco Chanel's rule about accessorizing, and remove elements that aren't needed.

DISTINCTIVE AND TIMELESS APPEAL Look around the field and do what others aren't. Gimicky graphics, clip art, and formulaic logo trends will just get you lost in the pack. You are special and your logo should reflect that. Do you have a unique approach or product that others don't? Floss it!

THOUGHTFUL SUBSTANCE Logos should convey an idea about your work. This could be a literal graphic or symbol related to your work, mood, or method.

COLOR Choose a color that has presence. Yellow is a hard-to-read hue unless it contains a lot of tone; other similar light colors might get washed out. Different colors evoke different psychological responses, so choose one that aids in conveying your message. For instance, orange is energetic, which might be good for a kid's clothing shop but would

distract from the calming feeling you want to evoke if you run a yoga studio. I would never hire lawyers who had a hot pink logo unless it was Elle Woods or my cousin.

SCALABLE FORMAT Your logo should read well at both a small and large scale. Will the words or symbol be legible printed smaller than 1" (2.5cm) on company letterhead?

DESIGNING THE LOGO

1. Select a name and symbol that are significant to the logo you're creating.

2. Choose a few adjectives to describe what you want to convey. If this is a business, think about what sets you apart from your competitors. If it's for personal use, think about the core values or emotions associated with the logo.

3. Write out the name in several fonts. Play around with the spacing between letters and the negative space in the letters themselves. Sketch the letters at different angles and orientations and play around with the line breaks between words. Style the letters in uppercase, lowercase, and a mix of the two.

4. Make a simple sketch of the chosen symbol. Evaluate the visual difference between the words and the symbol. Having fewer letters in the name will likely look less busy and could allow for more detail in the symbol or even allow the symbol to be larger. A longer name will have a lot going on, so better to go with a smaller, simpler symbol than something ornate that would distract from the words. Perhaps you don't need a symbol at all. Think about the contrast of both the color and thickness of line and form.

5. Solicit opinions once you have a logo that you think you're happy with. Family and friends can be nice—maybe too nice—so I find asking people on social media for their thoughts can be more effective. Sometimes strangers are the best at delivering gut reactions. Criticism can be harsh, but if it gets you to your goal faster, I say take the plunge.

6. Finalize your design. Remember it is always easier to make adjustments to the logo on paper—next you'll carve the text backward on the block, carving slowly and delicately around the text with the knowledge that while you can always carve more away (especially to create letters), you can't uncarve anything.

PRINTING THE LOGO

1. Design your own logo, as above, or trace the logo from the template provided on page 156 and add your own text as needed.

2. Turn the paper over so that the outlined design is facedown on the rubber block or Carve-a-Stamp block and burnish the design with the side of your thumbnail. Holding the paper in place with one hand, carefully lift a corner of the page to make sure the image is transferring.

3. Carve around the lines you transferred with a narrow V-gouge. Use a craft knife to cut around the outside of the shape.

4. Turn the stamp over and press it firmly onto the stamp ink pad several times until the face of the stamp is covered in ink.

5. Press the stamp firmly with the inked side down onto scrap paper. This is your print.

6. Examine the print. If details are showing up that you don't like, just carve the raised areas away.

7. Repeat steps 4–6 until you get the look you like and then stamp away!

papel picado print

TIME: 1 hour

DIFFICULTY: ● ● ● ○

LEARN: How to screen print with a hand-drawn design and print with split fountain

REMIX: Use templates from the Cut-a-Stamp project (page 21); print image on paper or fabric pieces several times and string together with bias tape or cords to create a garland

MATERIALS

Template (page 158)

Permanent marker

Tracing paper, 8½" × 11" (21.5cm × 28cm)

Painter's or drafting tape, 1" (2.5cm) wide

Pre-stretched screen printing frame, 11" × 14" (28cm × 35.5cm) screen, 12xx multifilament or 120 mesh monofilament

Blockout pen

Clear packing tape, 2" (5cm) wide

Plastic spoon

Fabric screen printing ink, 4 oz (118.3mL), two colors as desired

Scrap paper, at least as big as the screen

Squeegee, 6" (15cm) wide

Bristol paper, 11" × 14" (28cm × 35.5cm)

In San Francisco, you'll find delicately cut tissue decorations lining taquerias and strung up outside for events. These decorative paper banners are called *papel picado,* which is Spanish for "cut paper." I used a blockout pen to create this intricate pattern. While I could have done this with the contact paper screen printing method on page 67, this technique gives me a lot of flexibility with design because I don't have to consider bridges and islands as I would for a regular cut stencil and I can get finer detail. I also decided to use a "split fountain," which is like making a rainbow on your print by mixing two colors with the squeegee as you print. Here I made a small print, so I used only two colors. This allowed each color to have at least 3" (7.5cm) of the virgin color and 2" (5cm) where the colors create a blended gradient.

instructions

CREATING THE STENCIL

1. Use permanent marker to trace template onto tracing paper.

2. Use painter's or drafting tape to secure the template in the center of the screen with mesh facing down. **(a)**

3. Turn screen over so the mesh is facing you. The design will appear in reverse. Use blockout pen to draw inside the tracing to create the stencil. Set to dry at least 1 hour.

4. Apply strips of clear packing tape to cover area between drawn stencil and edge of screen.

PRINTING THE IMAGE

1. Dollop about 3 spoonfuls of orange ink (or other color, as desired) along top left of screen.

2. Dollop about 3 spoonfuls of red ink (or other color, as desired) along bottom left of screen so it meets with the orange ink. **(b)**

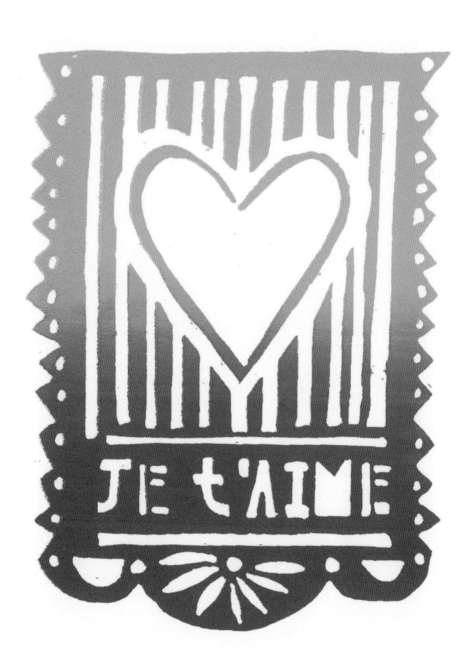

a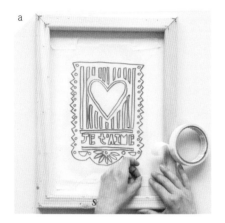
b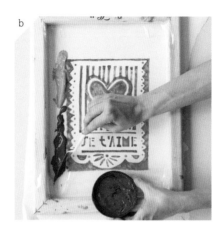
c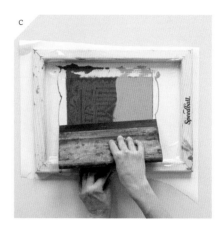

3. Rotate the screen 90 degrees clockwise and center it over a piece of scrap paper. Holding the squeegee at a 45-degree angle, gently spread ink from top to bottom of screen, making a slightly squiggly line. This makes the holes of the mesh fill with ink and mixes the colors in the middle. Pick up squeegee while scooping up ink and gently tamp ink off squeegee just above the stencil. **(c)**

4. Repeat step 3 on scrap paper until colors blend to form a gradient.

5. Print onto finished paper.

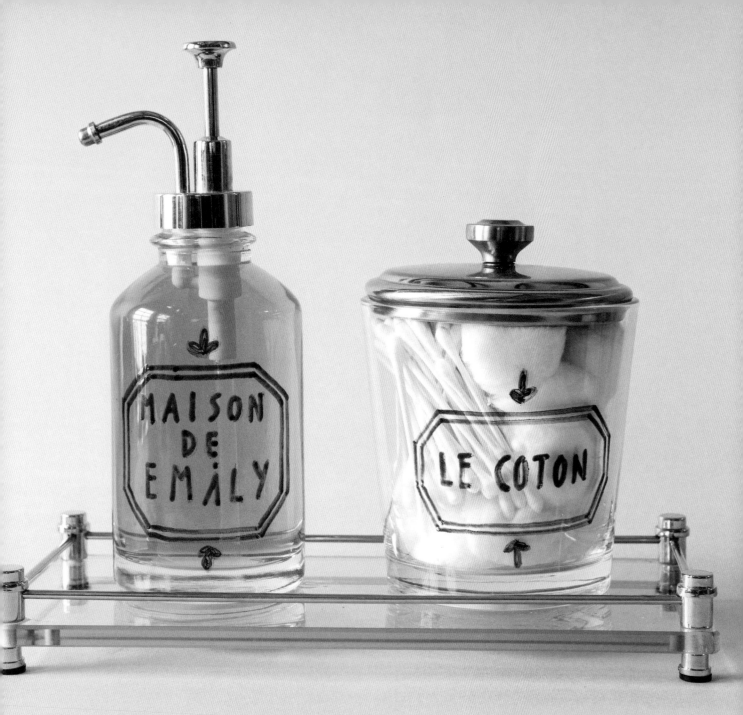

très bien
bathroom set

If there is one room in your house that could likely use some jazzing up, it is the bathroom. I whipped up this project as a housewarming gift for my sister. I found these vintage-looking apothecary-style bathroom accessories online for a song, but thought this little custom touch transformed her new bathroom into a Parisian hotel: a little romantic, a little Old World, but completely functional and custom. Use this technique for any glass or ceramic pieces, but note that it's easier to transfer designs to items with straight sides.

TIME: 1 hour

DIFFICULTY: ● ○ ○ ○

LEARN: How to transfer design to terra-cotta, glass, and finished ceramics

REMIX: Use technique to adorn glass containers in your kitchen, or make custom coffee mugs that your office mates can't steal; use these templates to create Carve-a-Stamp projects (see page 49)

MATERIALS

Templates (page 162)

Pencil

Tracing paper

Glass soap dispenser and apothecary container

Saral transfer paper

Clear or painter's tape

Colored pencil

Glass paint marker or paint

Scrap paper

instructions

1. Trace top template from page 162 with pencil onto tracing paper and add names, initials, or any words you like. **(a)**

2. Place transfer paper in position on glass soap dispenser with the bright red side down. The paint used in step 5 will be repelled by the oil from your hands so take care not to get fingerprints on the area that will be painted. Secure all four corners with small bits of tape. **(b)**

3. Place traced template in position on container and secure all four corners with small bits of tape. **(c)**

4. Use a colored pencil to trace template, transfering pigment from back of the paper to the glass. Remove tracing paper and transfer paper. **(d)**

5. Shake glass paint marker well and press tip onto scrap paper until ink starts to flow. Carefully go over the traced design. It helps to work from the inside of the design out to prevent smearing. **(e)** Be patient and let it dry between sections. Set to dry.

6. Repeat steps 2–5 with other template for the apothecary container.

7. Examine the painted designs. Go over them again with paint marker until the color is as opaque as you like.

8. Remove push pump from the soap dispenser and the top from the apothecary container and place glass items in a cold oven. Set temperature to manufacturer's instructions for heat-setting. After specified time, turn off oven. Do not remove from oven until the glass has returned to room temperature.

a

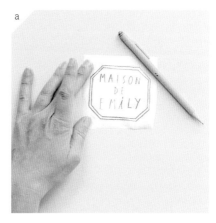

b

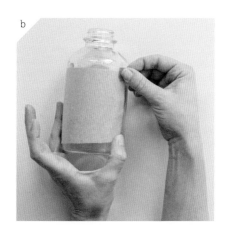

c

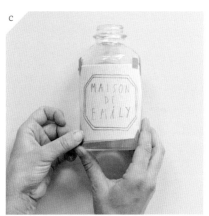

d

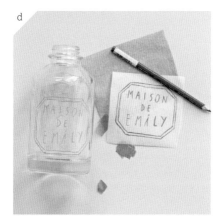

e

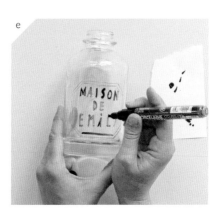

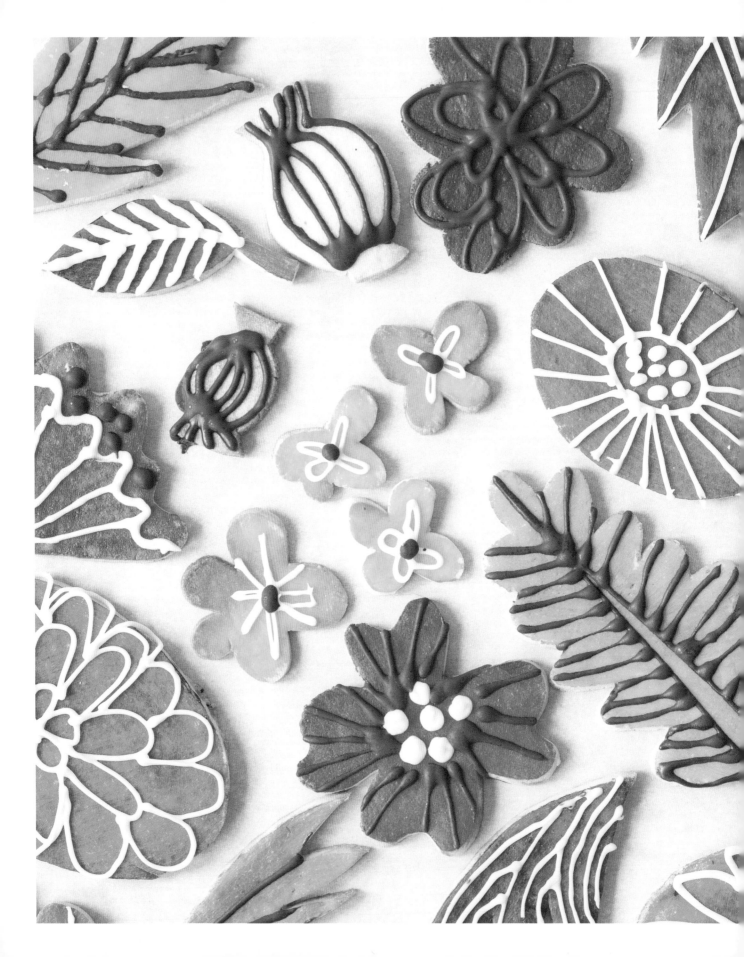

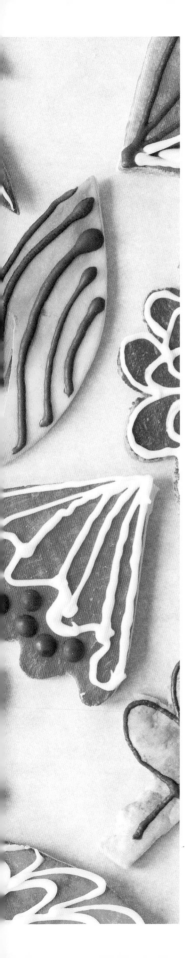

occasions & celebrations

Time to get out of the studio and into the kitchen for some printmaking projects you can actually eat! In this chapter we print with food and draw with chocolate. You did read that right! Make those special celebrations more memorable by adding personal touches and handmade, delicious details.

fondant decorations

TIME: 30 minutes

DIFFICULTY: ● ○ ○ ○

LEARN: How to create names or greetings for sweet decorations

REMIX: Use templates from Cut-a-Stamp (page 21); create a cohesive party motif to apply to your cake, tablecloth, and napkins, and even to the party invitation

MATERIALS

Rolled fondant, three golf ball-sized amounts

Roll of parchment paper

Gel-based food dye

Rolling pin

Cutting mat

Craft knife

Templates (page 154)

Pencil

Cardstock

Scissors

Neutral-flavored vegetable oil (optional)

Confectioners' sugar (optional)

Think of rolled fondant as an adaptable art medium you can eat. Roll it out thin and it will drape over a cake. Use it to build your own edible sculptures. Make it any color with gel food dye. Fondant keeps for a long time, so you can prep decorations far in advance and chill them in the fridge till it's party time! Here I roll the fondant out thin and cut out letters to form words. The sheets with cutout letters are a refreshingly new way to write messages on your cake—no icing required! Plus, you can use the fondant to make interesting collages and geometric patterns on your cake or to decorate the plate. It's a cool way to soup up even a store-bought cake or cupcakes.

instructions

1. Select one ball of fondant and place it in one hand. Use thumb of the other hand to flatten the ball in your palm. Place a few drops of gel-based food dye in the center of the flattened fondant and smear it around. Knead the fondant with your hands until it is smooth and malleable and the color is mixed. The heat from your hands will soften it. **(a)**

2. Place fondant between two sheets of parchment. Use rolling pin to roll it out to ⅛" (3mm) thick. **(b)**

a
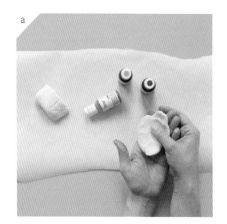

b
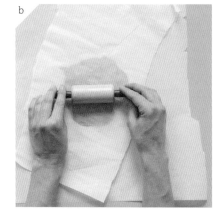

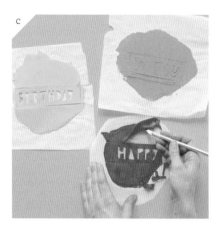

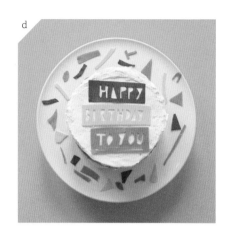

DON'T HAVE A ROLLING PIN?

Find any bottle with straight sides (like a wine or liquor bottle) and soak it in hot dishwater to remove the paper label if needed. Dry the bottle and roll away.

3. Repeat steps 1–2 with other colors. Place all sheets flat in freezer for about 10 minutes to firm them up.

4. Trace templates from page 154 with pencil onto parchment paper, using the letters to write any message you like. Turn tracing paper over and position on cardstock. Use your thumbnail to transfer the lines, then cut out letter stencils with scissors.

5. Remove one color of fondant from freezer and place on cutting mat. Position letter stencils as desired. Wipe your craft knife clean and cut out shapes. Repeat with other colors. If knife tears fondant, lightly oil knife with a neutral oil (like canola). If fondant sticks to surface, just sift a small amount of confectioners' sugar on the parchment and rotate the fondant sheet. **(c)**

6. Place fondant decorations carefully on cakes. **(d)**

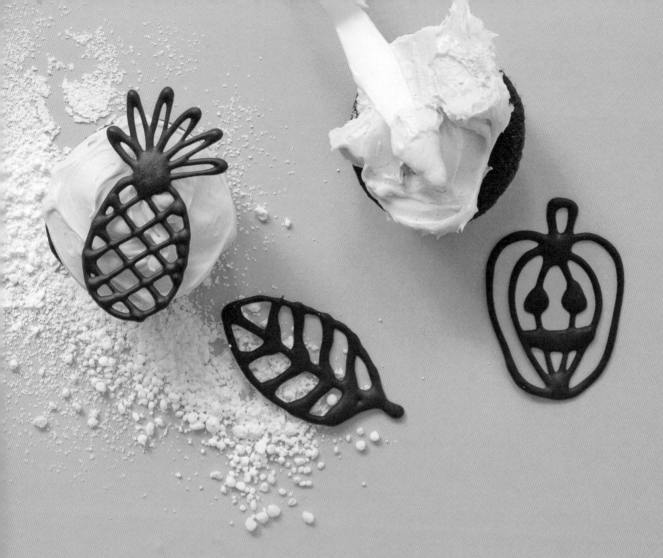

drawing with chocolate

What better way to eat chocolate than as a graceful decoration to your favorite baked goods? This skill will up the ante on all your confections. You won't believe how easy, clean, and fast this is. It pays to skip the Toll House morsels and go for a more expensive chocolate if you can. Cheap chocolate is filled out with waxes that interfere with the flow of the chocolate. No need to temper the chocolate—just melt, draw, set, and go. These decorations are great because you can make them way ahead of time and, if you mess up, just toss the mistake back in the bag and reheat.

Candy melts (available in cake decorating stores and some craft and big box stores) are a good option for colors and will remain stiff at warmer temperatures, whereas chocolate will re-melt at high temps (like at an outdoor party). Consider white chocolate or even coloring the background frosting with gel-based food dye to create more contrast. As with any kind of drawing, you will get better with practice.

TIME: 30 minutes

DIFFICULTY: ● ○ ○ ○

LEARN: How to draw delicate shapes to decorate baked goods

REMIX: Use this technique to write personal messages on cakes

MATERIALS

Roll of parchment paper

Templates (page 159)

Permanent marker

Baking sheet

Chocolate or candy melts, heaping handful

Small plastic freezer bag

Scissors

instructions

1. Place parchment paper over template and trace with permanent marker. Position paper, drawing side down, on a baking sheet. The drawing will present in reverse, but the chocolate decorations can be flipped over once chilled, so this doesn't matter. No worries if you want to draw freehand. **(a)**

2. Place a large handful of chocolate chips or candy melts in one corner of the freezer bag. Microwave bag for 10 seconds, remove, and massage the bag. Continue heating the bag in 10-second intervals until the chocolate has melted. Note: If you don't have a microwave, melt the chocolate in a double boiler (or create one by placing a bowl over a slightly smaller pot of simmering water). Then, scoop it into the freezer bag.

3. Cut a tiny piece from the corner of the bag to turn it into a piping bag. The smaller the hole, the finer the line quality. If you are filling in a large area, you should cut a slightly larger hole. If you cut a hole that is too big, just slide the mass to the other bottom corner and cut a smaller hole.

4. Practice making lines. Hold the bag above the parchment and let chocolate fall from the tip, rather than dragging the tip across the parchment. Once you've got the hang of it, begin tracing the simplest design. **(b)** Reheat chocolate as needed.

5. Place the baking sheet in the refrigerator until the chocolate is firm. Keep the design refrigerated until serving.

6. Place chilled drawing on plate, cake, or cupcake and serve.

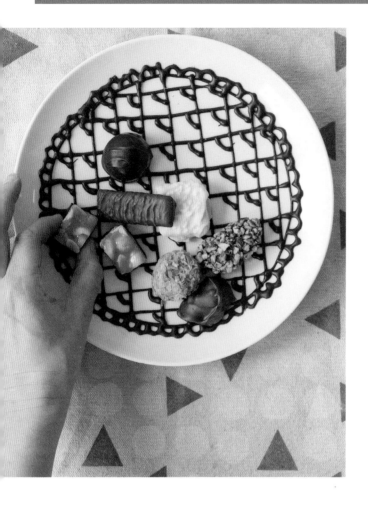

chocolate doilies

You can use the same melt-draw-and-go method to spruce up other sweet treats for a polished look. This round drawing would look good on top of a cake, but I used it to dress up a dessert plate with store-bought treats. Measure the well of your plate (the flat part that contains the food) to determine how large it should be.

Additional Materials: Template (page 159); round dessert plate; treats for serving

1. Trace the template onto parchment and complete steps 2–5 of the Drawing with Chocolate project (page 91).

2. Slide doily from parchment onto plate, add your treats, and serve.

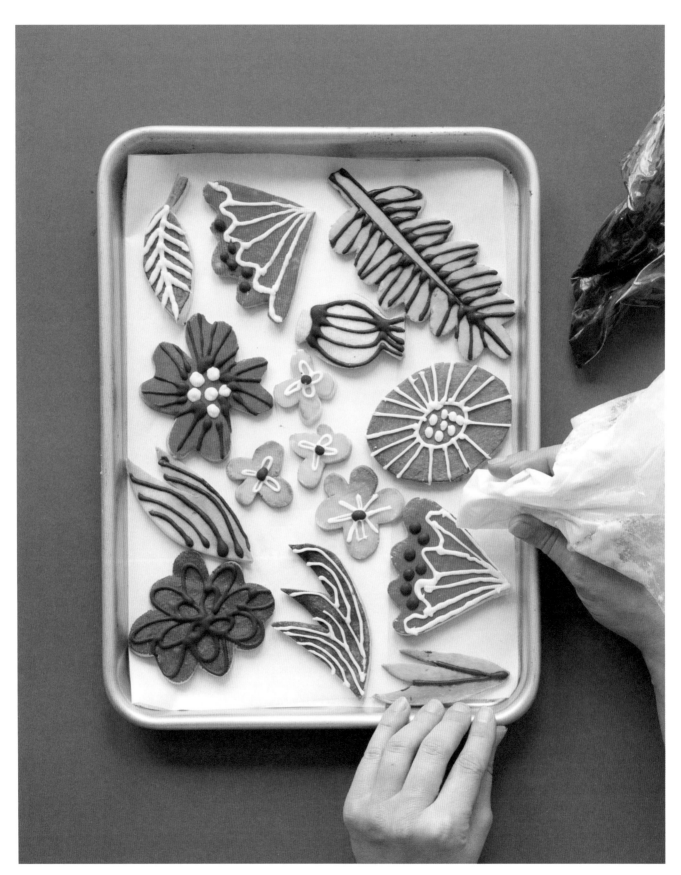

YELLOW OWL WORKSHOP'S MAKE IT YOURS

garden party cookies

TIME: 1 hour + chilling time

DIFFICULTY: ● ● ● ○

LEARN: How to cut cookie shapes without cutters

REMIX: Use templates from Laundry Bag project (page 42) or any solid shapes you like

MATERIALS

Scissors

Roll of parchment paper

Cardstock

Baking sheet

Flour

Sugar cookie dough, chilled and divided in half

Rolling pin

Templates (page 160)

Tracing paper (optional)

Pencil

Manila folder or cardstock, 9" × 12" (23cm × 30.5cm)

Cutting mat

Craft knife

Dinner plate

Gel-based food dye

Flat brush, 1" (2.5 cm)

Chocolate and white chocolate

Small plastic freezer bag

There is rarely an occasion when flowers and/or cookies are not appropriate. So why not combine them for a sweet treat that's easy on the eyes? While you can use any basic cookie dough recipe for this, it is best to go with one that does not contain baking soda, which is a leavening agent that will make the dough spread and rise during baking. You can also use store-bought tubes of dough, but be sure to throw them in the freezer for 10 minutes before and after cutting so the cookies don't spread too much. The gel-based food dye applied directly to unbaked cookies will give you vibrant results, and the Drawing with Chocolate technique on page 91 will give your cookies finer details, for a perfectly decorated result.

instructions

PREPPING THE DOUGH

1. Use scissors to cut four sheets of parchment paper as large as your baking sheet. Set aside.

2. Tear a fresh sheet of parchment, position it on your work surface, and sprinkle it with a light layer of flour.

3. Place half the dough in center of parchment and cover with second sheet. Use rolling pin to flatten it to a uniform thickness of about ¼" (6mm) and place on baking sheet in freezer for at least 10 minutes before cutting. This will give you a clean line and allow the shape to hold through baking.

4. Repeat steps 2–3 with other half of dough.

BAKING AND DECORATING THE COOKIES

1. Trace templates or draw your own designs onto tracing or parchment paper with heavy pencil marks. **(a)**

2. Turn tracing over onto cardstock and rub with thumbnail to transfer the outlines. **(b)**

3. Use scissors to cut out shapes from cardstock. **(c)**

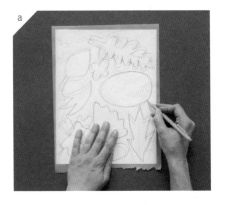

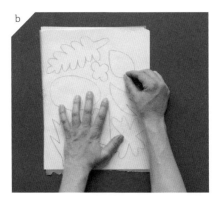

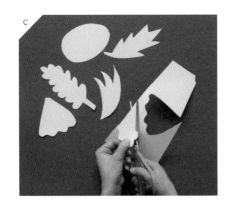

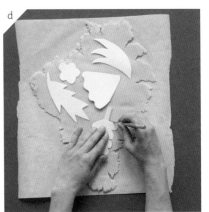

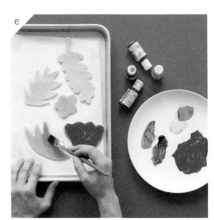

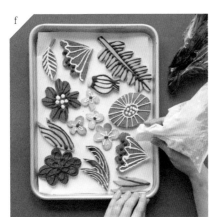

4. Place chilled dough on parchment over cutting mat. Fit templates, pencil side up and spaced at least ⅛" (3mm) apart, on dough. Use craft knife to cut out shapes. **(d)**

5. Peel away excess dough and place cookie shapes onto a parchment-lined baking sheet. Save excess dough, chill it, and roll for reuse.

6. Squeeze a quarter-size amount of gel-based food dye onto your dinner plate. Use a flat brush to paint the top of each cookie. **(e)**

7. Continue painting cookies, adding more colors and cleaning brush as needed. Try mixing colors on the plate or overlapping colors for different effects.

8. Bake cookies as specified by recipe.

9. Use Drawing with Chocolate technique on page 91 to add details. **(f)**

stamped clay ornaments

Stamping clay is a great way to create deep impressions, with or without ink. You could use air-drying clay, but I prefer polymer clay because it is smooth and allows crisp details that help show off the stamp. In this project we use white Sculpey, bake it, and stipple it with gouache. By wiping off the surface of the clay, the embossed motif made by the stamp remains painted, giving the ornament an engraved natural clay or stone look. Acrylic paint will work as well. You could also ink and stamp directly on the unbaked clay with an all-purpose stamp pad.

The polymer clay will be a little stiff and you will condition it, that is, make it softer and more malleable, by kneading it with your hands. Mix colors of clay together to create new colors or even stop mixing halfway through to get a marbled effect. When I am using a small amount, I flatten it with my fingers or roll it with the round barrel of a fat pen. When I am rolling out large sheets, I use a straight-sided glass bottle or a rolling pin. Don't use a regular rolling pin or cookie cutters if you plan on using them in the kitchen again. I picked up these cookie cutters for this project because I thought they gave a fine finished look, but you could just use a craft knife to cut any shape you like.

instructions

1. Wash your hands so the oils on your hands don't make the polymer clay stick to you. Grab a golf ball–sized hunk of clay and knead it with your hands to soften.

2. Place clay on parchment paper and, using a pen with a large barrel or a small rolling pin, roll out the clay, picking it up and flipping it occasionally until you get a uniform thickness of ⅜" (1cm).

3. Press cookie cutter firmly into clay. Gently tear away portions around cookie cutter. **(a)**

4. Look at the clay from the side and press the stamp into the clay. **(b)**

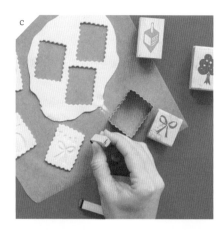

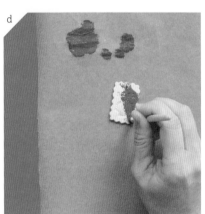

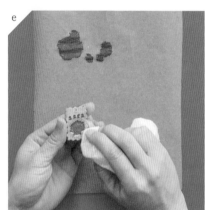

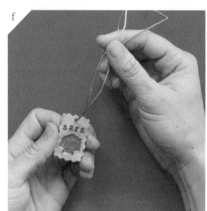

5. Press letter stamps onto clay to spell out name or greeting. **(c)**

6. Make a hole using a skewer, a coffee stirrer, or the end of a straw.

7. Line a baking sheet with parchment paper and bake according to the manufacturer's directions and temperature, which will vary by brand. Remove and cool completely.

8. Add a small dab of paint to the parchment and use stencil brush to stipple paint all over the ornament, making sure to get paint in all grooves created by the stamped impression. **(d)**

9. Use a damp rag to wipe paint away from surface of ornament, leaving paint in stamped impression. **(e)** Let dry.

10. Thread hemp, twine, or string through hole and knot. **(f)**

11. Attach to anything you like, such as a small gift box.

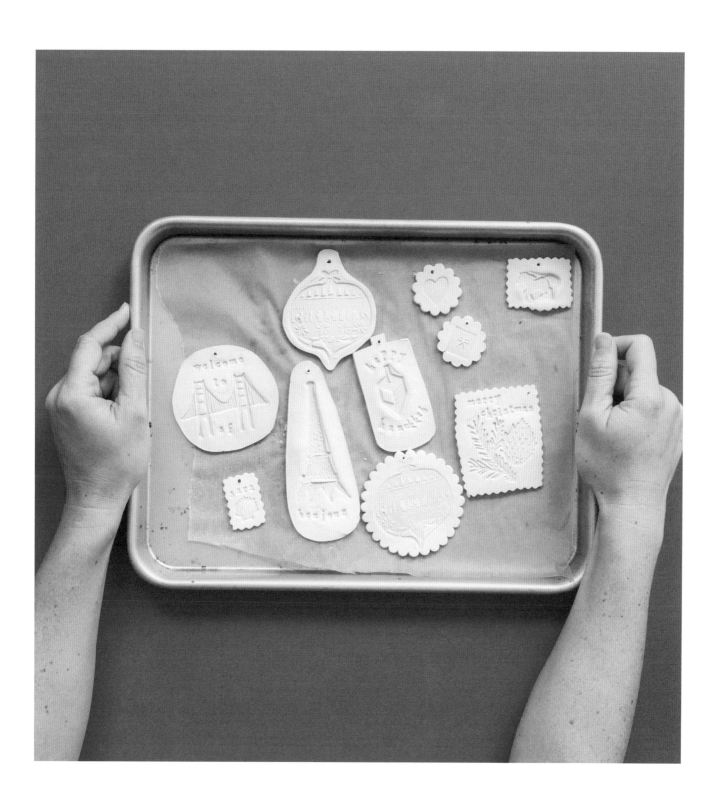

wax seal

Personalize your gift with this clever seal. Note: For hand deliveries only! The U.S. Postal Service will not accept a letter with a seal like this.

Additional Materials: Pencil; hot glue gun with glue stick

1. With clean hands, pull off a nickel-sized hunk of clay and press flat with your fingers.

2. Press a small-scale stamp in the center and incise the perimeter with a pencil.

3. Repeat steps 1–2 until you have the desired number of clay items.

4. Bake according to manufacturer's instructions. Allow to cool completely and then follow steps 8–9 from Stamped Clay Ornaments project (page 97).

5. Use hot glue gun to attach decoration to back of envelope.

floral charm

A good project to add something to floral arrangements for special events or weddings. You could also attach the charm to a boutonniere for the gents. I wrapped the flowers with ribbon but threaded the charm through hemp because making a hole big enough for the ribbon would overwhelm the petite scale.

Additional Materials: Floral arrangement; satin ribbon, 1" (2.5cm) wide, length as needed

1. Follow steps 1–9 from Stamped Clay Ornaments project (page 97).

2. Wrap ribbon around the bottom of the floral arrangement and knot in the back.

3. Wrap the hemp around the ribbon several times and thread the charm through one end. Pull hemp around to the back, knot, and trim excess.

cheese markers

Jazz up the grazing table at your next cocktail party with these reusable cheese markers. Great for identifying charcuterie as well!

Additional Materials: Toothpicks

1. With clean hands, knead polymer clay to soften. Place clay on parchment paper, and roll to desired thickness.

2. Press cookie cutter firmly into clay, repeating until desired quantity is created. Gently tear away excess.

3. Stamp text on each marker and insert toothpick. Bake markers and allow to cool.

4. Stipple paint on each marker, carefully filling the grooves. Wipe away excess.

5. *Buon' appetito!*

jar medallion

A great project to gift or for selling your homemade canning and preserves. Stamp your own fabric or paper bonnet if you like! I use a rubber band to secure the bonnet in place as I wrap the twine.

Additional Materials: Jar; fabric or paper bonnet; rubber band

1. Follow steps 1–9 from Stamped Clay Ornaments project (page 97).

2. Center bonnet on lid and use rubber band to secure in place.

3. Wrap hemp or twine around the jar, thread ornament through on the end, and knot or tie with bow.

roll stamp table linens

TIME: 30 minutes

DIFFICULTY: ● ○ ○ ○

LEARN: How to create and print a border stamp

REMIX: Use this technique with other motifs as a border for bed linens or with letters to form a message for wrapping paper

MATERIALS

Pencil

Tracing paper

Template (page 159)

Self-adhesive craft foam, 9" × 12" (23cm × 30.5cm)

Scissors

Hole punch

Packing tape, 2" (5cm) wide

Inking plate

Fabric screen printing ink, 4 oz (118.3mL)

Rubber or foam brayer

Rolling pin

Painter's tape, 2" (5cm) wide

Natural cloth dinner napkins

Iron

Decorative borders are created with motifs printed in a specific pattern structure that repeats seamlessly from side to side (if printed horizontally) or top to bottom (if printed vertically). The classic border is the Greek key. The repetition of angled lines, where the line connects to seemingly create one continous motif, is said to represent infinity. This is a craft book so I'll just say using repeating motifs to create a visual border is a quick and quiet way to make prints with balance and symmetry. For it to truly be a border, you need to see the pattern structure.

A roll of packing tape can be used as a stamp mount to create a continuous pattern to decorate napkins and a table runner. This is a great method to stamp a border on a large sheet of paper or fabric quickly. Successive rolls will create gradually lighter effects, giving your print a cool fade. Make sure to place the motifs close together on the roll of tape because large spaces between shapes will receive ink and then print. I prefer using fabric screen printing ink or fabric block printing ink over stamp pads because it's easier to get opaque color and an even coating. While you can stick this roll stamp around your wrist and print it as if you were pressing a bracelet down on the ink and then substrate, I find it easier and faster to just thread a rolling pin though the inside of the tape ring. This allows for faster printing and a more even print because you can keep the pressure constant.

instructions

1. Use pencil on tracing paper to outline template with heavy pencil marks.

2. Turn tracing paper onto craft foam and rub design with your thumbnail to transfer it. **(a)**

3. Use scissors to cut out shapes and hole punch to create dots.

4. Peel adhesive backing from foam shapes and attach them to the outside of the tape roll. **(b)**

5. Squirt a 5" (12.5cm) strip of ink along top of inking plate.

6. Roll out ink. **(c)**

7. Slide rolling pin through tape roll and roll stamp through ink. Pick up rolling pin and run tape roll through ink again until stamp is evenly coated. **(d)**

8. Place strips of painter's tape around the four edges of the napkin. Place inked stamp on bottom left of napkin and use rolling pin to stamp image. **(e)**

9. Re-ink stamp and place it next to the row you just printed. Continue inking and printing with stamp until the napkin is covered. **(f)** Or you can stamp a border only. **(g)**

10. Remove tape and heat-set your fabric with an iron.

a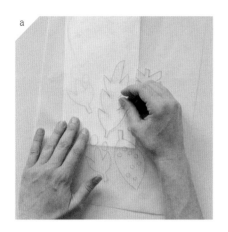

b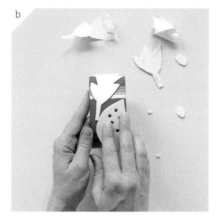

c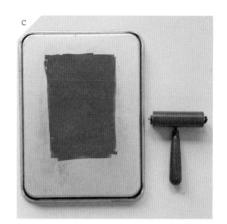

d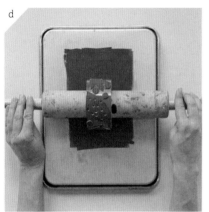

e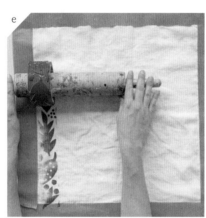

f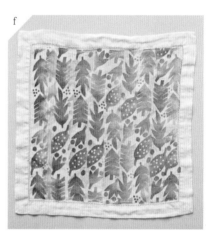

g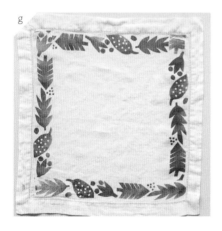

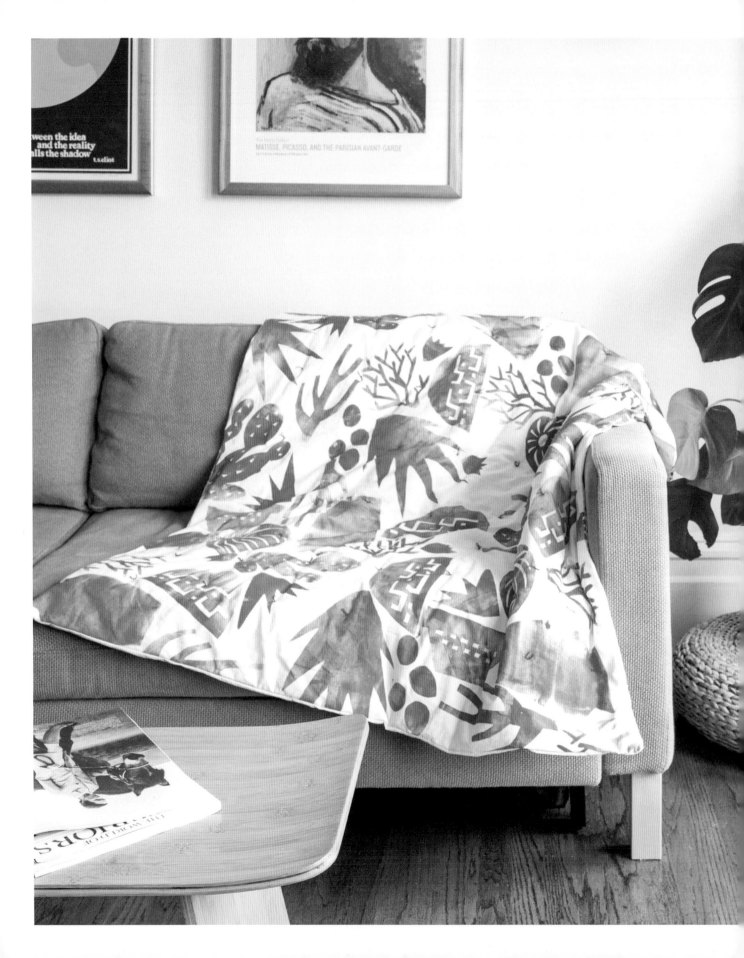

flora & fau

Nothing has provided more fodder than the beauty of nature. Flowers, animals, insects, and plants have served as points of inspiration across different cultures and varying art forms for millennia, though they can take on different meanings in separate cultures. Look no further than flowers. Red roses from a suitor are a sign of love in both Japan and the United States. But if someone gives you a yellow carnation in Japan, it means rejection. Where I live, it probably just means he didn't plan ahead and scooped up the dregs from the corner store.

The benefit of designing and printing using natural motifs is that you get to determine what these elements mean to you and can print to suit your own tastes. Look around and cull inspiration—there's a lot to see in the many colors, textures, and shapes of our natural world.

shoji blinds

1 hour

DIFFICULTY: ● ● ○ ○

LEARN: How to decoupage on paper

REMIX: Use this technique to decorate a lamp shade or a glass surface that has been prepared with Mod Podge; use these templates to make a Carve-a-Stamp (page 49) for fun wrapping paper, fabric, or cards

MATERIALS

Tissue paper, 18" × 24" (45.5cm × 61cm), colors and quantity as desired

Scrap paper

Bone folder (optional)

Spray adhesive

Clear acrylic UV spray

Template (page 161)

Black permanent marker

Scissors

Shoji blinds, in desired size and quantity

Adhesive plastic hooks that will take the weight of the blinds (capacity is listed on the package)

When we first moved into our current house, I scoured the Internet for weeks, looking for blinds that gave me privacy while allowing the sun to shine in. I was thrilled when I came across shoji blinds (also called rice paper blinds, Japanese shades, and paper blinds), which are so inexpensive and defuse light beautifully. After a few weeks, though, I wanted a way to give them personality. As these blinds are in our kitchen, I was inspired by varying colors and shapes of fruits. Wanting to maintain the transparency of shoji blinds, I decided that tissue paper would be opaque enough to be seen in daylight while still allowing light through. The adhesive spray strengthens the thin, pliable tissue for drawing and cutting and the UV spray protects it from fading in the sunlight.

If you prefer an opaque shade or need a window covering for a high-moisture area, you could use the same technique with a bamboo screen. These blinds are available in a variety of widths and lengths. The blinds should be wider than the window, or use two shades if your window is extra wide. I used 48" × 72" (122cm × 183cm) blinds.

instructions

1. Lay a single sheet of tissue paper over scrap paper with the long side closest to your body. Fold the left side to the right side like a book. Crease with thumbnail or bone folder.

2. Unfold sheet and apply a thin, even coat of spray adhesive and fold sticky sides together. Smooth with your hands to make two-ply tissue.

3. Spray one side of the folded tissue paper with a thin coat of UV spray. Set aside for 5–10 minutes to dry. Flip tissue over, spray other side, and set aside for another 5–10 minutes.

4. Repeat steps 1–3 with the other colors until you have the desired number of sheets.

5. Place the tissue over one template and trace it with a permanent marker.

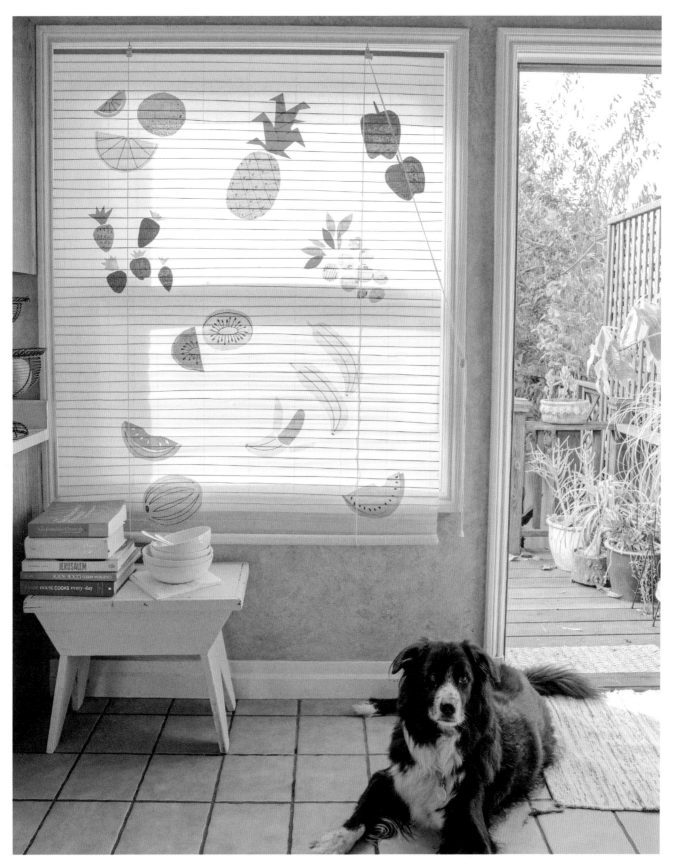

6. Use scissors to cut out the fruit motif.

7. Repeat steps 5–6 with as many fruit motifs as you like.

8. Unroll the blinds onto a flat surface with the lift cord facing up. Place the fruit motifs in position. Move them around to create varying compositions until you land on the placement you like.

9. Remove one fruit motif, flip it over, and place it on a piece of scrap paper. Spray the back side with a light, even coat of adhesive spray.

10. Place one corner of the fruit motif in position while holding other edges up. Use your thumbnail to smooth corner to blinds. Slowly lower rest of motif onto blinds, smoothing tissue over blinds and raised dowels.

11. Repeat steps 9–10 until all fruit motifs are secured in position.

12. Mount blinds to window or wall, according to manufacturer's instructions with fruit motifs facing interior of room. I used Command brand adhesive plastic hooks, which won't damage window frames and can be removed cleanly.

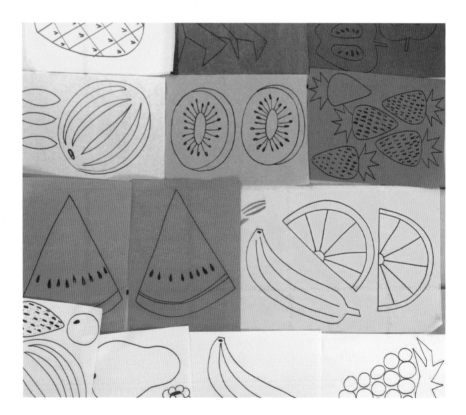

animal tessellation

TIME: 1 hour

DIFFICULTY: ● ● ○ ○

LEARN: How to design, carve, and print a tessellation

REMIX: Use stamps as a border for sheets and pillowcases; use fox template on page 162

MATERIALS

Pencil

2 sheets of tracing paper, each 8½" × 11" (21.5cm × 28cm)

4" × 6" (10cm × 15cm) rubber carving block

Templates (page 162)

Stamp carving tool and multiple gouges

Craft knife

2 all-purpose ink pads in desired colors

Scrap paper

Ruler

Substrate as desired, either paper or fabric

Iron or dryer (optional)

Tessellations are motifs designed to fit together like puzzle pieces. Here we design a stamp with custom contours that, when repeated, completely and neatly covers a printed surface. You could print these in one color, but the motifs pop more if you use more than one ink. I printed these with a half-drop repeat and a brick repeat (as described on page 184) to further differentiate the motifs from one another. Steps 1–5 are the instructions to design your own tessellation, but I have included two templates for your printing pleasure. Technically you could repeat steps 2–5 with all four sides of the stamp, but I find it easier to align for printing when there are two straight sides. The sides, clockwise starting from the top, are A, B, C, and D. These instructions are for a brick repeat. If you would like to do a half-drop repeat, simply draw vertical rather than horizontal lines for your printing grid. Skip to step 6 if you want to use the template provided.

Use these motifs to stamp on any surface you like! I just did these on large sketch paper so I could later cut it down for cards or use it as wrapping paper.

instructions

MAKING THE STAMP

1. Draw a 4" × 6" (10cm × 15cm) rectangle on tracing paper using heavy pencil lines. Repeat on second sheet of tracing paper. These are your two frames.

2. Select one sheet of tracing paper and draw a line near the right edge that connects sides A and C. Go for a simple line without a lot of contours or jagged edges.

3. Place second sheet of tracing paper over first and align the frame. Slide the top tracing paper sheet to the right so the simple line in the bottom sheet is near the left edge of the top sheet but still inside the frame. Sides A and C of both frames should still meet. Trace the simple line again. **(a)**

4. Fill in details of design, using the outside contours as your guide. **(b)**

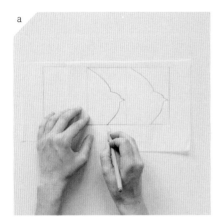

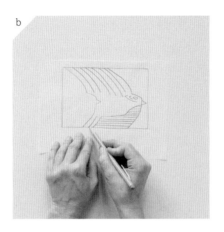

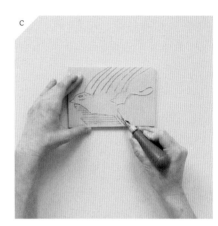

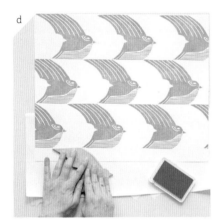

5. Turn design over onto rubber block and align frame of drawing to sides of block. Use your thumbnail to transfer design from tracing paper to block.

6. Use your carving tool to articulate the design (if using the bird motif provided instead of designing your own, see page 162) and outline the shape of the stamp with a narrow V-gouge. **(c)**

7. Use craft knife to cut out shape of stamp.

8. Turn stamp faceup and press ink pad onto the face.

9. Turn stamp over and press down on scrap paper to proof the stamp. Practice stamping on paper.

PRINTING THE TESSELLATION

1. Use ruler and pencil to lightly draw parallel horizontal lines 4" (10cm) apart along the width of substrate. Ink stamp and place it at the top left of substrate. Ink stamp again and place on second line so top left of stamp meets bottom right of first stamped impression.

2. Continue inking and stamping in this checkerboard fashion. **(d)**

3. Select second color and stamp in all the blank spots. **(e)**

4. Heat-set with hot, dry iron on appropriate fabric setting or put in the dryer for one high-heat cycle if printing fabric to be washed.

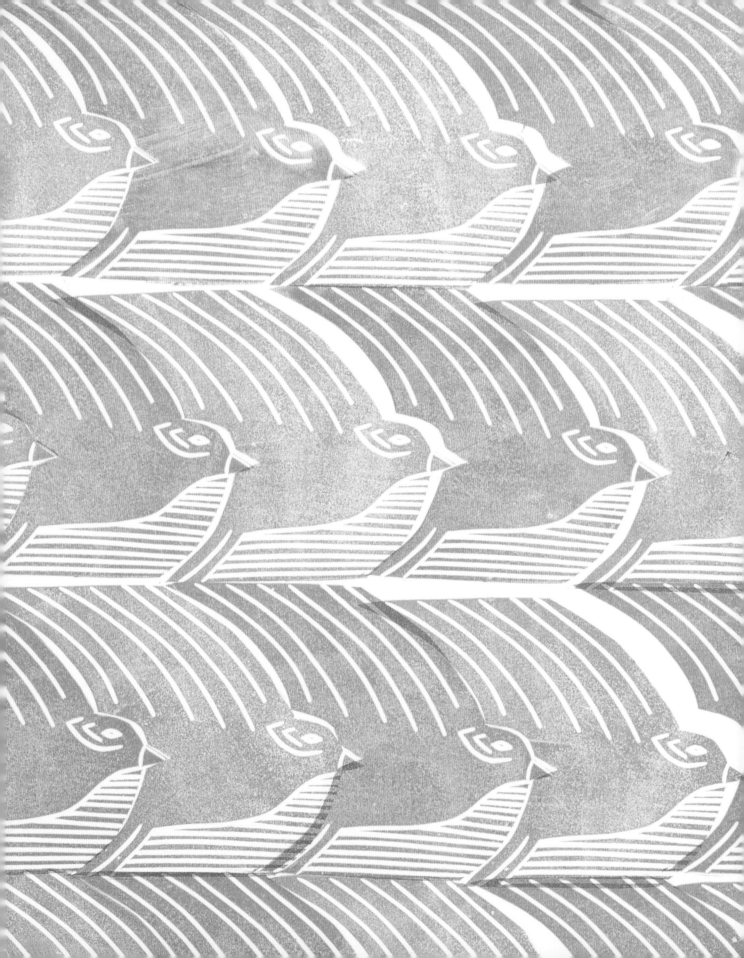

diy iron-on appliqué

TIME: 1 hour

DIFFICULTY: ● ○ ○ ○

LEARN: How to create your own printed appliqué on fabric

REMIX: Use any stamped, stenciled, dyed, or screen-printed cloth for your appliqué; cut out shapes and go crazy

MATERIALS

Iron

4 white cotton fabric pieces, each 8½" × 11" (21.5cm × 28cm)

4 sheets Heat 'n Bond Ultra Hold, each 8½" × 11" (21.5cm × 28cm)

Scanner

Scrap paper

Templates (page 164)

Computer

Inkjet printer, with scanner

Fabric markers, crayons, or pastels

Scissors

Natural cloth item (such as tote or T-shirt)

Appliqué is basically decoupage for fabric and normally requires thread instead of glue. In search of a shortcut, I use an iron instead of thread, making this a quicker and easier project. A smooth, plain weave like muslin or cotton sheeting works best. With a thicker or more textured fabric, you run the risk of jamming in the printer or creating an uneven print. You don't need any special kind of printer here. I just used the cheap inkjet I had at home. The Heat 'n Bond provided the stiffness necessary to run the fabric through the printer. After printing, we use an iron to heat-set the coloring while simultaneously bonding the appliqué to fabric.

instructions

1. Preheat iron to medium heat with no steam.

2. Determine which side of the fabric pieces you want to print on. (For plain-woven fabrics both sides are the same.) Flip it over and place adhesive sheet on top, with papery side facing up. Top with a sheet of scrap paper.

3. Hold the iron in place for 2 seconds until adhesive is firmly bonded to back of fabric. This is the adhesive side.

4. Scan template pages and save files on your computer.

5. Place the fabric with the adhesive side facing down and hand-feed into inkjet printer. Print scanned images.

6. Color in your shapes with fabric markers, crayons, or pastels.

7. Cut out shapes with scissors and place them on desired fabric item. Position scrap paper on top of shapes.

8. Place and hold iron for 6–8 seconds until appliqué is bonded.

desert quilt

TIME: 5 hours

DIFFICULTY: ● ● ● ●

LEARN: How to print large-scale stamps on fabric two ways

REMIX: Use this technique to print large scale on curtains, bed sheets, duvets, pillow covers and sheets, and dining linens.

MATERIALS

Templates (page 163)

Pencil

Tracing paper

8 sheets self-adhesive craft foam, each 8½" × 11" (21.5cm × 28cm)

Scissors

Craft knife (optional)

8 sheets stencil film, each 8½" × 11" (21.5cm × 28cm)

White twin duvet cover, 86" × 64" (218.5cm × 163cm)

Scrap paper

Fabric screen printing inks, 4 oz (118.3mL), in desired colors

Inking plate

Plastic spoon

Rubber or foam brayer

Rolling pin

Detail paintbrushes (sizes can vary)

80/20 twin quilt fusible batting, 72" × 90" (183cm × 229cm)

Iron

Box of straight pins

Spool of white thread

Sewing needle

Washable marker

Ruler

Embroidery needle

Skein of embroidery floss in desired color

Dryer

My basic sewing skills and lack of patience make me a poor candidate for traditional quilting, so I worked up this project. Consider this a rules-busting hack that makes a cool printed/quilted throw with 80 percent of the labor removed. I found this twin duvet cover at Ikea, and it was actually cheaper than the fabric yardage I would buy to make the usual 50" × 60" (127cm × 152.5cm) throw blanket. The duvet cover measured 86" × 64" (218.5cm × 163cm), so I cut it down to a length of 50" (127cm), removing the end with the opening, which left me with three finished seams. I chose fusible batting with a composition of 80/20 (80 percent cotton and 20 percent polyester) in a standard twin 72" × 90" (183cm × 229cm) quilt size and trimmed it down to fit. This new product bastes (adheres) the batting inside your quilt sandwich with heat and steam from the iron. The heat from the iron also heat-sets the print so it's a two-for-one, but I tossed my finished quilt in the dryer for one high-heat cycle just to make sure the ink was set. I used the back of a clean baking sheet as my inking plate so I could easily wipe it down in the sink. Match the color of embroidery floss according to the color of ink you are using or use a white floss to disguise it. Feel free to skip the quilting portion and just use your existing duvet!

I used large stamps in two different ways for this project. I decorated the first side of my quilt with single-color stamps that I inked with a brayer and placed close together. The uniform color lets the essential shapes of the stamps pop, and because I rotated the stamps it is a multi-directional print. For the second side of my quilt I painted the stamps to create monoprints with multiple colors. This way I got a more realistic look for the plants. I stamped them all in the same orientation for a unidirectional print. Because this side was jammed with color, I let the negative space (the space between motifs) serve as a resting place for the eye.

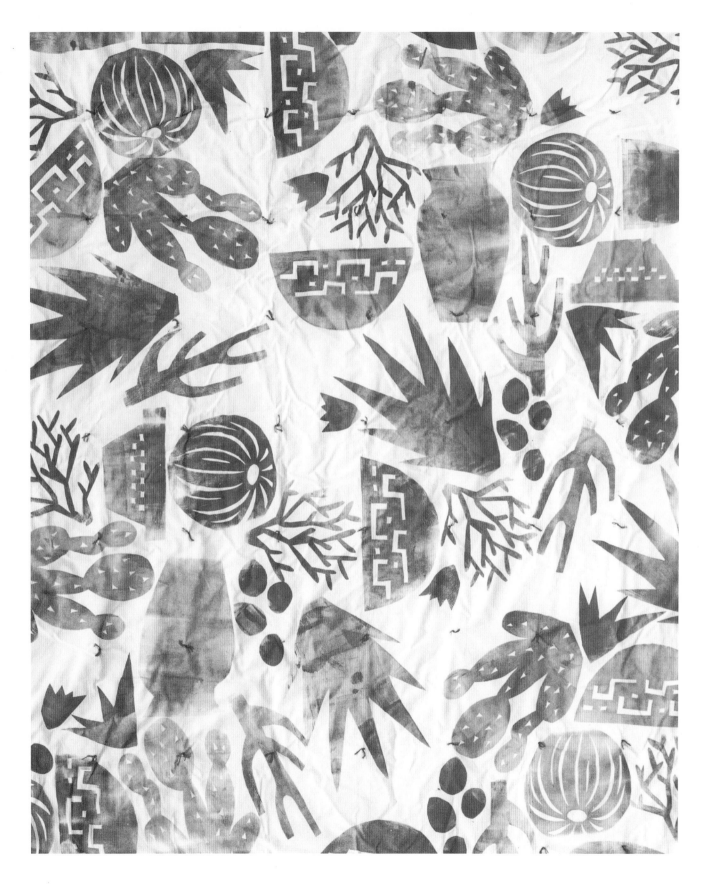

instructions

MAKING THE STAMPS

1. Trace templates with pencil onto tracing paper, making sure to create heavy pencil lines.

2. Turn tracing paper over, place it on craft foam, and burnish lines with your thumbnail to transfer the graphite to the foam.

3. Use scissors or a craft knife to cut out stamp shapes.

4. Peel off adhesive backing from stamps and place each on stencil film.

5. Use scissors to cut a 1" (2.5cm) border around each stamp. **(a)**

STAMPING THE SINGLE-COLOR SIDE

1. Place scrap paper between the layers of the duvet and smooth it out flat on a large printing surface.

2. Drip two heaping spoonfuls of ink on inking plate and roll ink around with brayer until plate is evenly coated.

3. Roll ink onto a stamp until it has an even coat. **(b)**

4. Place inked stamp in desired position on duvet and use rolling pin to press stamp onto fabric. It's helpful to have an extra set of hands to hold stamp in position while you print. **(c)**

5. Peel a portion of the stamp up to see if it transferred adequately. If not, place it back in position and press again with rolling pin.

6. Ink stamp again. Turn inked stamp to a different angle, place in a new position, and stamp again. (I rotated my stamps in every direction to make a multidirectional pattern.)

7. Repeat steps 3–5 with all stamps until fabric is covered. Set fabric aside to dry while you clean stamps with a sponge and warm dishwater.

8. Once fabric has dried (usually less than an hour), remove scrap paper from inside the duvet.

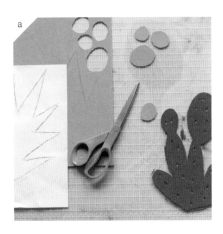
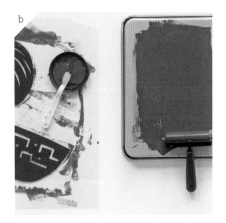
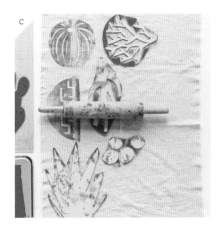

STAMPING THE MONOPRINT MULTICOLOR SIDE

1. Insert fresh scrap paper between the two layers of the duvet, and lay it flat on a large printing surface.

2. Put dollops of screen printing ink into the lid of the ink bottle or mix your own inks.

3. Select a stamp and use detail brushes to paint the stamp in any pattern you like. You can even use multiple colors!

4. Position the stamp onto the surface of the fabric and use a rolling pin to print.

5. Repeat steps 2–4 until you achieve desired effect and set to dry. **(d)**

6. Remove the scrap paper and heat-set according to ink instructions.

FINISHING THE QUILT

1. Lay batting flat on the ground and use scissors to cut the batting to 48" × 62" (122cm × 157.5cm).

2. Turn duvet cover inside out and place centered over batting. Because the batting is slightly smaller than the duvet cover, the duvet cover will drape over the corners evenly.

3. Set iron to manufacturer's recommended setting (no steam) and iron to activate the batting adhesive. The heat has to go through both layers of fabric so check and make sure it's working.

4. Turn duvet right side out so the batting is now on the inside. Be careful not to pull or tear the batting out of shape. Repeat ironing as above. Batting is repositionable if you have uneven bumps.

5. Fold the two open edges in 1" (2.5cm) and pin fabric together every 2" (5cm). Thread a sewing needle and use a straight or hidden stitch to sew open end closed.

6. Use washable marker and a ruler to make a grid of small dots spaced 6" (15cm) apart, covering the entire duvet.

7. Thread embroidery needle with embroidery floss.

8. Push needle through all layers and back through to top. Tie in a double knot and trim thread to about ½" (13mm). Repeat until the entire duvet is secured (as shown on page 117).

9. Toss it in the dryer for one high-heat cycle to heat-set the ink.

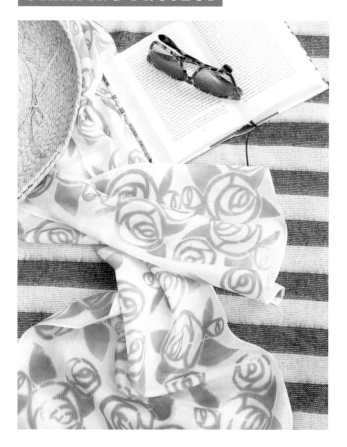

stamped scarf

Looking for something simple and quick? Use a cut foam stamp (mounted to a CD cover like in the Cut-a-Stamp project on page 21) to make a summery, light scarf. Silk is a light fabric so I used weightless all-purpose stamp ink here. Let ink dry completely before handling scarf so it doesn't smudge.

Materials: Cut-a-Stamp; silk scarf; iron; all-purpose ink pad

1. Follow steps 1–5 for Making the Stamps (page 118), using a design of your choice.

2. Wash and iron scarf and lay it flat on work surface.

3. Lay stamp faceup and press ink pad onto the face of the stamp until all the foam has an even coat of ink.

4. Press stamp onto the scarf. Continue inking and rotating stamp to get random pattern on the scarf.

5. Let scarf dry completely and heat-set according to manufacturer's instructions.

travel-inspired patterns

This worldwide tour is all about patterns and motifs inspired by cultures and techniques from around the globe. Oftentimes, these motifs were driven by cultural and historical significance but came to signify a style. I am not going for authenticity here; rather, my interpretation of these styles and methods is to suit the home printmaker. You likely don't have any of the fermented mud required to make mud cloth, so I use a solar dye to achieve the effect with varying vivid colors. The blue and white china project draws from both European and East Asian traditions, but I adapted it for those without decades of guild practice. All of these projects are relatively inexpensive to make, so let's span the globe and get our hands dirty.

shibori dye with indigo

TIME: 2 hours

DIFFICULTY: ● ● ○ ○

LEARN: How to dye with bound or folded fabric

REMIX: Use dyed cloth to make a quilt (page 116) or the *Furoshiki* Wrap projects (page 24); dye your own natural-fiber clothes or table and bed linens

MATERIALS

Plastic tarp

Bucket with lid, 5 gallons (19 liters)

Warm tap water

Indigo dye kit with dye and reducing agents (soda ash and thiox)

Stirrer

Large spoon

Small bowl

Fabric

Rubber gloves (some kits have gloves, but longer dish gloves will protect more of your arms)

Disposable aluminum tray

Wash bucket or washing machine

Mild detergent (optional)

An inexpensive indigo kit allows for many hours of play. You can bind, twist, fold, clamp, and even stitch fabric in an infinite number of ways to get different looks. Be warned: This is a little messy, but, oh man, it is worth it! This is not something you can do in your apartment because it requires an area for the dye vat (bucket) and a place to unfurl and dry the dyed pieces. I ran a clothesline and placed a drop cloth below to catch the errant drips. Do this project outside when the weather is nice.

instructions

1. Lay plastic tarp down so it covers work surface. Fill bucket with 4 gallons (about 15L) of warm tap water. Pour in indigo dye and mix it with a stirrer in a circular motion.

2. Add soda ash and thiox packets slowly into bucket, while stirring. Reverse direction of stirring gently so as not to introduce oxygen into water. Cover bucket with lid and wait 15 minutes to one hour.

3. Remove lid and examine dye. A metallic purple film (called a "bloom" or "flower") should be resting on the surface of the dye, which will be a yellow-green color. Slowly skim off bloom from bucket with a spoon and reserve it in bowl.

4. Soak fabric in water and squeeze out excess moisture. Fold or bind fabric into desired pattern (pages 127–28).

5. Use gloved hands to gently and slowly lower fabric into bucket. Gently massage fabric so dye penetrates all folds.

6. Remove fabric slowly from bucket while gently squeezing out excess dye over bucket. Place fabric on aluminum tray and allow it to sit for about 20 minutes. Use gloved hands to open up any areas you want to expose to air to create blue color.

7. Place cover back on bucket to prevent more air from getting into it.

8. Once fabric has oxidized, you can repeat steps 5–6 to achieve darker blue results for more contrast.

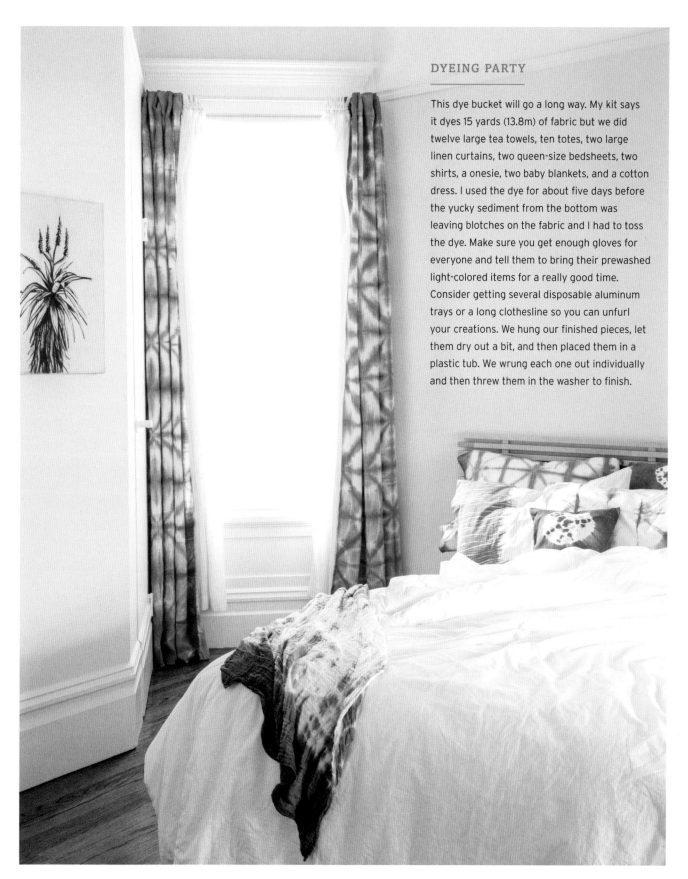

DYEING PARTY

This dye bucket will go a long way. My kit says it dyes 15 yards (13.8m) of fabric but we did twelve large tea towels, ten totes, two large linen curtains, two queen-size bedsheets, two shirts, a onesie, two baby blankets, and a cotton dress. I used the dye for about five days before the yucky sediment from the bottom was leaving blotches on the fabric and I had to toss the dye. Make sure you get enough gloves for everyone and tell them to bring their prewashed light-colored items for a really good time. Consider getting several disposable aluminum trays or a long clothesline so you can unfurl your creations. We hung our finished pieces, let them dry out a bit, and then placed them in a plastic tub. We wrung each one out individually and then threw them in the washer to finish.

PRESERVING YOUR INDIGO DYE

The indigo dye naturally grows a metallic, purple foam (called the "flower" or "bloom") on top of the bucket. This is the indigo compound becoming insoluble again because it is coming into contact with the air. This protective layer needs to be skimmed off or pushed to the side before you dye, but save it! By putting it back on the surface of the vat after dyeing you can prolong the life of the bucket because it protects the dye below from air.

9. Rinse out excess dye in a large bucket filled with water or launder with mild detergent. No rush on this step because dye becomes permanent after being exposed to air.

10. Scoop the flower back onto the surface of bucket when you are finished dyeing and close lid. The dye will keep for several days. When you are ready to dispose of the dye, do not pour it down a storm drain! Dispose as you would house paint. Drop off or arrange pickup by your local waste management company.

 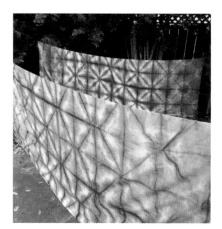

A BIT ABOUT INDIGO DYE

The indigo dyeing process is all about oxygen. The indigo compound itself is insoluble in air. The dye manufacturer takes out the oxygen so the compound can become soluble in water to create a dye vat. We submerge cloth in the vat slowly because adding it quickly or vigorously stirring the dye will reintroduce oxygen, making the indigo compound insoluble again. Once cloth has been soaked in the vat, we remove it and expose the dye to air. Indigo dye becomes permanent by being exposed to the air in a process called oxidation. Areas that get oxygen will turn from yellow-green to deep blue. Areas that don't get oxygen will remain the original color of the fabric. Areas that receive less oxygen or aren't saturated with dye will become lighter in color, but still blue.

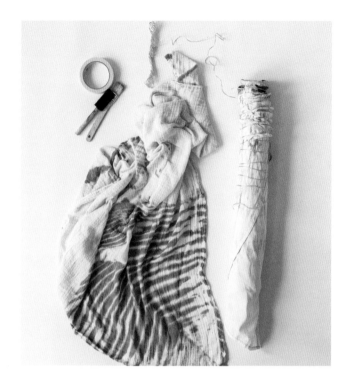

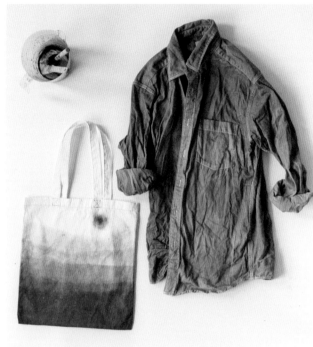

pole wrapping

Named after the Japanese word for "storm," the *arashi* pattern looks like sheets of rain in a downpour.

Additional Materials: Mailing tube, 36" (91cm) long; masking tape; cotton twine

1. Soak fabric in water, then wring. Tape one corner of fabric to mailing tube then wrap it around tube. Tightly knot string at top of tube and tightly wrap it around fabric.

2. Push the fabric every few inches toward the top of the tube to bunch the fabric and string together.

3. Continue wrapping and bunching until the fabric is bunched tightly on tube and tape the end of string to an unexposed portion of tube.

4. Proceed with steps 5–9 from *Shibori* Dye with Indigo project (pages 124–26).

dip dyeing

This method is just as it sounds. You dip fabric in the bucket and gently agitate to make sure cloth is saturated. Stick only one end of fabric in dye and watch dye slowly creep up fabric. This will result in a gorgeous blue gradient from dark to light. Wet cloth with water and squeeze out excess if you want the dye to creep further up the fabric. This will provide more tonal change.

1. Dip cloth into dye.

2. Remove from bucket and hang to oxidize and dry in the same position so dye doesn't run in a different direction.

3. Proceed with step 9 from *Shibori* Dye with Indigo project (page 126).

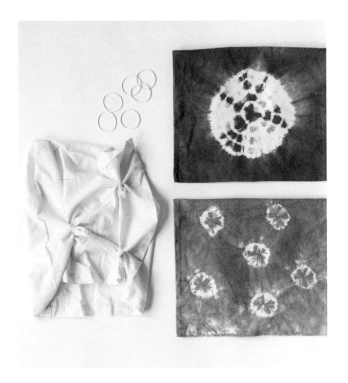

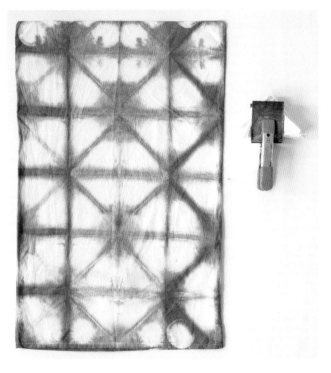

ring shibori

This may look familiar to you, as it's similar to tie-dyeing. Try making small concentric rings, or arrange them in a straight line for a fresh look. I like to dye just the tip or the area below the ring again after the first dye dip to give more contrast. Create small bundles with river stones held inside cloth with rubber bands for another variation.

Additional Materials: Rubber bands; stones (optional)

1. Pinch the prewet fabric where you want to center a ring and loop a rubber band around it. Add more rubber bands (and possibly stones, too), as you like.

2. Proceed with steps 5–9 from *Shibori* Dye with Indigo project (pages 124–26).

board clamping

Here we use the same accordion folding technique from the Dyed *Washi* Paper project (page 15), but clamp folded fabric with rubber bands, or sandwich fabric between boards with spring clamps, to create different resist patterns. Some kits have two small wood pieces for this but you can use chipboard, jar lids, or other rigid objects, as long as you have two matching pieces.

Additional Materials: Metal spring clip or large rubber bands; 2 flat, rigid boards

1. Fold prewet fabric in an accordion pattern as in the Dyed *Washi* Paper project (page 15).

2. Place fabric between the two boards and clamp or secure with rubber bands.

3. Proceed with steps 5–9 from *Shibori* Dye with Indigo project (pages 124–26).

mud cloth pillow

TIME: 2 hours

DIFFICULTY: ● ● ○ ○

LEARN: How to use solar dye with a painted film positive and a pattern painted directly on cloth

REMIX: Print black-and-white photographs onto clear transparency sheets for a photographic look

MATERIALS

2 sheets of clear acetate stencil film, 14" × 19" (35.5cm × 48.5cm)

Template (page 164)

Flat paintbrush, 1/2" (13mm)

Black acrylic paint

Solar dye, 4 oz (118.3mL)

Basin large enough for dye and fabric

Water

Stirrer

2 pieces of white linen or cotton fabric, at least 15" × 20" (38cm × 50cm)

Rubber gloves

Solar wash

Washing machine

Dryer

Iron

Box of straight pins

Sewing needle

Sewing machine (optional)

Spool of thread

Chopstick (optional)

Polyfill or similar, 32 oz (904g)

I love mud cloth, also called "bogolan," for its distinctive geometric patterns. This dye process uses fermented mud to give the cloth rich earth tones, which contrast with the light or white parts of the design. While I love the earthy spectrum of these original cloths, I didn't have any fermented mud and I wanted to play with brighter and more varied colors. Solar dye uses compounds that change color and become permanent when exposed to UV light or sunlight and the liquid evaporates.

I devised this project to play with solar dyes using hand-painting techniques and a film positive. Because the dye is sensitive to evaporation, I placed the wet fabric in between two pieces of acetate film. This allowed the water to evaporate evenly. While the bottom acetate film is optional, it does make for a more consistent-looking print. For the freehand painting you can lose the top acetate film because the painted image will expose evenly. You can order film positive through dye companies Jacquard's and Lumi's apps or you can print your own on a clear transparency sheet if you have a graphics program that allows you to reverse the image from a positive to a negative. I painted my own on a stencil. The acrylic paint provided a brushed texture rather than a solid look, which is more in tune with the spirit of the original mud cloth. Make sure to prewash and iron all items before starting this project because this dye is sensitive to chemicals and stiffeners. If you simply want to dye fabric a color without a printed image, skip to step 2 and expose the fabric to sunlight.

instructions

MAKING THE PRINTS

1. Place acetate stencil film over template and paint design with a brush and black acrylic paint. This is your film positive. Set it aside to dry. **(a)**

2. Go to a dimly lit room and pour three-quarters of the bottle of solar dye into basin and stir in lukewarm tap water. More water will make for a lighter look, while leaving the dye concentrated will make for a stronger

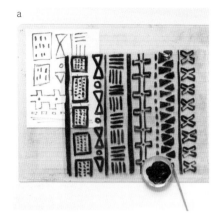
a

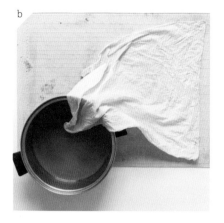
b

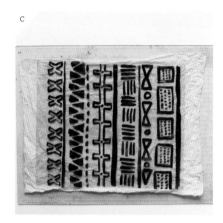
c

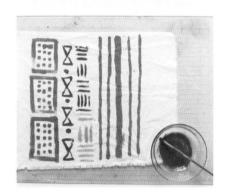
d

printed color. I added just enough water so my fabric could move around freely. Wearing rubber gloves, place *one* piece of fabric in the basin and knead until it's coated in dye. Wring out excess. **(b)**

3. Place fabric on top of blank sheet of acetate film and take into direct sunlight. Quickly place film positive over fabric and press down until it is even with fabric. Expose the image for 10–24 minutes. The back of the film positive will have dye residue. Gently wipe it off before making another print. **(c)**

4. Immediately launder fabric in a washing machine with three capfuls of solar wash. This will stop the dye from exposing, so do this quickly!

5. Dry wet fabric with clothes dryer and iron if there are wrinkles.

6. Place the second piece of fabric on top of the blank sheet of acetate film. In a dimly lit room paint solar dye directly onto fabric. The design can be painted freehand. **(d)** Lay flat in direct sunlight and expose fabric for 10–24 minutes. Then follow laundering instructions in steps 4–5.

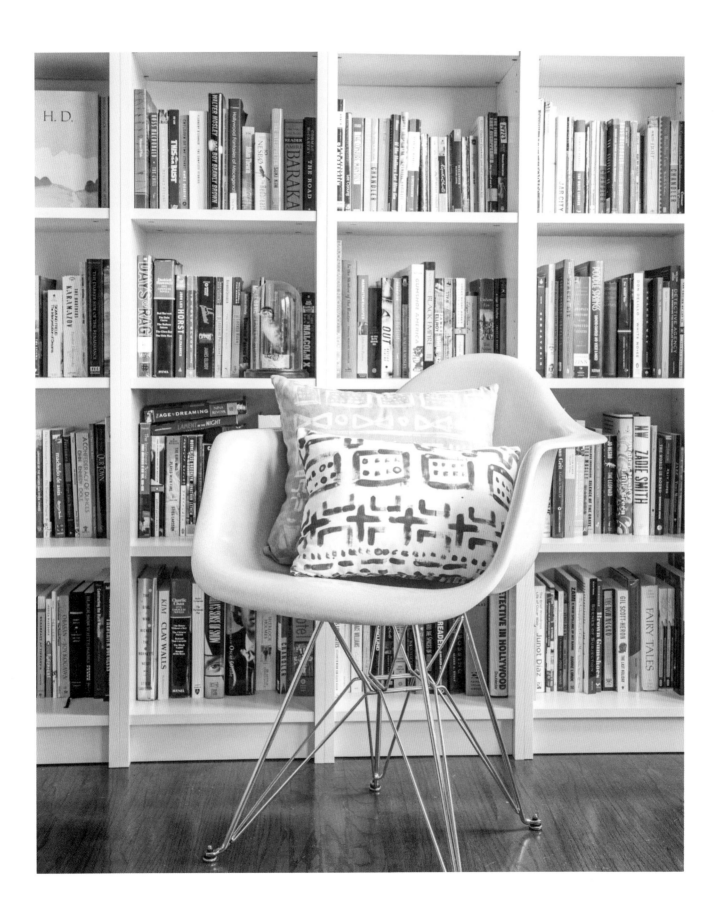

e

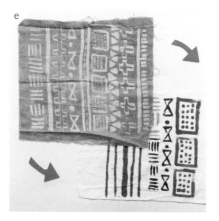

f

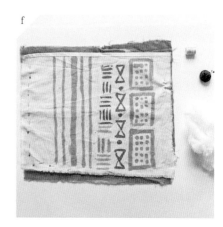

MAKING THE PILLOW

1. Look at your two prints and decide how you want to orient them in relation to each other for the pillow. **(e)**

2. Place one fabric print faceup and the other fabric print facedown so they meet like a sandwich and the edges align.

3. Pin about ¼" (6mm) from the edges, leaving a hand-size gap of about 7" (18cm) in the middle of one of the sides. **(f)**

4. Sew with a straight stitch by hand or use a sewing machine to sew all edges except for the hand-size gap.

5. Turn the pillow cover right side out. Use the small end of a chopstick or your finger to poke the corners out straight.

6. Stuff with handfuls of polyfill until the pillow is full.

7. Sew with a hidden running stitch by passing a threaded needle in and out of both fabric sides. Knot and trim thread.

BUT I HATE SEWING!

I was once like you, friend, and I get it. If sewing isn't your thing, simply deliver the pinned pillow to your local tailor and have him or her stuff and finish it. You can also use a premade pillow cover, but you'll only be able to print one side. In a dark area, dip the pillow cover in dye, quickly insert a piece of cardboard slightly smaller than the pillow cover between the layers, and print as instructed in steps 3–5 on page 130.

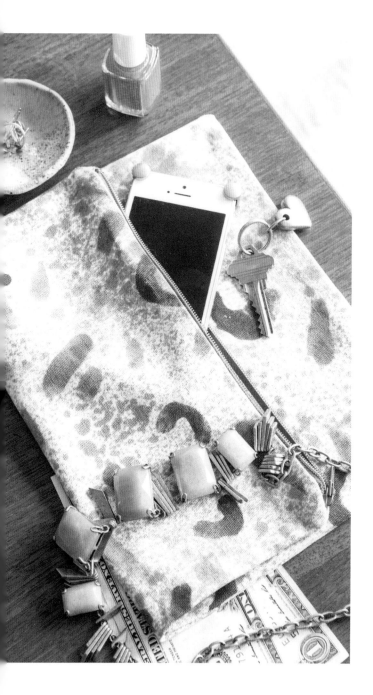

painted bag

A freestyle painted design makes good use of color overlays and different paint applications. If the fabric is thin, insert chipboard cut just slightly smaller than the bag to prevent the dye from bleeding through to the other side. Use this method for a lunch sack, messenger bag, or backpack!

Materials: Measuring tape; zippered bag (made with natural fibers); chipboard; craft knife; fabric pastels; scrap paper; iron

1. Measure bag and cut chipboard to size just small enough to fit snugly between the two layers of cloth.

2. Use fabric pastels to decorate bag as desired. Remove chipboard.

3. Place scrap paper on top of bag and, using an iron, heat-set the design.

4. Repeat step 4 on the other side of the bag.

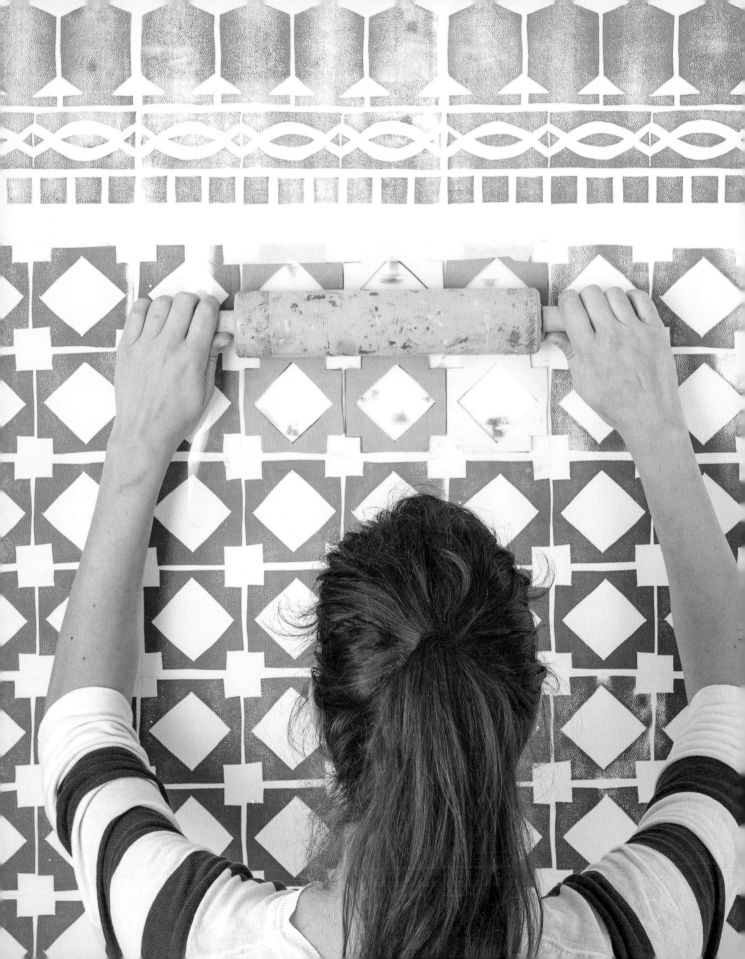

stamped moorish tiles

TIME: 3 hours

DIFFICULTY: ● ● ● ○

LEARN: How to create a large-scale stamp and print on walls

REMIX: Create and print large stamps for walls or large areas of fabric; use templates from Desert Quilt project (page 116) to create a garden room

MATERIALS

Templates A and B (page 165)

Tracing paper

Pencil

Adhesive craft foam, 8¹/₂" × 11" (21.5cm × 28cm)

Cutting mat

Craft knife

Clear stencil film, 8¹/₂" × 11" (21.5cm × 28cm)

Level

Measuring tape

Plastic spoon

Acrylic or latex paint

Inking plate

Rubber or foam brayer, 4" (10cm) wide

Large sheet of scrap paper

Painter's tape

Rolling pin

I love the look of Moroccan tiles and wanted to give a plain room a little dimension by printing images directly onto the wall. While I could stencil, I knew that cutting a stencil with such fine lines in between the shapes would be tricky and paint could easily bleed under the stencil, obscuring those fine lines. Screen printing, on the other hand, wouldn't allow me to get in the corners of the wall. Eventually I settled on this technique because by simply stamping the wall with repeated motifs I could quickly get a tiled look.

After playing around a bit, I found using a rolling pin and acrylic paint, rather than thinner house paint, gave me good coverage while still producing the textured look of a stamp. I opted for a single dark color because the design has a lot of busy elements and leaving the negative space between the tiles pulled the original wall color into the design. Practice printing with a sheet of paper attached to the wall before you begin. The number of tile stamps you print will be determined by the size of your wall. Stamp A creates the top border, and stamp B (which you can repeat as many times as needed) fills in the space below.

instructions

1. Trace templates A and B onto separate pieces of tracing paper with heavy pencil marks.

2. Turn one piece of tracing paper over onto a sheet of craft foam. Rub back of tracing paper with side of your thumbnail to transfer pencil marks to craft foam.

3. Place craft foam on cutting mat and carefully use craft knife to cut out shapes.

4. Turn tracing paper drawing side down and place stencil film over it. Peel paper backing off each craft foam piece and place in position on stencil film.

5. Repeat steps 2–4 to create second stamp.

6. Place a level against the wall in the area you want to decorate and, using a measuring tape and pencil, lightly mark a grid of 8½" × 11" (21.5cm × 28cm) squares. Calculate how many tiles you will print across, up, and down. If the math doesn't work out precisely, you will need to trim the stamps to print the gaps, so map out your grid and plan to print the gap areas last.

7. Place both stamps faceup on a table. Place two heaping spoonfuls of paint on an inking plate and roll brayer up and down until it is evenly coated with paint.

8. Use brayer to roll an even layer of paint onto the face of stamp A.

9. Attach large sheet of scrap paper to wall using painter's tape. This will mask the area you don't want to print. Position stamp A on scrap paper. Hold rolling pin at the top edge of the stencil and firmly roll down with even pressure to create impression. Repeat process on scrap paper until you feel comfortable enough to print on wall.

10. Place stamp A in corner of border area to be printed. Position rolling pin on top edge of stamp and firmly and evenly roll down to create impression. Apply brayer with paint to stamp A again, position stamp left or right of first impression, and repeat process. Continue until you have completed the entire top border.

11. Repeat step 10 with stamp B until until you have printed the remainder of the wall.

12. Remove scrap paper. Erase pencil marks after paint has dried.

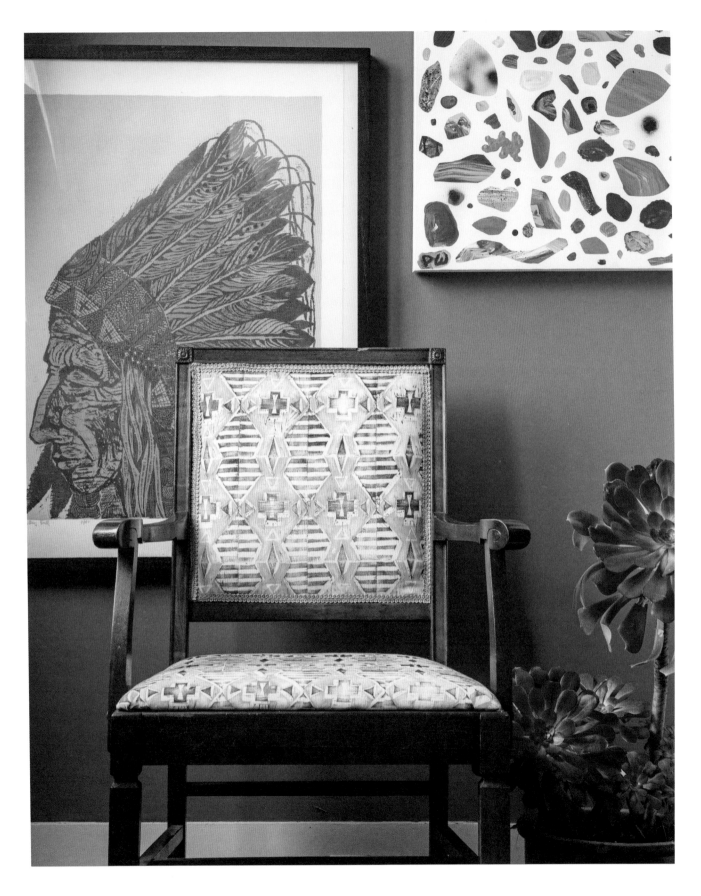

upholstered chair with hand-printed fabric

TIME: 4 hours + drying time

DIFFICULTY: ● ● ● ●

LEARN: How to upholster a chair with printed fabric

REMIX: Use any of the printing, dyeing, or stenciling techniques from this book on the fabric

MATERIALS

Upholstered chair

Needle-nose pliers

Screwdriver

Fabric, dimensions as needed

Scissors

Batting, 1/2" (13mm) thick

Templates A and B (page 166)

Tracing paper

Pencil

Rubber stamp block,
4" × 6" (10cm × 15cm)

Linoleum carving tool with assorted blades

Plastic spoon

Fabric screen printing ink,
4 oz (118.3mL), two colors as desired

Inking plate

Foam brayer, 4" (10cm) wide

Iron

Staple gun

Staples

Gimp, length as needed

Hot glue gun

Hot glue sticks

This project allows you to take cues from your chair's particular shape, style, and scale because we use existing fabric as our pattern. You only print what you need and you print the pattern in the direction you want. We cut the fabric a little larger than we need so you can move the print around for optimal positioning and so there is extra room for stapling. On the chair back we use a woven trim (unfortunately called "gimp") that hides the staples. The original gimp on this chair suited the background color of my printed fabric so I removed it carefully for reuse. Buy new gimp by the yard at a fabric or upholstery store. Just measure and cut according to the original size. I used the batting from the Desert Quilt project on page 116.

This is a riff on Navajo Chief blankets, traditionally printed in two colors in a simple grid pattern. This continuous pattern runs in one direction so make sure you print accordingly. (The print orientation should be the same on the back and the seat unless the pattern is multidirectional.) I initially chose red and black but the strong colors were fighting each other. By making one of the colors a subtle peach, I let the black take center stage. Play around with any color combination that suits your decor, mixing paints and printing on scrap fabric to test it out. While you could use all-purpose ink pads or fabric block printing ink, I chose a fabric screen printing ink for a more opaque print. That paint also allows me to mix the exact colors I want, which is impossible with ink pads and hard with fabric block printing ink. I went with a tight twill fabric because it will wear well and won't stretch during use (which can cause bubbles in the ink). Twill (think denim) has visible diagonals on one side. I knew these might affect my print, so I turned it over and printed on the side that looks like a plain weave. Remember to prewash the fabric to get rid of conditioners and allow it to shrink a bit. The best part about this project is that you can truly make it your own. Use any other form of printing in this book or even store-bought fabric. And there's no shame if you print the fabric and hand it over to a professional to upholster.

CHOOSING THE BEST FABRIC FOR UPHOLSTERY

When deciding what fabric to print on, it's good to consider what kind of use it will get and how often. Always look for fabrics without stretch because they will leave wrinkles on the finished piece and will distort your pattern. Here's a rundown of commonly used fabrics.

COTTON Good for most areas, even those with kids and pets. Look for high thread counts and tight weaves because they are more durable and easier to clean. I like to use the back of twill fabric because it has a tight weave that is good for repelling and cleaning up stains.

LINEN Good for accent pieces or formal rooms, but not good for dining areas that might see stains or living areas that will receive heavy use. Wrinkles easily. Likely requires professional cleaning.

SILK This delicate fabric will have to be professionally cleaned and is suited for light wear only.

instructions

PREPARING CHAIR AND CUTTING FABRIC

1. Remove fabric and gimp or trim from chair back. Reserve for later use or measure for replacements and discard. Remove staples or attaching fabric and batting from chair back, using pliers as needed. **(a)**

2. Unscrew padded seat from frame and remove staples, fabric, and batting from bottom of seat. **(b)**

3. Lay existing fabric for seat and chair back over unprinted new fabric. Use old fabric as templates, adding at least 1" (2.5cm) to each side. Cut new fabric pieces. **(c)**

4. Lay existing fabric for seat and seat back over batting and use as templates, cutting exactly around on each side. **(d)**

PICKING YOUR
CHAIR AND FABRIC

The hardest part about this project is picking the furniture you want to reupholster. While eBay is my savior, my muse, and my addiction, I highly recommend seeing the item in person before you buy. Sit in it. Make sure it is solidly made, doesn't creak, and is free from springs that might stick into your bum. Those repairs will be costly and not worth your time. Smell it, and if you detect any mildew or pet weirdness, move on. Look for simple shapes. Items with rounded corners, curves, or puffy cushions will be a challenge.

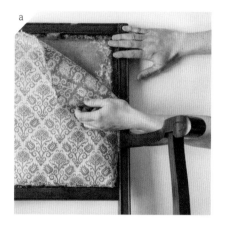
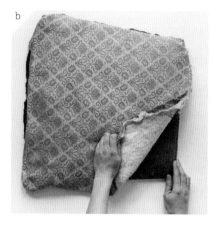
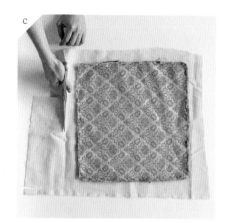
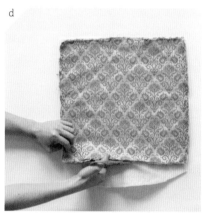
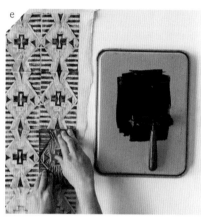
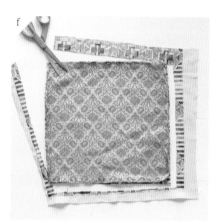

PRINTING THE FABRIC

1. Follow steps 1–4 from the Carve-a-Stamp project on page 49, and trace, transfer, and carve templates A and B onto opposing sides of rubber stamp block.

2. Lay fabric pieces on flat surface. Using spoon, scoop first ink onto inking plate, roll with brayer, and coat first stamp. Print stamp A in a grid pattern on each piece of fabric and allow to dry.

3. Clean stamp, inking plate, and brayer. Using spoon, scoop second ink onto inking plate, roll with brayer, and coat second stamp. Print stamp B in a grid pattern on each piece of fabric and allow to dry. **(e)**

4. Heat-set with iron.

g

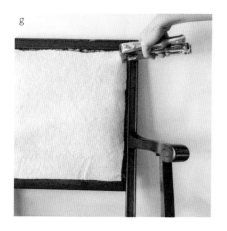

h

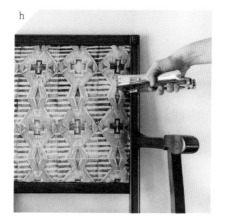

i

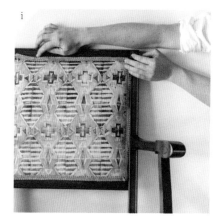

j

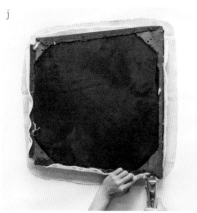

k

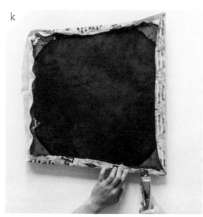

REASSEMBLING THE CHAIR

1. Lay original fabric pieces over printed fabric and cut to specified size. **(f)**

2. Take chair back batting and fasten it in position with a staple every 2" (5cm). **(g)**

3. Place printed chair back fabric in position and place staples every 1" (2.5cm). **(h)**

4. Use hot glue gun to secure gimp to seat back over the staples. **(i)**

5. Stretch batting over seat cushion and staple every 2" (5cm) along the edge of the back side and in the corners. **(j)**

6. Stretch fabric over seat cushion and staple every 1" (2.5cm) and on either side of corners. **(k)** Screw seat cushion back into place.

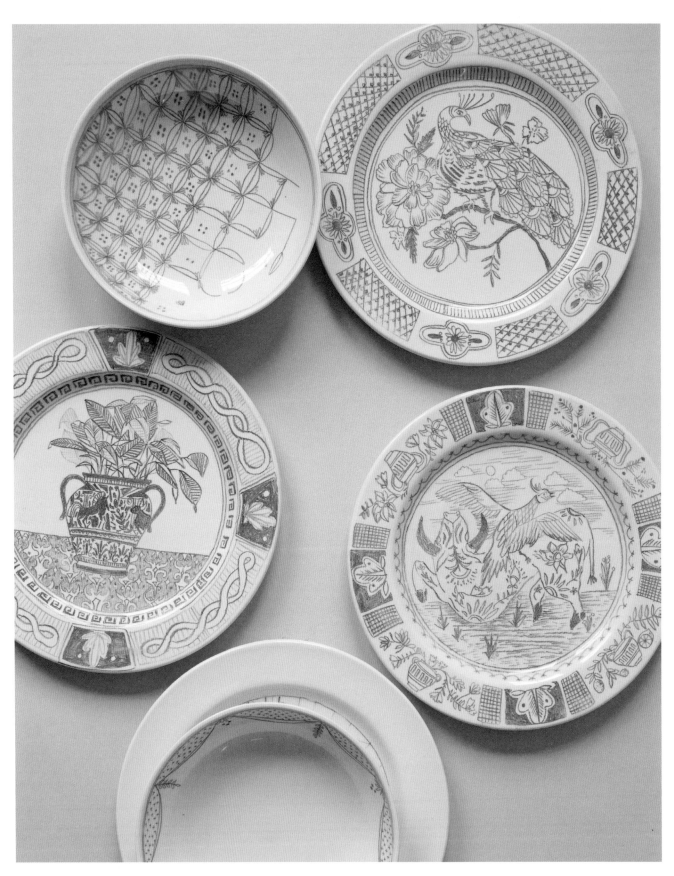

diy delftware

TIME: 1 hour

DIFFICULTY: ● ● ○ ○

LEARN: How to transfer graphics to ceramics and glass

REMIX: Use this transfer technique on finished ceramics or terra-cotta pots, but use glass paint, which heat-sets in the oven (see Très Bien Bathroom Set on page 83), for decorative use

MATERIALS

Templates A, B, and C (page 167)

Tracing paper

Permanent marker

Saral transfer paper

Scissors

Drafting or painter's tape

Plates, as many as desired

Colored pencil

Underglaze pencil

Delftware is blue and white china made in the Netherlands that was popular in the seventeenth and eighteenth centuries. I love the restrained palette and how motifs from Japan and China mingle with European ones. The restricted palette, symmetry, and repetition of marks make for awesome compositions. These designs look complicated, and in a way they are, but the busy-ness of the composition and the mark of your hand (even the mistakes) will just add to the charm. I find it's easiest to make this project using plates with a flat rim. I used an 11" (28cm) dinner plate with a 2" (5cm) rim. Use a scanner to scale motifs down or up as needed. You can start this project at home or, for an even easier time, head to your local paint-your-own pottery studio, where they will sell you the bisqueware, provide glazes, and fire your finished pieces in a kiln. After transferring the design you can paint it with underglazes, but I like the fine-line quality of underglaze pencils. It is essential to use red Saral transfer paper because the marks will disappear in the high heat of the kiln.

instructions

1. Trace templates onto tracing paper with permanent marker. **(a)**

2. Place tracing paper over Saral transfer paper and cut out with scissors, leaving at least ⅜" (1cm) margin on all sides. **(b)**

3. Place small pieces of tape to adhere template A (central motif) and the transfer paper to well of plate. Go over lines of template with colored pencil to transfer template to well of plate. **(c)**

4. Remove transfer paper, template, and tape. Trace design on plate with underglaze pencil. **(d)**

5. Place template B (rosette motif) and transfer paper at 12, 3, 6, and 9 o'clock and tape in place. **(e)**

6. Tape template C (grid motif) and transfer paper in spaces between rosettes. Trace rosette and grid designs on plate with colored pencil. **(f)**

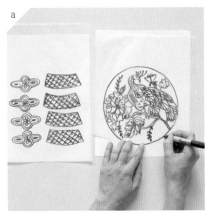

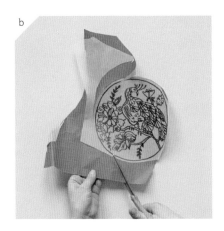

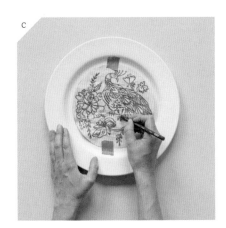

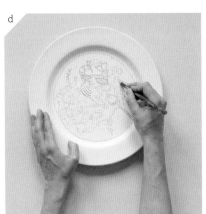

7. Remove transfer paper, template, and tape. Trace rosettes and grids with underglaze pencil.

8. Do not stack plates or rub underglaze marks off. Have plates glazed and fired at your local paint-your-own pottery studio.

glass marker plate

Here is an easy way to make a decorative plate without a ceramic studio (see Très Bien Bathroom Set on page 83 for more ceramic and glass decorating ideas). I first drew this design freehand but feel free to use your own designs or scale any template from this book!

Additional Materials: Glazed glass markers

1. Follow steps 1–2 from DIY Delftware project (page 143) to draw and trace design onto tracing paper and cut transfer paper to size slightly larger than the design.

2. Use tape to secure template and transfer paper onto a glass plate and outline the design with pen or pencil to transfer the marks to the finished plate.

3. Redraw traced design with glazed glass markers.

4. Heat-set plate in oven according to manufacturer's instructions.

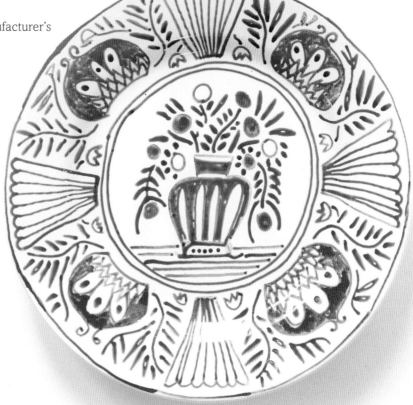

cut-a-stamp page 21

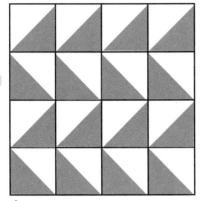

A enlarge 200%

B enlarge 200%

C enlarge 200%

at 100%

D

cork wall page 30
enlarge 200%

enlarge 150%

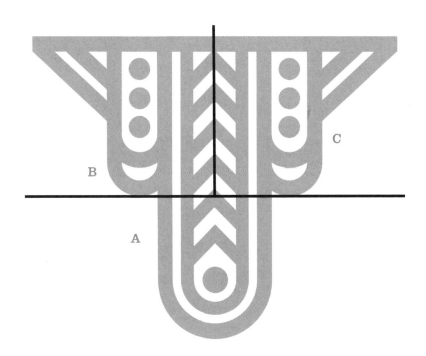

B+C

carve-a-stamp page 49
at 100%

enlarge 150%

message board page 52
at 100%

MARKET LIST

A

B

RECIPE

C

image transfer page 66
at 100%

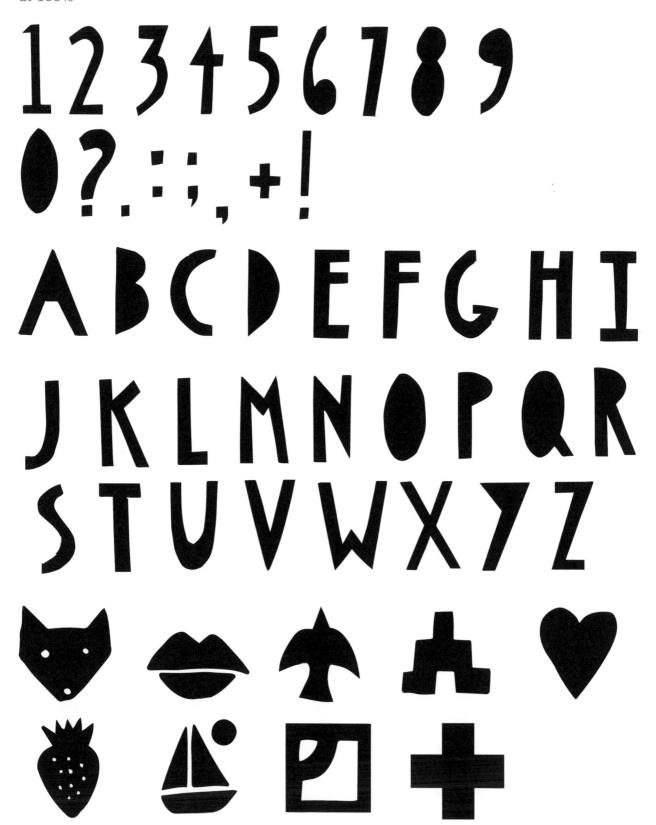

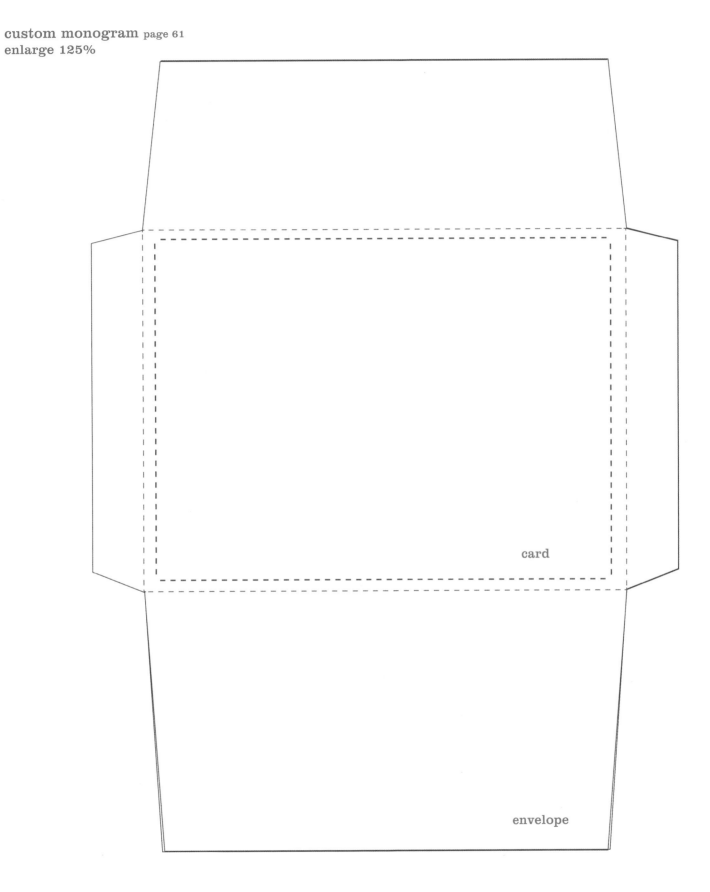

card

envelope

team t-shirts page 67
enlarge 250%

logo stamps page 77
at 100%

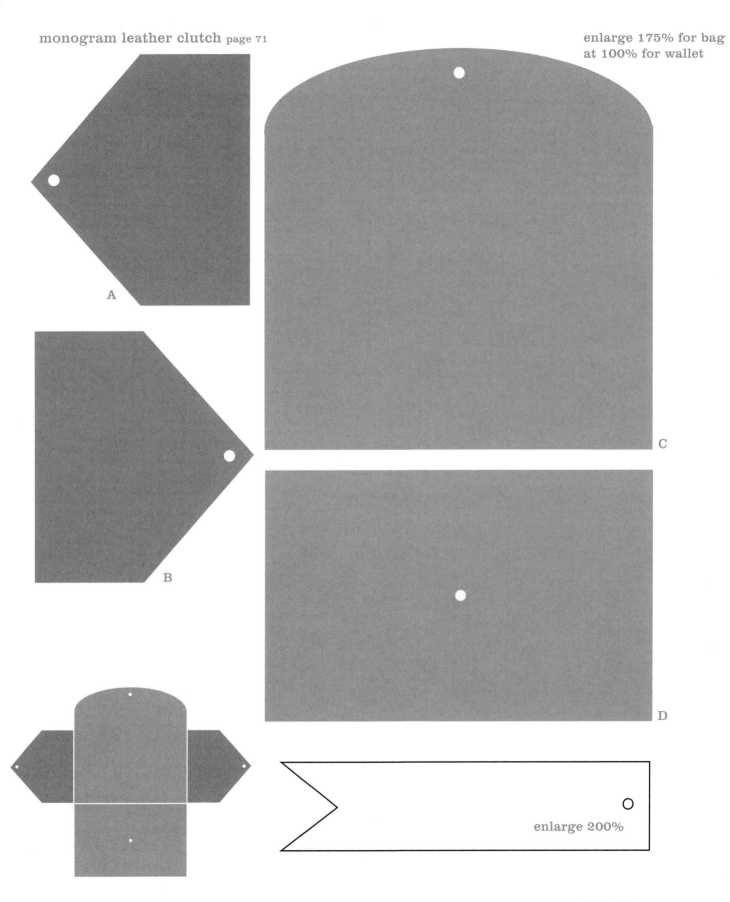

A

B

C

D

enlarge 200%

papel picado print page 80
enlarge 125%

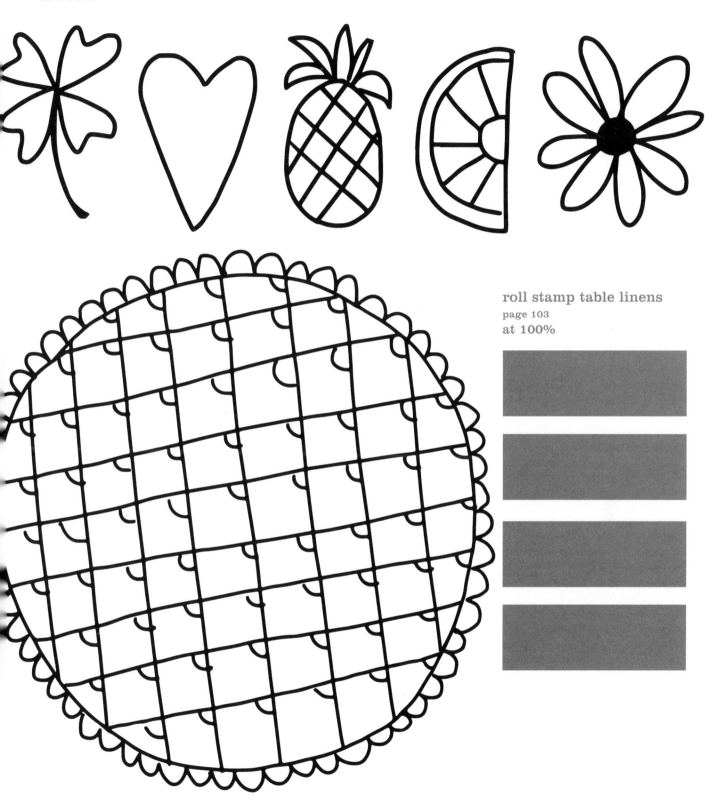

roll stamp table linens
page 103
at 100%

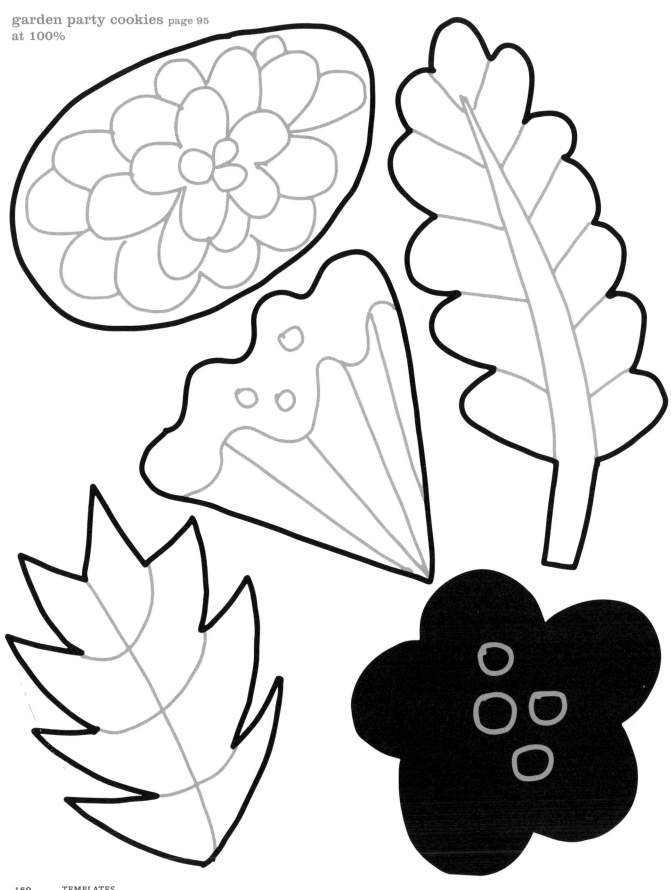

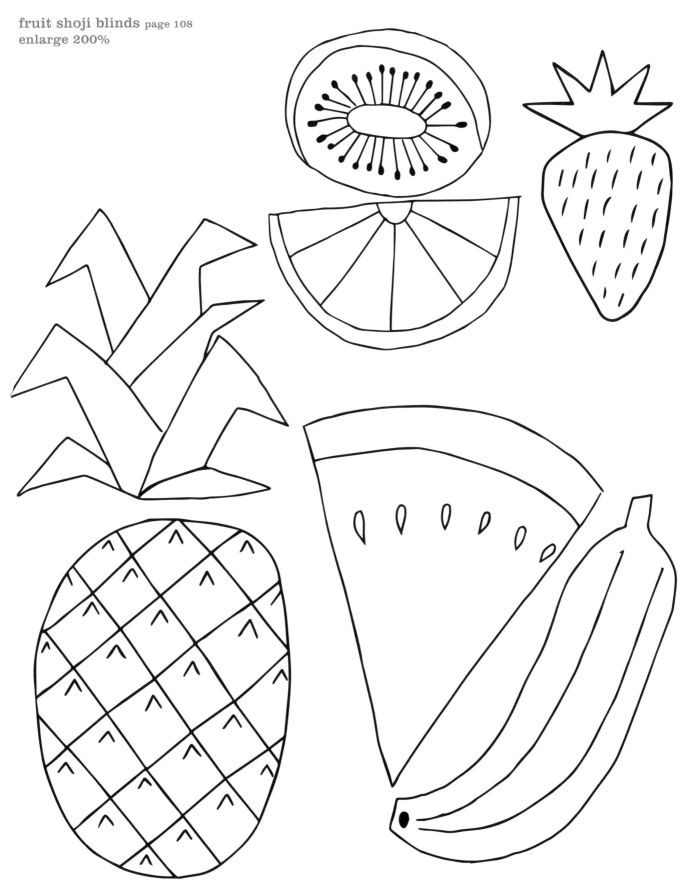

MAISON DE

LE COTON

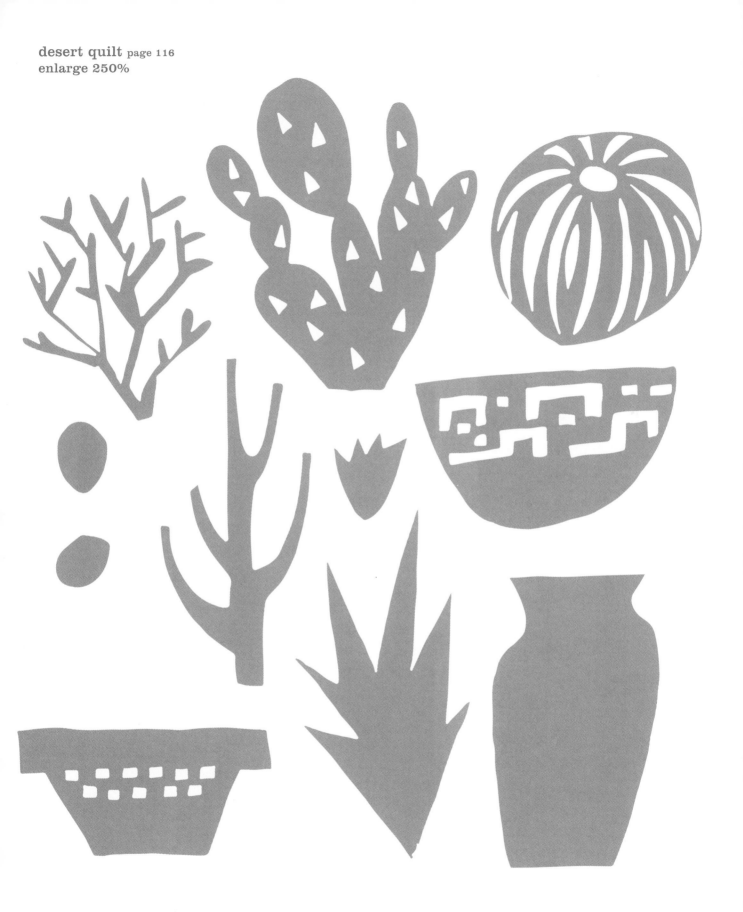

diy iron-on appliqué page 115
at 100%

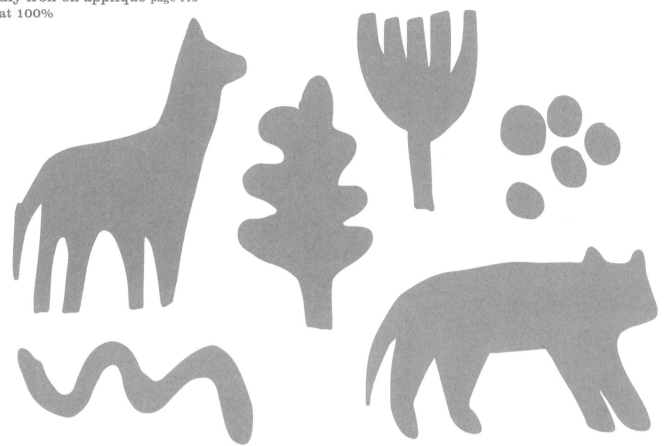

mud cloth pillow page 129
enlarge 325%

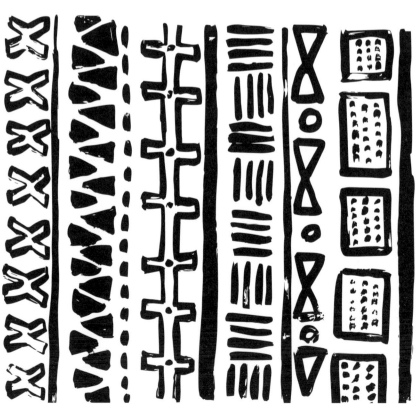

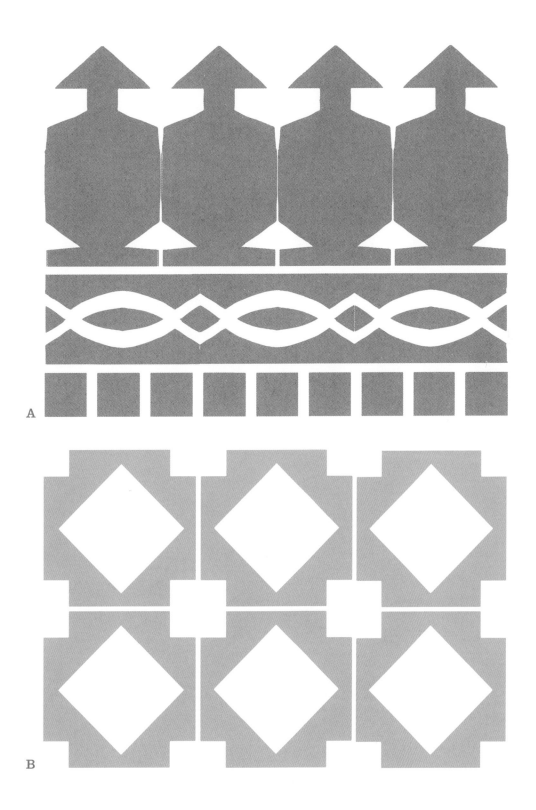

A

B

A

B

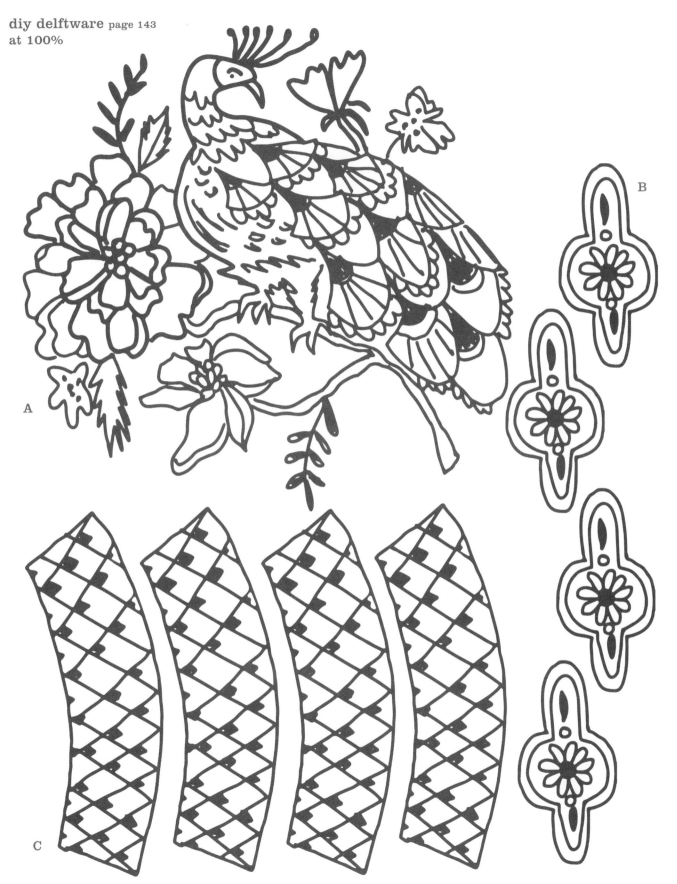

A

B

C

APPENDIX A: SUPPLIES BY TECHNIQUE

block printing materials

With block printing, you ink the raised portion of the block (called the "relief") and then either press it onto the printing surface or place the printing surface over the block to create a print. This accessible and versatile type of printmaking is one of the oldest art forms. Wood was the traditional choice of block, but, after the invention of linoleum in the nineteenth century, this inexpensive hard floor covering made its way into the art studio. While wood and linoleum are still tremendous blocks that can provide excellent detail, the rigidity of the material makes them challenging to carve. In this book we use contemporary products, like foam and rubber stamp blocks, to create prints in various sizes on many different materials.

CRAFT FOAM These sheets, usually made of EVA foam about 5mm in depth, are good for cutting shapes for stamping. Low-detail shapes are preferable. I use self-adhesive craft foam to mount it quickly to blocks, but if you can't find that, try double-sided tape or glue to attach the foam to the mount.

CLASSIC RUBBER STAMPS Traditional store-bought stamps are made by pouring liquid rubber into a mold, like water in an ice tray. This process allows for very fine detail but must be done by a pro and in great quantity.

CLEAR STAMPS A newcomer on the scene, these stamps are made with a clear photopolymer and are the favorites of scrapbookers. These are manufactured to stick to clear acrylic mounts so you can see exactly where you are printing. Clear stamps attach to the mount with static cling, rather than adhesive, so you can easily swap out stamps. I am starting to work more with these because the quality has improved over the last few years.

CUSTOM-ETCHED STAMPS Some companies will take your artwork and etch the design into your stamps. This is done with laser engraving that carves the design into the block and is perfect for small stamps that require text (like address stamps). For having these stamps made, see Resources on page 188.

RUBBER BLOCKS This soft and pliable material is what would happen if an eraser had a baby with a pancake. It carves like butter but is not good for fine detail (like small text). I recommend Speedball Speedy Carve, Yellow Owl stamp sheets, or MOO carving blocks. Traditionally wood or linoleum was used as a relief block, but rubber blocks are easier and safer to carve and can print reliably.

MOUNTS Generally wood or clear acrylic is used to provide a solid backing for rubber stamps. Professionally made mounts have finger grooves on two opposing sides for easier printing. Any rigid material that you can adhere the stamp to will work as a mount, but consider the technique, materials, and scale of the project. Clear plastic or acrylic mounts allow you to see exactly where the stamp is mounted. Poke around your house and you can find many suitable stamp mounts, such as kid's building blocks, scrap wood, plastic bottle caps, CD covers, tape rolls, and acetate sheets.

CARVE-A-STAMP I invented this kit, which includes carving tools, an all-purpose ink pad, and a ton of templates. It also has two rubber blocks already attached to either side of a wood mount with finger grooves. Mounting the rubber to the top of a block makes it easier to print accurately as well as safer to carve (when your hands are holding the block they are below the path of the carving knife).

SUPER GLUE For attaching the rubber blocks to the mount. Use in a well-ventilated area, and wear gloves because it is such a pain to get off your hands.

CARVING KNIFE Also called linoleum cutters (or lino cutters), these have a handle that fits a series of blades and "gouges." Each gouge is either U- or V-shaped and cuts different widths of lines. Wider blades will cut wider lines. Use the smallest V-shaped gouge for detail work, and a wider gouge to quickly clear out large areas you don't want to print. You just want to take off the top layer (like peeling a carrot), not dig into the material. Hold the tool with your dominant hand and secure the block with the other hand. A slighter angle will make a shallower cut while a steeper angle will make a deeper cut. I usually hold the carving knife at about a 30-degree angle. Rotate the block instead of the knife to create curved cuts.

DYE STAMP INK This ink is made of dye and is good for paper only. The type found in office supply stores provides a transparent color and is usually inferior to those stocked in art stores. Look for archival or acid-free formulas that are fade-proof. If working with rugrats, look for nontoxic, washable dye ink pads.

PIGMENT STAMP INK These use pigments suspended in a water-based solution, rather than dyes, to create richer colors and a longer working time. These stamps are particularly appropriate for metallic looks and stamped embossing. Good for paper only.

ALL-PURPOSE STAMP INK These inks are made with both pigments and dyes. This versatile type of pad will

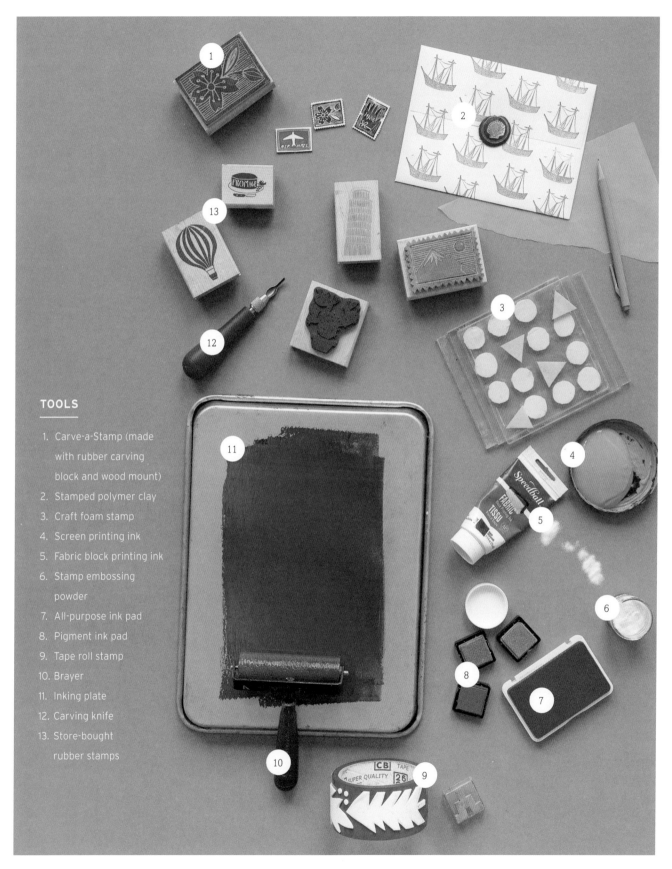

TOOLS

1. Carve-a-Stamp (made with rubber carving block and wood mount)
2. Stamped polymer clay
3. Craft foam stamp
4. Screen printing ink
5. Fabric block printing ink
6. Stamp embossing powder
7. All-purpose ink pad
8. Pigment ink pad
9. Tape roll stamp
10. Brayer
11. Inking plate
12. Carving knife
13. Store-bought rubber stamps

print on many surfaces, like paper, wood, clay, polymer clay, and fabric. Heat-set with an iron, stick in a hot dryer for a cycle, or allow to dry for at least 72 hours. Works best on finely woven, naturally light-colored fabrics. If you can buy only one type of ink pad, this is the way to go.

BLOCK PRINTING INK This ink comes in a tube and is rolled out on a flat surface with a rubber brayer. The ink is viscous and adheres nicely to blocks. Speedball now makes this ink for printing on paper and fabric. It is made of water-immiscible oil so it can be washed off with soap and water (no smelly, dangerous solvents required). Does not require heat-setting so it works for synthetic fabrics, though you do have to wait at least a week for it to dry. I was psyched to try this product, but it is pricey, smells a little weird, and colors are limited.

SCREEN PRINTING INK This is my favorite ink for stamping on fabric

because it delivers more opaque color than all-purpose ink pads. Roll onto a stamp or block with a rubber or foam brayer. Not ideal for store-bought stamps with fine details but rules on hand-carved stamps. Look for a water-based formula for easy cleanup.

INTAGLIO INK This is the ink of choice of professional printmakers who work on paper with intaglio, etching, and woodcut methods. I recommend Akua brand because it is water-based and gives luscious semitransparent color.

STAMP CLEANERS There are several products on the market specifically for cleaning stamps, but I often just use an old toothbrush and dish soap for heavy-duty scrubbing or baby wipes for quick jobs. Do not submerge wood-mounted stamps, as this could cause warping.

RUBBER BRAYER This tool looks like a small paint roller with a rotating rubber head. I prefer soft rubber brayers, but inexpensive craft foam brayers can also work. Store rubber brayers out of the sun because light will make them crack. Roll brayer through the ink on an inking plate several times to make sure it is evenly coated before rolling over the relief block or stamp. Generally you want a brayer that is larger than your print block.

CRAFT BRAYER A less expensive option, usually made of foam. Good for inking large stamps, but not recommended for small, detailed stamps, as the slight texture of the foam might appear.

INKING PLATE This flat sheet is used to roll out the block printing ink to evenly coat the brayer. I use clean baking sheets from a thrift store, but any flat surface you can clean (such as a sheet

of acetate, glass, or an acrylic panel) will suffice. Mix colors with a palette knife (which looks like a tiny, skinny spatula) on the surface of your inking plate before using the brayer.

EMBOSSING POWDER A fine dust that is applied to freshly stamped areas when the ink is still wet and then sealed in place with a special heat gun. Use the powder on paper, wood, and other porous surfaces. It's available in many colors and opacities. The clear has no color but results in a shiny appearance for a subtle look. The dimensional, my personal favorite, puffs when heated and provides a nice glossy sheen. You can use multiple colors of powder on one stamp for a rainbow effect.

EMBOSSING INK To be used with the embossing powder. Use pigment ink pads with a similar color to the embossing powder or a clear embossing ink pad.

HEAT GUN Used for heat-setting embossing powder or to dry paint quickly. This tool looks like a strange hair dryer but emits less wind and produces heat quickly. Use with caution because these babies get really hot and can melt things, if you are not careful. This product is available in some art stores, but because of its industrial applications, can be found online at hardware and industrial supply stores.

substrates

This is the general term I use for material you can stamp, stencil, or dye. In this book we cover everything from ceramics to walls to wood and the usual paper. The same techniques can frequently be employed on different materials. In this book we most often use paper and fabric.

PAPER Generally made from tree wood pulp or recycled paper; I prefer uncoated paper. Look for archival or

acid-free paper so your projects won't age with time or sunlight exposure. Lignin is the material that ages most papers, and cheap papers like newsprint have a lot of it. Other fibers (like cotton) are naturally lignin-free and good for archival projects. *Washi* paper, often called "rice paper," is usually made from fibers extracted from the mulberry tree (called "kozo"). It's stronger than wood pulp paper, especially when wet, but not as opaque.

FABRIC Buying fabrics to dye and print on can be challenging. I love the site Dharma Trading Company because it carries tons of RFD (meaning "ready for dyeing") and PFD (meaning "prepared for dyeing") fabrics; in other words, they have been washed of all gunky stiffeners and finishes that can interfere with dyeing. Look to see if your fabric contains a cellulose or protein thread if you want to dye them. (Synthetic thread either won't dye or will take dye differently.) Often RFD and PFD garments are also sewn with simple structures (no complicated pleats or darts) that can make printing a challenge. There are three types of fabric:

cellulose: Natural fabrics (like cotton, linen, hemp, and rayon) that are made from plants.

protein: Natural fabrics (like silk, cashmere, and wool) that come from animals.

synthetic: Human-made fibers (like polyester and acetate). They are difficult to dye and print on except with Speedball block printing ink for fabric.

Cellulose and protein fabrics will shrink because the fibers have been stretched and pulled to turn them into cloth. The heat and agitation in washing allows those fibers to shrink back to normal size. Cotton especially shrinks and not evenly in all directions! It can, for instance, shrink up to 5 percent in width and 12 percent in length. To avoid shrinkage hand-wash in room temperature water. In addition, fabrics vary in weight, drape, thread count, and weave.

COMMON FABRICS

SILK Made by weaving long proteins from the larvae of silkworms, this luxurious fabric is great for printing. Sold in different weaves like *habotai,* organza, chiffon, and crepe de chine.

LINEN Cloth made from the flax plant is usually more expensive than cotton, but it drapes beautifully and is suited to most printing methods.

COTTON Woven from spun cotton fibers, this is the most versatile fabric around because it can be used for anything, and takes inks and dyes like a dream. Look for a tight, plain weave (not twill or satin). The thick threads of durable cotton canvas can hide fine detail in stamps, but suit most printing methods.

RAYON The cyborg of fabrics, this is made from plant fibers like bamboo or wood, but is chemically altered and then woven to form threads. It gets weaker and stretchy when it is wet, but it is cheaper than silk and is awesome for warm-weather clothing. Super soft and absorbent, rayon is great for dyeing and stamping.

FACTORS TO CONSIDER

WEIGHT AND DRAPE The weight is determined by how many ounces or grams a yard of fabric weighs. The drape (or "hand") is how stiff the fabric is. Often heavier fabrics like twill and canvas are stiffer, hold shape well, and are very durable. Lighter fabrics like silk drape well. Choose the fabric that suits your purpose.

THREAD COUNT This refers to how many threads per square inch (2.5cm) of cloth. A lower thread count is usually coarser and a higher thread count is generally softer.

WEAVE Fabric is made of two sets of yarn. The warp runs up and down the length of the fabric, and the weft runs left and right on the width of the fabric. These go over and under each other to form the weave. There are three basic weaves: plain, twill, and satin.

PLAIN Same appearance and texture on both sides of the fabric.

TWILL A diagonal pattern on the face of the fabric that looks like angled columns of stairs. Denim uses this weave.

SATIN The face of the fabric has luster while the back side is dull. Snags easily and can be expensive.

fabric dye and painting materials

In this book we play with some traditional techniques like indigo vat dyeing and modern methods like solar dyeing. Dye is different from paint or ink; the former actually binds to the fibers, the latter just sits on the surface.

DETERGENT Used to prepare fabric for dyeing. New fabric has conditioners and sizing that can affect the way it accepts dyes, inks, and paints, so use laundry soap to make projects permanent and washable. Always wash printed cloth materials on the gentle cycle with cold water to preserve prints. If possible, turn garments inside out.

SOLAR DYE Readers of my first book, *Print Workshop,* know I am obsessed with cyanotype printing. Also called "blue printing" or "sun printing," the process yields wonderful results but can be finicky. (Expose your prints for too long and they will be all blue; expose your prints for too short a time and there won't be enough contrast in the blue or the blue will wash out.) This new product, called "solar dye," is cyanotype's easygoing, rainbow-colored cousin. Unlike with cyanotypes, it is easy to coat your own substrate, the exposure time is forgiving, it is applied wet (not dry), and it comes in a variety of colors. Both Jacquard and Lumi brands make this dye, but Jacquard has an ammonia-free version (read: it smells less) and their colors are more consistent.

SOLAR DYE WASH A special concentrated detergent that has an opposing ionic bond to draw undeveloped solar dye from fabric. A small bottle will go a long way: Even a large load only required three capfuls; it really is worth springing for.

INDIGO DYE Glorious blue dye with an ancient history that becomes permanent when exposed to air. Can be applied directly to fabric, wood, or paper. Used with *shibori* techniques. Good to purchase in a kit with other tools and in a pre-reduced form. Indigo is insoluble in water unless it is purchased in this form.

YELLOW OWL INDIGO BLUE INK I worked with a local chemist to make this ink that can be used as a paint and thinned with water for use as a dye without the mess of traditional indigo dye. The ink soaks into the fabric so it doesn't affect hand-feel and is permanent on natural fabric after heat-setting. The Yellow Owl kit is perfect for apartment use and smaller projects, and the applicator nozzle makes for easy cleanup with soap and water. The kit also includes instructions, gloves, and a creative user's manual.

DYE-NA-FLOW This new ink, made by Jacquard, works much like Yellow Owl Indigo Blue Ink, but is available as a thin water-based formula and in many colors. This transparent ink is best on light-colored fabric and can be diluted with water to achieve pastel colors. Clean up with soap and water and heat-set for washable fabric.

WATER-BASED RESIST This goopy substance is used to repel ink, dye, and paint. It can be piped, painted, or stamped on the surface of fabric. Air-dry and wash off in warm water. Best to use resist with a thin fabric like silk so it can penetrate both sides of the fabric. Use with solar dye, Dye-Na-Flow, Yellow Owl Indigo Blue Ink, or fabric screen printing ink diluted in water. Traditionally, batik prints are done with solvent-based Gutta, made from rubber or gutta-percha.

These work well but require solvent and are flammable. The Japanese have a stencil resist technique, called "*katazome,*" that uses a paste resist made from rice flour. Many people also make their own paste with flour and water. These paste resists are stiff and can crack—letting little veins of color in the print. A cool look, but I go for crisp prints so I prefer using an easy, water-based resist by Jacquard because it dries flexibly (no cracking), washes out with warm water, and allows for a tidy stamped impression with interesting texture.

Gel school glue and gel glue sticks such as those made by Elmer's also work as a dye resist and wash out with warm water after heat setting.

FABRIC MARKERS Available as washable or permanent, use these markers to draw directly onto fabric. The ink is transparent, so it's best to use on light-colored fabric and heat-set before washing. I have had good experience with Marvy and Tee Juice brands.

FABRIC PASTELS These oil pastels give a rich color that I prefer over fabric crayons. I use the Fabric Fun brand. Place scrap paper on top of drawn image to heat-set.

IRON-ON ADHESIVE Create a no-sew permanent appliqué with this paper attached to double-sided adhesive that is activated with heat. Don't let your iron touch the adhesive backing directly because it will kiss your iron and never let go.

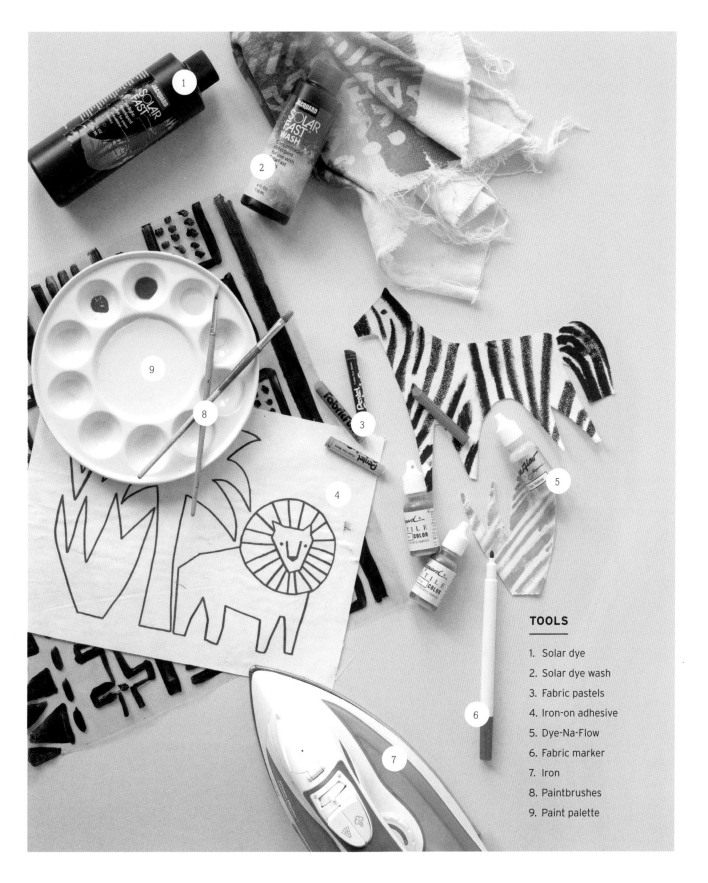

TOOLS

1. Solar dye
2. Solar dye wash
3. Fabric pastels
4. Iron-on adhesive
5. Dye-Na-Flow
6. Fabric marker
7. Iron
8. Paintbrushes
9. Paint palette

stencil and screen printing materials

Stencil techniques use materials with cut-out designs to control where the ink makes contact with the substrate. Screen printing is a type of stenciling. Together they can be used to create tiny, intricate prints or large, bold designs.

SELF-ADHESIVE SHELF LINER Also known by the brand name Con-Tact paper. I seem to use this self-adhesive vinyl for everything—as an easy-to-clean inking plate, a surface for mixing paint and ink, and a form for one-off stencils. Use bright-colored and metallic Con-Tact paper as wall decals. Also works as a protective coating.

CLEAR STENCIL FILM Transparent plastic sheet made of polyester or acrylic plastic. Cut the film with a craft knife to make stencils that can be used several times. Use these sheets as mounts for large foam stamps so you can see where you are printing (see page 134).

PAINTER'S TAPE A pressure-sensitive masking tape specially designed to block or mask paint; easily removable from most materials. 3M's painter's tape is good and widely available.

STENCIL BRUSH These fat, round brushes have natural hog bristles that can hold a lot of ink. They are used in an up-and-down stippling motion so the ink doesn't get under the stencil. Choose a larger brush to stencil expansive areas and a smaller brush for highlights or details.

SCREEN PRINTING INK A viscous acrylic paint good for stamping, painting, and screen printing on a variety of materials. Look for water-based formulas like Speedball or Jacquard for solvent-free cleanup. I only buy fabric screen printing ink because it works on paper but allows me to print on fabric, too.

WHAT IS A COLORANT MADE OF?

Colorants like paint, ink, markers, fabric pastels, and Dye-Na-Flow vary in hue (pigments) and medium (composed of both a binder and vehicle). Rather than memorizing arbitrary rules, I find it helpful to know what these things are made of so I can best match them with techniques and substrates.

PIGMENTS This is what gives the color. Pigments can come from nature (such cochineal, or carmine, which comes from the eyes of the female cochineal insect) or be made synthetically in a lab. Natural isn't always best because many traditional pigments are expensive, hard to obtain, or hazardous. In general, colorants with a higher ratio of pigmentation are called "professional grade" while those with less pigment or more filler are called "student grade."

BINDER The main body of the medium that glues it all together and allows the colorant to stick to the surface. The binder for acrylic paint is an acrylic polymer (plastic) emulsion; for watercolor and gouache it is gum arabic; and for colored pencils it is wax. Binder is the part that affects the viscosity or body of the paint. Screen printing requires a thicker paint because a thin paint would ooze around the stencil. It is easier to use a thin-bodied low-viscosity paint on metal projects because it's better for details and seeping into the grain of the material.

VEHICLE With water-based colorants, this is the liquid that evaporates to leave the binder and pigment bound to the surface. Stamp ink pads either have water or alcohol, which evaporates. Oil-based inks don't dry through evaporation; rather, when exposed to air, the oils harden to form something like a scab. Oil-based inks use flammable solvents for cleanup. As such, they can require special precautions and ventilation, so I generally don't mess with them. In this book we use water-based ink and paint because they are easier to clean up and present fewer hazards.

ADDITIVES Some colorants, like fabric screen printing ink or fabric paint, have a special additive that helps bind the colorant to fabric so it is washable. You can also buy fabric medium and add it to any acrylic paint to achieve the same result.

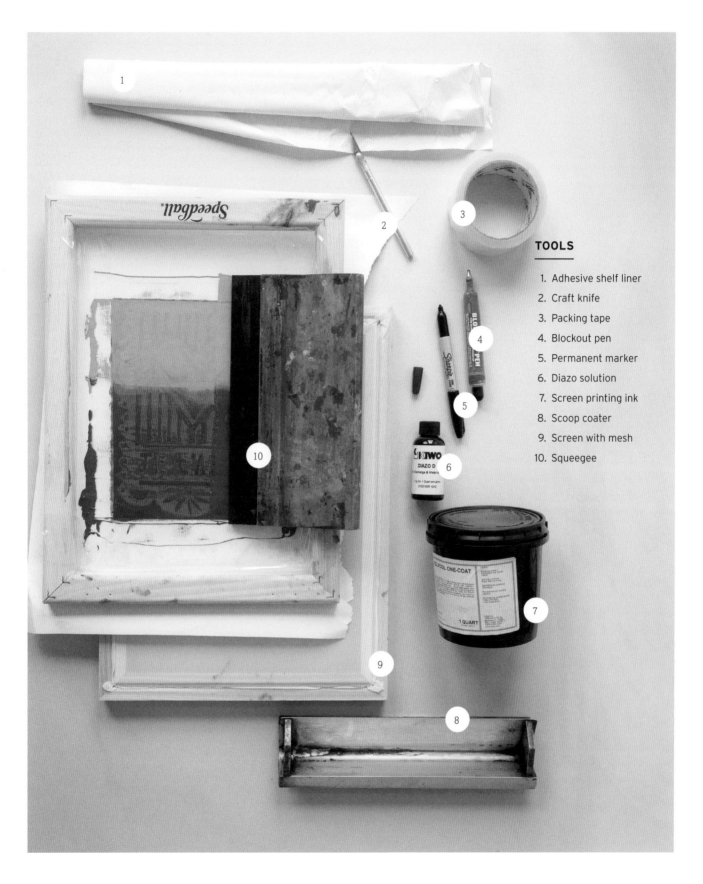

TOOLS

1. Adhesive shelf liner
2. Craft knife
3. Packing tape
4. Blockout pen
5. Permanent marker
6. Diazo solution
7. Screen printing ink
8. Scoop coater
9. Screen with mesh
10. Squeegee

FABRIC SCREEN PRINTING INK Same as screen printing ink but made to be permanent on fabric after heat-setting. Can be used on other surfaces without heat-setting.

SCREEN Nylon mesh stretched over a wood or aluminum frame to create a tight surface for screen printing. Purchase by frame size or mesh count. The size of your screen is determined by the image size you want or vice versa. I recommend adding at least 5"–6" (12.5cm–15cm) to the size of your image to determine frame size. Frames come in standard sizes so best just to round up. For instance, if you have a 10" × 14" (25.5cm × 35.5cm) screen, the max image size would be 5" × 9" (12.5cm × 23cm).

SCREEN MESH A nylon fabric stretched over screen frames to create the stencil for printing. The higher the mesh count (the number of threads per inch), the higher the level of detail possible. Check with printing ink brand for desired mesh count. Screens come in a variety of mesh counts from 80 to 400 monofilament lines per inch. When I screened we always used 305 mesh with our Speedball water-based ink. In my area, Speedball screens are the most readily available at art stores; they have a mesh count of 110. This is good for most jobs. If you have a highly detailed image, go to a professional. Unlike a student-grade wood frame that can warp, a professional frame has a sturdy aluminum frame that is glued with excellent tension for crisp prints.

DIRECT STENCIL A method of creating a screen print stencil that requires only tape and no diazo or film positive to create the stencil. Good for high-contrast images with little detail. Masking is taping around the image so the ink has a place at the top and bottom of the image to rest without creeping into your print. There is a specific blockout tape, but I always just use clear packing tape. Apply tape to the back and front of the screen like a frame around your image. You can also cut out small bits of tape and apply it to the back of the frame to plug pinholes where ink is coming through. If you have multiple images on the screen, cover the image in Mylar or plastic bags to prevent ink from seeping through. You never want to apply tape directly to screen images, unless you are done using them, because tearing off the tape can damage the images.

DIAZO SOLUTION This light-sensitive liquid is used to create a stencil on the screen for screen printing. The solution can be painted on with a brush or applied with a scoop coater to the screen and then exposed to light through a film positive to create the burned image. Exposing the screen to light hardens the stencil. This solution has a specified shelf life so buy only what you can use within six months. We only use water-based ink for these projects so purchase a solution that specifies use for this ink.

SQUEEGEE A rigid rubber blade inset into a wooden or metal handle. Used to "flood" the screen and then push ink through the stencil onto your printing material. Excellent for details and shades.

SCREEN REMOVAL SOLUTION Used to clean ink from the screen. Spray the solution onto your

KEEP IT CLEAN

When you are done printing, you always want to wash off the screen in your bathtub or sink. Ink can dry quickly, clogging up those holes. If you have done this (and I sure have!), a pressure washer can be used to blow out the screens. Scrub the screen with a sponge brush loaded with a little dishwashing detergent. When you are finished printing, you need to "reclaim" or clear the screen, which means washing the negative off. Do this as soon as you are done because tape, masking fluid, or emulsion won't wash off if you wait.

THE TRUTH ABOUT HEAT-SETTING

Turns out heat-setting for screen printing textile inks, all-purpose stamp pads, fabric markers, and fabric paints isn't about the heat at all. These colorants become permanent when all the water molecules evaporate. Heat from the iron, heat gun, hair dryer, or clothes dryer does this quickly, but you can do it the lazy way by waiting at least 72 hours before exposing a printed piece to moisture. I recommend using an iron, heat gun, or dryer if the weather is humid. For small items or small print runs, use an iron set to the appropriate heat setting for the fabric. For large printed textiles or large print runs, wait until the paint, ink, or marker is dry and put in your dryer for one cycle on high heat.

screen and wash out with water. Clean as soon as possible after printing to keep screens in good shape.

BLOCKOUT PEN Pen filled with blockout fluid to fit tiny holes in the diazo stencil. We use water-based ink for these projects so buy one specified for this purpose.

TRANSPARENCY FILM A clear sheet of acetate or Mylar on which the film positive image is printed.

HANDMADE FILM POSITIVE An opaque motif or image on transparency film. The image blocks the light.

DIGITALLY PRINTED FILM POSITIVE Film positive printed by a laser or inkjet printer.

glass and ceramic decoration materials

Because glass, mirrors, and fired ceramics are nonporous, they need special materials and techniques suited to the job. Terra-cotta and polymer clay items are porous, so all-purpose stamps pads and acrylic paints can be used on these surfaces for decorative use.

TRANSFER PAPER Regular carbon paper won't work on glossy nonporous surfaces, so use transfer paper. The Saral transfer paper is wax-free so it can be erased like pencil, washed out, or painted over. When transferring a design, I prefer to use a colored pencil that is white, even on white items, because it is still visible but it won't muck the color.

GLASS PAINTS Also called "overglaze" or "China paints" because they are painted on top of glazes, these are used for glass decoration and come in a variety of finishes such as opaque, translucent, or metallic sheens. The paint is usually made permanent and dishwasher safe after curing by either heat-setting in the oven or air-drying. In my experience, curing in the oven (with paints that recommend it) provides a more durable finish.

GLASS PAINT MARKERS I love Pébéo brand paint markers because they don't require a base coat of glass conditioner and they set in the air after 72 hours. I find the colors are more permanent, however, if I heat-set them in the oven: Place items in a cool oven and set the temperature to 300°F (150°C). Once the oven comes to temperature, bake for 30 minutes and turn off the oven. Let ceramics or glass slowly come back to room temperature inside the oven because a sudden change in temperature can crack or shatter the piece. Be sure to check current manufacturer's instructions.

GLASS CONDITIONER This primes the nonporous surface so it can accept the paint. You can also use clear Mod Podge.

PLATES OR FIRED CERAMICS Look for items without cracks or blemishes in the glaze. Ceramics such as dishes are usually bathed in a shiny or matte coating made of melted glass to make them waterproof and functional. Light-colored items work best because even the glass paint marketed as "opaque" isn't really.

TERRA-COTTA POTS Named after the Latin translation of "baked earth," these pots are usually red-orange (though that differs by region) and unglazed so the porous surfaces can be painted with most acrylic paints.

BISQUEWARE Unglazed white ceramic ware available at paint-your-own pottery places, ceramic stores, and online, these items have only been fired once and need to be fired again before use. Usually bisqueware pieces are commercially molded ceramics, like mugs, tiles, and pots.

GLAZEWARE Finished ceramic pieces like your dinnerware and mugs. These have been glazed and are therefore no longer porous. Use only glass paint or glass paint pens on them.

UNDERGLAZE PENCILS These pencils, available in blue, yellow, rose, brown, black, and green, are called "underglaze" because they go on before the final clear glaze. They are easy to use and excellent for drawing fine lines. Sharpen the pencil with a craft knife, not your pencil sharpener. Finished pieces need to be dipped in clear glaze and fired in a kiln, perhaps at your local paint-your-own pottery studio. See manufacturer's instructions for maximum firing temperatures.

POLYMER CLAY This modeling clay is composed of polyvinyl chloride particles that gel when heated in the oven to form a hardened surface. This clay is great for stamping and is widely available from brands like Sculpey and Fimo. You can't tint polymer clay with colorants before you bake, so if you want specific colors, you either have to buy the specific hue, buy several colors of clay and mix them together, or paint your Sculpey with any acrylic paint after it's been baked. Unless I have a specific color scheme in mind, I buy Sculpey in original or terra-cotta colors and paint the surface. Protect your baking sheets with parchment or foil and heat according to the manufacturer's instructions. Do not bake on things that will come in contact with food.

CLAY CHEAT SHEET Use this handy chart when deciding on the right clay for your project.

clay type	decorate	finish	pros/cons
Air-dry clay	Model into shapes or roll flat and stamp. Metal leaf when dry.	Air-dry and seal.	Decorative use only. Fragile.
Polymer clay	Model into shapes or roll flat and stamp. Metal leaf when dry.	Bake according to manufacturer's instructions. Apply acrylic paint or acrylic varnish (optional).	Decorative use only. Good for high-detail stamps and small-scale projects.
Terra-cotta pots	Stamp with all-purpose (hybrid) stamp ink pads.	Apply Mod Podge or triple-glaze spray (optional).	Smaller stamps work best on curved surfaces.
Bisqueware	Use underglaze pencils and underglaze.	Coat with clear glaze and fire.	Food safe. Requires firing in kiln (check your local paint-your-own pottery place).
Finished glazed ceramic pieces	Use glass paint or glass paint pens.	Bake in oven according to paint manufacturer's instructions to heat-set for durable finish. Some brands air-dry.	Decorative use only. Fine for outside of cups and surfaces that don't touch food.

leather decoration materials

Leather crafting is super satisfying, but it can require a load of special equipment. I picked projects in this book that use a few multipurpose tools so you can get your feet wet (and not go broke buying special supplies).

LEATHER A hide from an animal, usually cow, deer, sheep, or goat. Like people, animals have different types of skin on different body parts. Leathers are sold by weight/thickness and by size shown in square inches or square meters. Leather is generally sold in ounces or millimeters, and in increments of 1 oz or .4mm (1 oz = .4mm or 1/64"). For ease of use, I went with a thin, flexible leather so I could cut it with regular scissors and a craft knife. Also, because this thin leather is used to make apparel, it can be found in local fabric stores.

LEATHER TANS AND FINISHES Leather can vary in color, thickness, stiffness, and texture. Vegetable tanned leather is what we think of as "natural-looking" leather with a neutral color. It is tanned using tannins (usually from tree bark). A side is half of the skin of the animal.

SCREW BUTTON STUD This is a two-piece finding used to secure pieces of leather together. The part with the raised button is placed on the face of the leather and is secured with a screw that goes through the back of the leather. A slit is then cut from the adjoining leather to button the leather closed. These are sold by the diameter of the button on top.

DOUBLE CAP RIVETS Sold by the length and diameter of base and cap, this rivet type has two sides: a male post and a female cap. Select a rivet that is 1/8" (3mm) longer than the combined thickness of both leather pieces. Punch a hole in the leather pieces that is slightly larger than the diameter of the shaft. Push post through back of leather and close with cap on the front side. Turn leather to back side and hit with a hammer. This presses the two caps together, creating a strong mechanical joining with a finished look. Professionals use a specific setter and anvil, but the weight of leather we use for these projects can be punched with a hole punch (though I recommend a good one like a Crop-A-Dile) and set (closed) with a hammer. Make certain to buy a rivet whose shaft is the length of the leather you are joining for a tight seal.

GLUE A variety of adhesives are made specifically for leather but because of the porous nature of this material, I use a craft glue that dries flexible and clear, such as Elmer's CraftBond. Make sure to test whatever glue you use on a scrap before applying.

LEATHER PAINTS When choosing an item to stencil or paint, best to look for a smooth surface. Alligator, suede, or other textures are too bumpy for the stencil to adhere completely to the surface. I use Angelus leather paints and love the consistent opaque colors. They come in little bottles (like nail polish with the brush inside the cap) and work well. Plus you don't have to clean the brushes. Drugstore nail polish also works well,

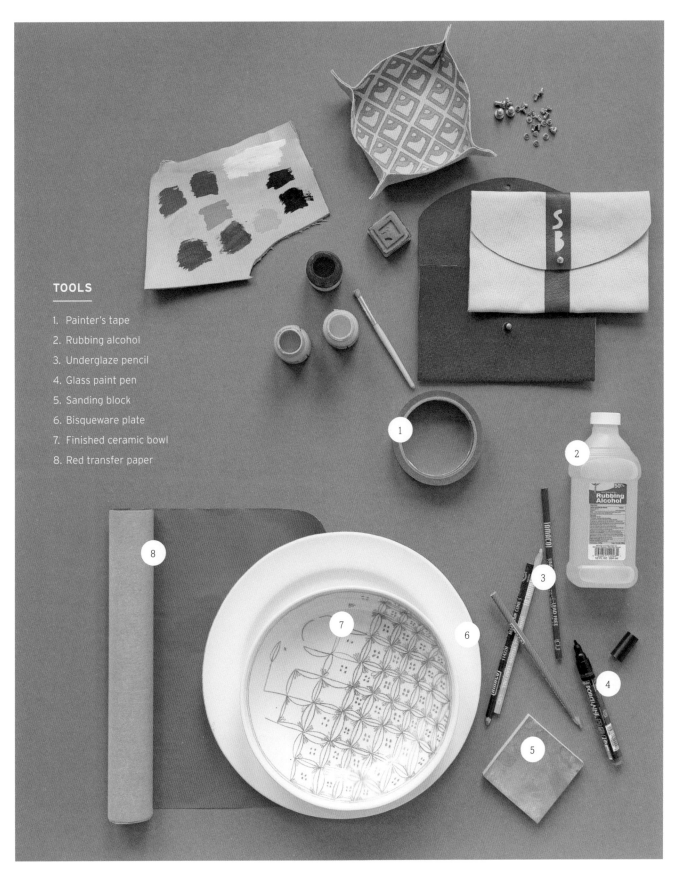

TOOLS

1. Painter's tape
2. Rubbing alcohol
3. Underglaze pencil
4. Glass paint pen
5. Sanding block
6. Bisqueware plate
7. Finished ceramic bowl
8. Red transfer paper

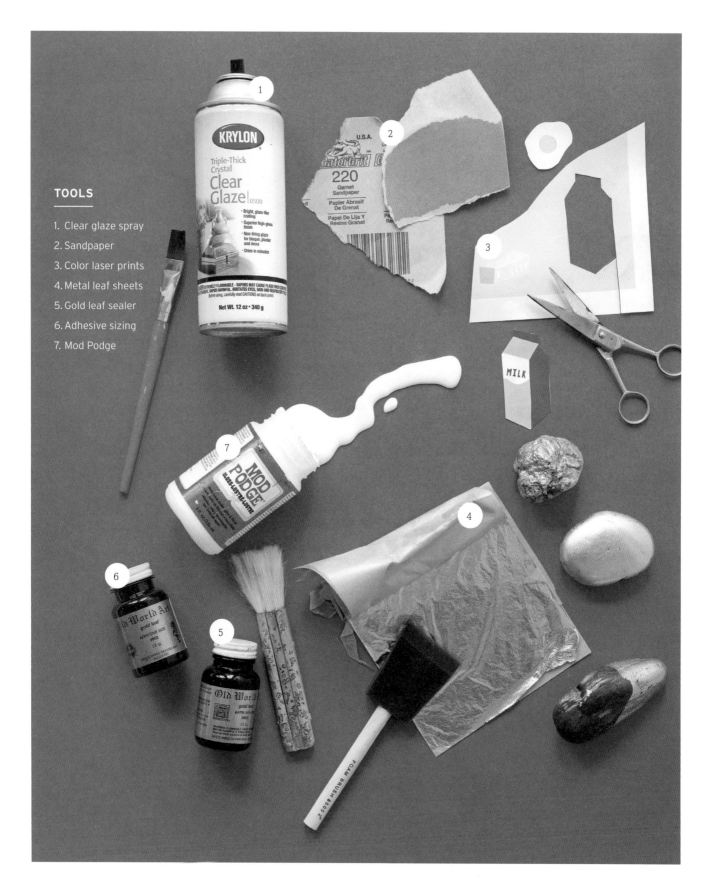

TOOLS

1. Clear glaze spray
2. Sandpaper
3. Color laser prints
4. Metal leaf sheets
5. Gold leaf sealer
6. Adhesive sizing
7. Mod Podge

although it requires more thin coats and brands vary in opacity. Best to apply in several thin layers and allow to dry for about 10 minutes between coats. Lay it out in the sun or hit it with a heat gun to speed up the process.

LEATHER PREPARER AND DEGLAZER Before leather can be decorated, it needs to be wiped clean with acetone or a leather preparer. These both break down the finishes or residual oils that can prevent paint adhesion. The acetone can permanently damage the leather and make it stiff, so test on a small area first. Leather preparer, such as Angelus brand, will do the job and leave the leather feeling soft.

FINISHER Although not totally necessary, it's a good idea to protect and seal your paint with a finisher. Manufacturers make specific finishers in a variety of sheens or matte, but I use Mod Podge and it works just fine.

decoupage and metal leafing materials

Decoupage and metal leafing techniques are essentially pasting films on surfaces of objects. The end results vary from a collage look to something sophisticated and blingy.

SEALANTS A UV acrylic spray applied in a thin coat to protect prints from color-fading UV rays. Use in an area with good ventilation and be sure to put large scrap paper on your work surface before spraying. Sealants are available in matte or shiny finish and are recommended for all colored paper, photocopies, and printed photographs.

CLEAR GLAZE This is my new favorite material, particularly the Krylon product called "Triple-Thick Crystal Clear Glaze." Spray this on to get a brushless finish with a glass-like surface that saves

you from painting on three coats of Mod Podge. Great for decoupage, gold leafing, and tape image transfers.

SPRAY ADHESIVE This glue in hairspray form (I like the Krylon brand) is good to adhere to stencils and paper and is an archival, acid-free formula to prevent paper yellowing. Use with good ventilation. Choose either "repositionable" or "permanent" type according to use.

METAL LEAF KITS These kits contain paper-thin sheets of gold, silver, copper, or composites. Use on sealed surfaces. Kits also contain adhesive sizing and a clear sealant. Kits come with a backing paper to separate sheets and apply leaf with hands. The sheets are very delicate and will fly away, so work indoors and have a vacuum handy to catch flyaways. I use gold composition leaf because it is cheap and you can't tell the difference. Metal leaf is very fragile, so you really need to seal it. For a small area I use the brush provided in the kit, but for a large area I apply the adhesive with a 2" (5cm) foam brush. Always clean the brush immediately because the adhesive will dry and make that brush crispy and unusable. Make sure all surfaces are dust-free.

food decoration materials

Admittedly, including a section on food decoration in what is a craft and printmaking book was a hard sell to my editors. But really, how is a blank sugar cookie (or unfrosted cake) not just another canvas to work with? After art school I lied on my résumé to get a job as a cake decorator and found the job required the same artistic skills I already had—it just used better-tasting materials. In this book I show you how to translate your printmaking practice into something you can eat!

LIQUID FOOD DYES Colors made in a lab just for putting in your belly. Bright, shelf-stable, and generally taste-free, seven synthesized colors are currently available. Blend colors to create new ones! Food coloring is any pigment or dye that turns liquids or foods different colors. Because these inks are ingested, they are scrutinized by health organizations like the U.S. Food and Drug Administration and the European Food Safety Authority. These are safe to eat and touch. Natural food dyes made from plant, animal, or mineral sources (like yellow from turmeric or purple-red from beets) are coming to market, but these dyes may impart some flavor.

GEL-BASED FOOD DYES These highly concentrated artificial food dyes are suspended in a gel and are available online and in bakery stores. Use to paint directly on cake. Because these are gel-based instead of water-based, they mix better with things that include fat, like fondant.

BUTTERCREAM ICING Generally used as a base for cake frosting, this icing is made from mostly butter and confectioners' sugar. Chill in fridge to set before stenciling and stamping.

CANDY MELTS Liquefy with heat like chocolate, but remain firm at room temperature because they don't contain cocoa butter. Available in specialty stores and online in a variety of colors. Blend colors of melts in varying proportions to create new colors.

FREEZER BAG Made for storing food, these durable bags can also be used to melt chocolate and candy melts. Snip off just a whisper of the corner to make it into a piping bag for decoration.

PIPING BAG Also called a "pastry bag," this cone-shaped bag with a narrow tip can be squeezed to pipe icing or chocolate. Purchase reusable bags with tips that screw or make your own with a freezer bag.

FONDANT This sugar dough (usually called "rolled fondant") is the modeling clay of the cake world. Very versatile because you can roll it out thin and cover cakes or use it to create small edible sculptures. Several recipes are available on the Internet (if you go that route,

marshmallow fondant is the tastiest), but I prefer to buy it premade online or from a bakery supply store. I buy white buttercream fondant and color it to my desire with gel-based food dyes because the regular (water-based) food dyes add too much water. I have had the same 32 oz (907.2g) container of Fondarific Buttercream Fondant for two years. It gets a little hard over time, but heat from your hands can make it malleable again. Having this premade means I can easily whip up some dessert decor even for store-bought cupcakes.

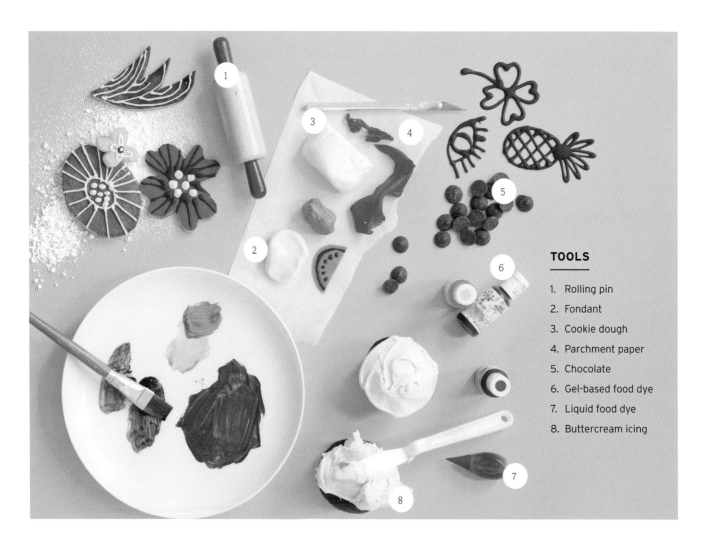

TOOLS

1. Rolling pin
2. Fondant
3. Cookie dough
4. Parchment paper
5. Chocolate
6. Gel-based food dye
7. Liquid food dye
8. Buttercream icing

APPENDIX B: DESIGN AND PATTERN PRINCIPLES (AKA BECOMING QUINCY)

Designing and printing patterns and motifs is like becoming Quincy Jones. Let me explain. If a motif is a singer, then a pattern is the chorus. Sometimes a motif is good all alone, like anything from Michael Jackson's album *Off the Wall*. That singular voice needs nothing else and, yes, I will "Rock with You." Some days just need MJ variety, so you add Janet and La Toya for the hook on "P.Y.T." It gets richer, more varied, but you still hear each singular element. Sometimes you go bananas and throw in some Willie Nelson, Cyndi Lauper, Bruce Springsteen, and the Kennies (Rodgers and Loggins) for "We Are the World." Each motif, each player, sings with his or her unique voice, but they merge into a harmony—a unified composition.

The person who selected the pieces and arranged them for unity is world-famous producer Quincy Jones. This is a book about building and producing your own voice in printmaking. By arming you with skills and motifs, giving you ideas on how to arrange and execute them, this book shows you how you can become the Quincy in your own home studio to make your hand-printed works sing.

I want every inch, word, and line of this book to serve one useful mission: to make you the printmaker you want to be. What do you like? What do you want to make? This book is about you printing for your passions. It's jammed with a wide variety of motifs and patterns so you can find and make something you fancy, or even create your own designs. Packed with practical advice, troubleshooting tips, and useful shortcuts, this book will equip you with the tools you need to get excellent results at home every time. It clearly explains print techniques ranging from stamping and stenciling to dyeing so you can create cool and functional printed goods for your life, home, or business. You'll learn to translate your inspiration into finished items, mix and match templates and techniques, and gain a deeper understanding of design and pattern structures so that you can conceive, design, and print by hand your own work with maximum efficiency and reliable results. Let's break it down to the nitty-gritty before we jump in.

MOTIF

A pattern just needs a motif and an order of repetition. By varying the direction, colorway, or space between motifs, you can create infinite patterns. Here is how you do it.

STRAIGHT REPEAT Motif is repeated along vertical and horizontal lines and is printed as if in a grid. This simple structure is suitable for motifs you really want to shine. **(a)**

DROP REPEAT Motif is repeated on vertical columns but each column drops down a bit—usually either halfway (called a "half drop") or a quarter of the way (called a "quarter drop"). This gives the pattern more movement between motifs and creates a more dynamic composition. Staggering motifs pulls the focus away from the gap between motifs. **(b)**

BRICK REPEAT Motif repeats with each row moving to the right—usually either halfway or a quarter of the way—in a formation similar to a brick wall with staggered brick rows. This pattern structure relies on the interplay between motifs to create a dynamic composition where your eye can wander around the fabric. **(c)**

MIRROR REPEAT Motif is flipped either vertically or horizontally or both to create a mirror image. This requires a separate stamp or a stencil that has been flipped over. **(d)**

ROTATION REPEAT Motif is rotated around a single point. Alter the angle of rotation for more variety. This is good for multidirectional and all-directional patterns. Can be very lively but look for where positive and negative spaces come together to draw attention away from the motifs. **(e)**

RANDOM REPEAT Motif is repeated arbitrarily with no recognizable order. This is great for a multidirectional pattern that can be viewed from multiple angles. While this is the easiest pattern structure for winging it, it takes precision to get a truly random pattern, with no disruptive lineups and gaps. **(f)**

COMPOSITION

The relationships among color, lines, and space is called the "composition." In this book we use motifs (or defined lines and shapes) and alter their color and the space between them to create different looks. I encourage you to play around on scrap paper to see what each motif can do for you or at least to decide what you don't want it to do. Even the simplest motif can be repeated to create an elaborate composition and the templates in this book can be used for an infinite number of compositions.

COLOR CHANGE Using multiple colors can change the look of a pattern.

HOLES AND ALLEYS Gaps between motifs that provide a resting place for your eyes.

a

d

b

e

c

f

LINEUPS Alignment of motifs in a specific pattern. It's very important to look at the negative spaces between motifs that create holes and the positive spaces that can join to create shapes you might not intend.

SCALE The size of the printed motif. Use a scale that works for your project. If you print a large-scale motif on a small project, you might not be able to see the whole motif and appreciate the composition.

DENSITY Refers to the space around and between the motif. This is where the background shows. High-density means less space between motifs, and low-density means more space around your motif.

DIRECTION

The orientation of a motif. This should be determined by the project you are making. For instance, clothing could have a single-direction pattern because it will always be viewed from the same vantage point. A scarf that's wrapped around your neck could use a multidirectional or random pattern because it will be viewed from several angles.

SINGLE-DIRECTION PATTERN Motifs appear upright in same direction either vertically or horizontally.

MULTIDIRECTIONAL PATTERN Motifs are repeated in several directions or angles and look the same in every direction.

RANDOM PATTERN Motifs are repeated to always appear right way up. These are trickier than they appear because placing motifs randomly might create accidental alignment of motifs or gaps that can make for a discordant composition.

COLOR

Technically, you may have been talking about color the wrong way your whole life. This would be an annoying cocktail party discussion but being specific about how we talk about colors is important when you are composing your patterns. Colors are made up of four things—hue, saturation, value, and luminosity—and we use the relationships among these characteristics to highlight or play down elements of our designs.

HUE This is pure color that you can remember by my terrible rap name ROY G BIV. The letters stand for the chromas of red, orange, yellow, green, blue, indigo, and violet. These are pure spectrum colors and usually come right from the colorant. Think about the pretty rainbow you see after it pours or that Pink Floyd prism poster somebody you knew in high school had. Colors can vary in temperature, which is why we refer to how warm or cool a color is. Warm colors like red and orange remind you of a fire and tend to be more energetic! Cool colors like green and blue remind you of the ocean and are more soothing.

SATURATION This is how much hue is in the color—how intense or dull the color is. Pastel colors appear softer because they have low saturation (see tone).

VALUE This is how much white or black is in each color, and is also known as "grayscale."

LUMINOSITY This refers to the lightness of a color and is determined by its saturation and value. It's really a technical term you don't have much use for unless you only see in black and white.

PRIMARY COLORS Red, yellow, and blue. All colors are made from these.

SECONDARY COLORS Purple, orange, and green. These are made by mixing two primary colors. Mix any of these together to get a brown.

TERTIARY COLORS Yellow-orange, red-purple, blue-green, and so forth. These are made by blending a primary color and a secondary color together.

TINT AND TONE Any color with white added, these colors tend to be brighter. When mixing colors always start with white and sparingly add in the hue.

SHADE AND VALUE Any color with black added. When more black is added, its value becomes darker. When mixing a shade, always start with the hue and add black a little bit at a time.

COLOR RELATIONSHIPS (AKA WHO IS COMING TO DINNER?)

Any time you print, stencil, or dye a material you need to consider how well the colors are going to get along. Even if you are making a one-color print, you need to think about the substrate because it too has color. Think about your color selections as you would the seating arrangement at a dinner party. Go for analogous colors, complementary colors, and neutrals.

ANALOGOUS COLORS These colors hang around each other on the color wheel and they are great pals. Think about, say, green and blue and all the colors that sit between them on the color wheel. In our dinner party they have similar views and they will chat harmoniously with nobody grabbing the spotlight. These guys provide a low-contrast and subdued vibe that can suitably showcase a pattern where you want the intricate design to shine, rather than the color.

COMPLEMENTARY COLORS These colors are pairs that sit directly opposite each other on the color wheel and clash and fight for attention. Examples: yellow and purple, orange and blue, red and green. These clashes can be very exciting and dynamic but as anybody who has suffered through heated political debates during the holidays can tell you, sometimes the clashing just drowns everything else out—whether it be motif details or my awesome pear-cranberry pie. I generally choose one color to dominate and use the other color sparingly to keep the tension down.

NEUTRALS So called because they are found in many other colors and provide a soft and soothing low contrast. Think white, black, beige, and brown. Here is your sweet aunt who can talk to anybody and, fine inquisitive conversationalist that she is, will bring out the best in each guest. In the composition of your printed pattern or dinner party, she is essential because she gives the eye a place to rest, even in a busy composition. While solo (or with several of her neutral kind) she might put you to bed with tales of her cat, she shines by letting bolder colors or pattern designs take center stage.

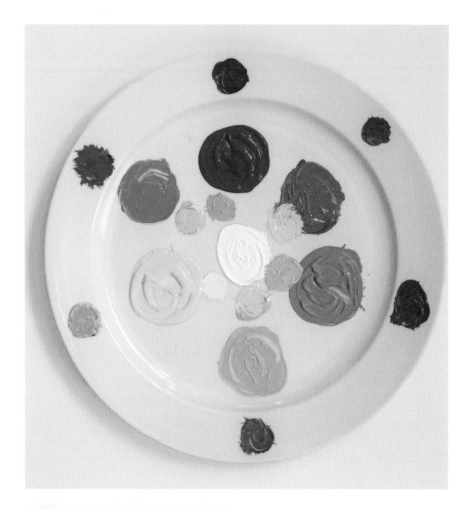

RBG, CMYK, PMS, AND FLUORESCENT: COLOR MODELS AND THEIR PRACTICAL USES

Different color processes can be used, depending on what you're printing and how. While we only use one of these processes in the book, I'm often asked about the difference between the different processes, so here's a quick lesson.

RGB Stands for "red, blue, and green." All the colors the human eye can see are made by adding these three colors together to make more colors, so RGB is called "additive color." We deal with this mode for all the projects in this book. When to use: For mixing paint and stamping with ink pads.

CMYK Stands for "cyan, magenta, yellow, and black" (black is shortened to "K"). In mechanical printing these colors are used exclusively for commercially printed items like four-color process offset printing and your inkjet printer at home. Paper or printed items reflect light because the ink sits on the surface. The pigments of CMYK act like filters, taking away RBG from the white light to express a smaller gamut of colors. When using a printer, always convert your image to color mode CMYK for accuracy. When to use: For printing decoupage (see page 115), offset printing, and digital printing.

PMS Stands for "Pantone Matching System." Color is blended in specific proportions so colors can be consistent across mediums and formats for printing on fabric and paper. For "process color" the proportions are given as CMYK proportions (0-100 percent of each). For "spot" colors the proportions are given in RGB because they are mixed separately with thirteen base pigments. When to use: For offset printing and general print color targets.

FLUORESCENT These are special inks that absorb ultraviolet light and emit waves in the visible spectrum. When to use: For printing and painting with colors specified as fluorescent. These are usually not archival and lightfast.

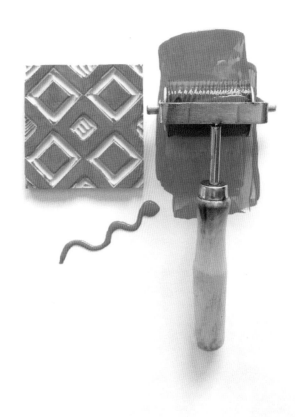

resources

Shopping your local mom-and-pop shop is always best. Even if you don't support local stores for the righteous virtue of enriching the local economy, at least know that your business will keep those doors open. This means you can run in at closing time for supplies in a pinch and you'll have a place to get priceless advice from a knowledgeable staff that will save you time, headaches, and money. I'd take their employees' advice over an anonymous online review any day. As a wholesale business operator, I have personal relationships with many of the "small guys" and regrettably more disappear every day. Smaller arts and craft retailers are usually driven by passion, rather than the bottom line, and they want to meet your needs to cultivate a loyal clientele. If they don't have something, just ask for it! I designed these projects to be used with materials you can get mostly from local places. All that said, we really do benefit from the variety larger retailers can provide. If your local joint doesn't have the variety you need, turn to the following pages for my favorite online stores. I have also included manufacturers of specific items so you can contact the manufacturer to find a local supplier.

GENERAL (UNITED STATES)

amazon.com
With lightning-fast delivery and almost anything in the world for sale, this online behemoth is hard to beat. However, inaccurate descriptions from third-party sellers can cause headaches, so stick to products you already know.

dharma trading company
1805 South McDowell Boulevard Extension
Petaluma, CA 94954
dharmatrading.com
The place to get inexpensive clothing and fabric items to print on. Wide selection of ready-to-dye goods as well as most dyes, textile inks, and water-based resists. They also have a store north of San Francisco that is worth the visit if you are in the area. Excellent and informed customer reviews and low prices set this place above the rest!

dick blick
800-828-4548
dickblick.com
With about forty locations spread around the United States and a website so packed I am certain I will never see it all, this store has everything when it comes to craft and art supplies. Excellent prices, too.

GENERAL (UNITED KINGDOM)

hobbycraft
hobbycraft.co.uk
Supplier of general arts and craft materials.

fred aldous
fredaldous.co.uk
This rad UK art store is full of contemporary craft stuff and traditional art materials. Also a Yellow Owl Workshop stockist!

SELF-ADHESIVE SHELF LINER

con-tact brand
kittrich corporation
1585 West Mission Boulevard
Pomona, CA 91766
714-736-1000
contactbrand.com
This company does one thing and does it well. The source for the self-adhesive shelf liner I seem to never run out of uses for!

STAMP CARVING TOOLS

speedball
2301 Speedball Road
Statesville, NC 28677
800-898-7224
speedballart.com
Speedball's carving tools are available at most art stores, but their website has a store locator for ease.

BLANK STATIONERY

paper source
papersource.com
Amazing assortment of colors and sizes of blank envelopes, cards, and sheets for wrapping. They also have a wholesale site, called Waste Not Paper (http://www.wastenotpaper.com), for people with a seller's permit.

envelopes.com
envelopes.com
An easy-to-navigate website jam-packed with all sorts of envelopes and invitations in a variety of colors and sizes. Better for bulk orders (more than twenty-five pieces).

jam paper & envelope
jampaper.com
Good selection of unique envelopes and paper sheets.

CLOTHES

american apparel
americanapparel.com
This American company makes plain white and colored T-shirts and kids' apparel with responsible labor practices. Available online and in their chain of stores.

DYES

jacquard products
jacquardproducts.com
Manufacturers of Dye-Na-Flow, SolarFast dye, an indigo dye kit, and water-resist paste. All their products are of high quality and comply with current safety standards. Purchase elsewhere (see General), but their website is jam-packed with very helpful information! They also import dyeable fabrics specially geared toward textile dyeing and printing.

SHRINK PLASTIC FILM

grafix
5800 Pennsylvania Avenue
Maple Heights, OH 44137
800-447-2349
grafixarts.com
Makers of shrink film in a variety of colors.

TRANSFER PAPER

saral paper corp.
400 East 55th Street, Suite 18B
New York, NY 10022
212-223-3322
saralpaper.com
This company makes wax-free transfer paper. Make sure to buy the color of transfer paper that best suits your project. I only use red and white rolls.

INKS AND PAINTS AND SEALERS

delta
800-842-4197
deltacrafts.com
This craft store staple brand just came out with a good eco-friendly craft acrylic and varnish line. They also sell dye-based ink pads.

plaid
800-842-4197
plaidonline.com
This is the maker of Mod Podge and Folk Art acrylic paints.

speedball
This is the brand of water-based fabric screen printing ink I use.
See Stamp Carving Tools.

yellow owl workshop
650 Florida Street, Unit E
San Francisco, CA 94110
415-282-2025
yellowowlworkshop.com
Hey, this is me! I sell dye-based and pigment-based (for fabric printing) ink pads made just across San Francisco Bay. I also design loads of stamps and we create them in our San Francisco studio with a team of talented folks!

MUSLIN BAGS

muslin bags
619-861-6220
muslinbag.com
Huge variety of sizes of American-made and imported bags. Good for bulk orders when you need more than a dozen pieces.

RICE PAPER

yasutomo
1805 Rollins Road
Burlingame, CA 94010
650-737-8888
yasutomo.com
Produces large sheets of thin inexpensive *washi* paper.

RUBBER BLOCKS FOR CARVING

speedball
See Stamp Carving Tools.

RUBBER STAMPS

ask alice
askalicestationery.com
Melbourne-based Sass Cocker makes some adorable stamp sets.

cavallini papers & co.
401 Forbes Boulevard
South San Francisco, CA 94080
800-226-5287
cavallini.com
This San Francisco Bay Area company has been making antique-inspired stamps for ages.

present & correct
presentandcorrect.com
My good pal Neil Whittington makes some very cool stationery, office supplies, and rubber stamps for his shop in London.

the small object
thesmallobject.com
Artist Sarah Neuburger makes the loveliest little stamps, perfect for kids.

STAMPERS

Xstamper
20775 South Western Avenue, Suite 105
Torrance, CA 90501
800-541-9719
xstamper.com
I order custom stamps here. When I need tiny text or a design so intricate I know I won't be able to carve it, I go here. The quality is good and it only takes a week.

CERAMIC SUPPLIES

duncan
iLoveToCreate, a Duncan Enterprises Company
5673 East Shields Avenue
Fresno, CA 93727
800-438-6226
ilovetocreate.com
Maker of bisqueware and glazes.

mayco
4077 Weaver Court South
Hilliard, OH 43026
maycocolors.com
Maker of a wide variety of bisqueware and glazes.

amaco
6060 Guion Road
Indianapolis, IN 46254
800-374-1600
amaco.com
Maker of the lead-free underglaze pencils I use as well as underglazes, glazes, and clay.

pébéo
pebeo.com
Makes the glass paint markers we use on page 83. Also available through Amazon and Dick Blick.

further reading

GENERAL

The Artist's Handbook of Materials and Techniques, by Ralph Mayer, Viking

The Grammar of Ornament, by Owen Jones, Gramercy

FABRIC PRINTING AND DYEING

Mastering the Art of Fabric Printing and Design, by Laurie Wisbrun, Chronicle Books

Shibori: The Inventive Art of Japanese Shaped Resist Dyeing, by Yoshiko Iwamoto Wada, Mary Kellogg Rice, and Jane Barton, Kodansha USA

Visual Texture on Fabric: Create Stunning Art Cloth with Water-Based Resists, by Lisa Kerpoe, C&T Publishing

Wild Color: The Complete Guide to Making and Using Natural Dyes, by Jenny Dean, Potter Craft

PATTERNS

Pattern Design, by Lewis F. Day, Dover

Repeat Patterns: A Manual for Designers, Artists, and Architects, by Peter Phillips and Gillian Bunce, Thames & Hudson

SEWING

The New Complete Guide to Sewing, Editors of Reader's Digest, Reader's Digest

acknowledgments

For my Emmy and my Evan. This project robbed you of our shared time and my good moods. Sincerest apologies and deepest gratitude to you and to the following:

Maria Niubo, Nina Coloso, Nathalie Roland. Thanks to Emily Proud for being our lovely model with impossibly beautiful and well-maintained hands, especially for a painter. Muchas, muchas gracias to Natalie Kafader, my smart and talented assistant.

Kirby Kim, my tireless agent, Aubrie Pick, ace photographer, and Rob Schultze with the photo assist. Thanks to Christiana Coop and Miranda Jones for styling. Editors Amanda Englander, Aliza Fogelson, and Caitlin Harpin. Special props to lovely Lisa Tauber who saw this through and put up with me! Gratitude to La Tricia Watford for book and jacket design, Alison Hagge for copyediting, Cathy Hennessy, and Heather Williamson. Tip of the hat to Betty Wong, Kimberly Small, and Tom O'Hearn, who brought me onboard for all these books.

index

NOTE: Page numbers in italics indicate projects and (templates).